Praise for Kathy
Face Down

"Lady Appleton is a formidable h ...elligence
and independent spirit make it po .. her to triumph over
some of the constraints imposed upon her sex by society at large.
[*Herbal* is] highly recommended for readers who appreciate sus-
penseful historical mysteries with a feminist slant."
 —*Booklist*

"...a sparkling series... Emerson neatly ties together the two
major plotlines, generating credible characters and a convincingly
detailed background, and making this a solid bet for historical
mystery fans."
 —*Publishers Weekly*

"*Winchester Geese* is provocative and instructional. More important-
ly, it is entertaining. Emerson plays fair with her readers in provid-
ing all the necessary clues and in planting red herrings so craftily
that the end is a totally satisfying surprise."
 —*Maine Sunday Telegram*

"An intriguing plot and strong sense of time and place make this
page-turner an immensely satisfying read. The extremely appeal-
ing Susanna—a woman who inspires deep friendship and fierce
loyalty—is clever, determined, and quite independent for her
time. Fascinating glimpses into Elizabethan life are seamlessly wo-
ven into the fabric of the story, making *Eleanor Cross* a treat for
daily-life history buffs. As an Elizabethan might say, Here there be
much good stuff. Highly recommended."
 —*I Love a Mystery*

"Exploiting the chaos for its criminal possibilities [in *Wych Elm*],
Emerson poses enduringly hard questions about women and
worth in this exemplary historical mystery."
 —*Kirkus Reviews*

FACE DOWN BELOW THE
BANQUETING HOUSE

Face Down Below the Banqueting House

A MYSTERY FEATURING

Susanna, Lady Appleton

Gentlewoman, Herbalist, and Sleuth

Kathy Lynn Emerson

M M V
PALO ALTO / McKINLEYVILLE
PERSEVERANCE PRESS / JOHN DANIEL & COMPANY

This is a work of fiction. Characters, places, and events are the product of the author's imagination or are used fictitiously. Any resemblance to real people, companies, institutions, organizations, or incidents is entirely coincidental.

A PERSEVERANCE PRESS BOOK
Published by John Daniel & Company
A division of Daniel & Daniel, Publishers, Inc.
Post Office Box 2790
McKinleyville, California 95519
www.danielpublishing.com/perseverance

Book design: Studio E Books, Santa Barbara, www.studio-e-books.com
Set in Perpetua

Cover painting by Linda Weatherly S.

10 9 8 7 6 5 4 3 2 1

LIBRARY OF CONGRESS CATALOGING-IN-PUBLICATION DATA
Emerson, Kathy Lynn.
 Face down below the banqueting house : a Lady Appleton mystery / by Kathy Lynn Emerson.
 p. cm.
 ISBN 1-880284-71-5 (pbk. : alk. paper)
 1. Appleton, Susanna, Lady (Fictitious character)—Fiction. 2. Great Britain—History—Elizabeth, 1558–1603—Fiction. 3. Women detectives—England—Fiction. 4. Visits of state—Fiction. 5. Herbalists—Fiction. I. Title.
 PS3555.M414F2935 2005
 813'.54—DC22
 2004005559

ᴄᴡ Cast of Characters

† *indicates a real person*

Susanna, Lady Appleton widowed gentlewoman, herbalist, and sleuth; owner of Leigh Abbey, Kent

ᴄᴡ At Greenwich, March 1573

Jennet Jaffrey Lady Appleton's housekeeper and friend

Sarah Jaffrey Jennet's sister-in-law, tiring maid to

Jeronyma Holme waiting gentlewoman to

† Frances, Lady Cobham mistress of robes to

† Elizabeth Tudor, Queen of England

† Robert Dudley, Earl of Leicester the queen's favorite; known as Lord Robin

† Blanche Parry keeper of the queen's jewels

† William Lambarde author of *Perambulation of Kent* (written 1571, published 1576)

Brian Tymberley yeoman of Her Majesty's chamber

Miles Carter Tymberley's manservant

ᴄᴡ At Leigh Abbey and Whitethorn Manor, Kent

Mark Jaffrey Leigh Abbey steward; Jennet's husband

Susan and Kate Jaffrey their daughters, ages twelve and eleven

Rob Jaffrey their son, age ten

Grace Fuller Lady Appleton's tiring maid

Catherine, Lady Glenelg the late Sir Robert Appleton's half sister, now a widow

GAVIN RUSSELL, LORD GLENELG Catherine's young son

CORDELL RUSSELL Catherine's baby daughter

AVISE HAMON Lady Glenelg's servant

JOYCE laundress at Leigh Abbey

FULKE ROWLEY horsemaster at Leigh Abbey;
a widower with a baby, Jamie

NICK BALDWIN owner of Whitethorn Manor

WINIFRED BALDWIN Nick's mother

SIMON BRACKNEY AND TOBY WHARTON servants at
Whitethorn Manor

ᘒ In the village of Eastwold

DENZIL HOLME owner of Holme Hall; Jeronyma's father

EDWARD PEACOCK miller; Fulke's father-in-law

JOAN Peacock's second wife; Mark and Sarah's mother

ALAN Peacock's son

NATHANIEL LONSDALE vicar of the parish of St. Cuthburga,
Eastwold

GERALD SPARKE churchwarden and village carpenter

ULICH FULLER churchwarden and village blacksmith;
Grace's uncle; Mark and Sarah's brother-in-law

ᘒ Elsewhere

JULIUS PORT coroner

DAME STARKEY fortune teller

† JOHN DEE the queen's astrologer

ᨀ Glossary

apillion to ride perched sideways on a special seat attached to the back of a saddle

arras a tapestry made in Arras, France; or any wall hanging

assizes the periodic sessions of visiting royal judges riding a circuit to hear cases

banqueting house a separate structure used, not for banquets, but for what we'd call dessert; often of fanciful design or in an unusual location, such as up in a tree

bawdy court any church court, because these courts spent much of their time hearing cases of immoral behavior

buttery larder

church ale a feast held to raise money for the local church, usually on a saint's day

cinquepace galliard, a dance characterized by rapid steps

close stool chamber pot, often contained in an elaborate box with a padded seat and a lid

clothes press a moveable clothes chest

codpiece a fabric pouch at the front of a man's hose, attached by points; for much of the sixteenth century it was padded, decorated, and sometimes doubled as a pocket

comfit sweet containing a nut or seed, preserved with sugar

copesmate lover; comrade

dagswain a cheap, rough, shaggy cloth used to make blankets

farthingale a petticoat made of hoops of rushes, wood, wire, or whalebone and used to extend the skirt

fox-in-the-hole, tick, and **all-hid** three children's games

garderobe a lavatory; often cut into an overhang in the wall of a building so that waste fell to the ground below

girdle a woman's belt; most women attached purses, keys, fans, and other small items to their girdles for ease in carrying them

Glastonbury chair wooden chair with a folding seat, decorated on the arms and back; the legs formed an X at each side

gramercy thank you (from the French *grand merci*)

groat a devalued coin (worth twopence under Elizabeth)

humour one of the four fluids of the body (blood, phlegm, choler, and black bile); a person's humour (sanguine, phlegmatic, choleric, or melancholic) played an important role in treating ailments; physicians diagnosed the balance of the humours by examining the patient's urine

jointure the portion of a new husband's estate that was settled on his bride as an endowment for possible widowhood

kirtle a woman's skirt, and sometimes the skirt and bodice together (what we'd call a dress); the Elizabethan "gown" was more like a coat and was worn over the kirtle

manchet bread the highest quality white wheat bread

messuage a dwelling house, outbuildings, and the enclosed land surrounding them

partlet a garment used to fill the space between the bodice and ruff or collar; bodices, skirts, collars, even sleeves, were separate items of dress fastened together by points

physic garden herb garden (*physic* meant medicine)

points laces used to fasten clothing

posset a soothing drink, usually heated and flavored with herbs

presentment a formal statement laid before a person in authority on a matter requiring legal consideration and judgment

privy, common a latrine or outhouse

Privy Council the queen's advisory board

safeguard a heavy overskirt worn when riding to protect the good clothes beneath

saye a finely woven woolen cloth

solar a private upstairs room used by the ladies of the household

steward the most important servant in a household; he was responsible for all the other servants as well as for provisioning the estate and selling what it produced

staple, merchants of the those who traded in wool, particularly in Calais before 1555; a stapler was any trader who bought wool from the grower and sold to the manufacturer

stillroom a room or building used for distilling medicines and perfumes

tables, game of backgammon

tailclout or clout diaper

tilt boat a large boat covered by a tilt (canopy) and carrying as many as twenty-five passengers

tiltyard the area where tournaments were held

tiring maid a maidservant who helped her mistress with her attire

trencher platter of wood, metal, or earthenware

verge the twelve-mile radius around whatever house the monarch currently occupied

wardship rights held by the monarchy over land that was once held from the Crown by feudal military service; when such lands were inherited by a minor, the monarch took custody of both the land and the heir; those who bought wardships from the Crown gained the profits from the land during the heir's minority and the right to arrange the heir's marriage

wherry a small boat with cushions for seats that carried two to five passengers

FACE DOWN BELOW THE
BANQUETING HOUSE

1 ⚭

March 19, 1573

THE ROYAL standard flew over Greenwich. Jennet Jaffrey's heart fluttered in unison with Elizabeth Tudor's ensign as the wherry that Jennet's sister-in-law had hired carried them past the queen's favorite residence. Behind them, boats and ships of all sizes passed by, some on their way to nearby dockyards, others bound for London or headed out to sea.

Jennet had no interest in the colorful water pageant of barges, tilt boats, and merchant vessels. Mouth dry, she could not tear her eyes away from the sprawl of high brick walls and gilded turrets that made up the rambling palace.

"You act as if you've never seen Greenwich before," Sarah chided her.

"Only from the land side." The road from Rochester to Deptford ran between a two-hundred-acre deer park and the sixteen acres that comprised Greenwich, but that view lacked the impact of the water approach. The royal gardens, a tiltyard, the tennis court, bowling alley, cockpit, banqueting house, and stables stood between the road and the palace itself.

The river façade of Greenwich dazzled the eye. The wooded hill behind, lush with the pale green of spring, joined a cloudless

blue sky to form a perfect background for bricks painted bright red and decorated with black. Each mortar joint had been picked out in a white so brilliant it reflected the sun. Every battlement was surmounted by an elaborate carved beast. Some held flagpoles, others glittering golden vanes.

But splendid as the exterior appeared to Jennet, what awaited her within was more wonderful still. This very day, she would see the queen. Jennet Jaffrey, a simple goodwife from Kent, would be among the spectators in the great hall when Her Majesty performed the annual Maundy Thursday ritual.

The waterman turned his small craft toward shore, pulling with steady rhythm on the oars until the wherry bumped against a nondescript pier some four hundred paces east of the elaborate water gate by which more prestigious guests entered the palace. On the few rare occasions when they had leave from their duties, lower servants attached to the court used this side entrance to reach the Thames.

"Hurry, Jennet." Sarah tugged on her arm.

Like Jennet's husband, Mark, Sarah had fair skin, pale blue eyes, and light brown hair. She was more delicate than her brother, but she shared with him one characteristic that plagued many of their kin: oversized ears. The close-fitted, trellis-work cap she wore as part of her livery did a good job of hiding this defect, but also leeched away what little color she had in her face.

"If Mistress Jeronyma notices how long I've been gone," Sarah said, "she will be wroth with me."

"She cannot begrudge you time to feed." As if to emphasize the argument, Jennet's stomach growled. She'd had only bread and ale to break her fast and now it was well past the hour at which she was accustomed to eat dinner.

"You do not know her." Sarah clambered out of the wherry and ascended wooden steps set into the embankment with more speed than grace. When Jennet stood beside her, she pulled impatiently at her sleeve.

Jennet had no wish to cause trouble for Mark's sister, but having been a tiring maid at one time herself, she did not understand Sarah's worry. Once she had arranged Jeronyma Holme's hair and helped her dress, Sarah's remaining duties—empty the chamber pot, mend any damaged clothing, and run errands—should all have been chores that could be carried out at any point during the day.

"Does some fiend pursue us that I must be dragged along at such an undignified pace?" Jennet was hard put to keep up with her husband's youngest sister as they negotiated the narrow path from riverbank to palace.

"I did not think it would take so long to fetch you." Far from slowing her steps, Sarah walked faster.

"I could scarce come with you until Lady Appleton set out for Westcombe Manor."

Lady Appleton intended to pass the afternoon poring over old books and manuscripts with a man whose greatest ambition was to produce an alphabetical description of places in England and Wales. Jennet had been glad of the excuse to escape such tedium. She would have accepted Sarah's invitation to visit her at Greenwich Palace even if it had not included the chance to come within hailing distance of royalty.

As she puffed and panted, Jennet reminded herself that Sarah knew best how her mistress would react, just as Jennet knew that Lady Appleton regarded Jennet, who was, strictly speaking, only her housekeeper, as a friend and favored traveling companion, entitled to her own pleasures. It had been Jennet's sense of responsibility that had kept her in attendance on the widowed gentlewoman all morning, not the exacting demands of a mistress.

If Sarah had other matters to attend to before she could take Jennet to see the queen, so be it.

All the Jaffreys were proud of Sarah's advancement. Ten years ago, as a girl of fifteen, she had entered service at Leigh Abbey, where Jennet was housekeeper and Mark the steward. Sarah had,

from time to time, taken charge of Jennet's children, but in the main she had been given extensive training as a tiring maid. Once she'd mastered the necessary skills, she had found employment with Mistress Jeronyma Holme, the only daughter of one of Lady Appleton's neighbors, and when Mistress Jeronyma had been summoned to court to be a waiting gentlewoman to Lady Cobham, the queen's mistress of robes, Sarah had accompanied her.

A royal guard, instantly recognizable by his long crimson tunic, braided in black and emblazoned with the Tudor rose, challenged the two women the moment they reached the servants' entrance. Then he recognized Sarah. She smiled at him with such warmth that he colored all the way to his flat, plumed bonnet and admitted them without further question.

From the small outer courtyard just inside the gate, they passed through back service ways until they emerged into an inner courtyard. Sarah would have rushed across without stopping had Jennet not dug in her heels. "Let me catch my breath," she begged.

Reluctantly, Sarah stopped.

"And you did promise me a bit of food," Jennet reminded her.

"Mistress Jeronyma——"

"How can Mistress Jeronyma need you when she has duties of her own? Why, the queen herself must be dining by now, with all her ladies in attendance and all their ladies attending on them."

"Mistress Jeronyma does not wait on the queen direct. And those of little importance do not dine in Her Majesty's company."

"And you?"

"Domestic servants sleep with their workmates. We eat in those rooms as well."

"Then let us go to your room."

"We have already missed dinner, and there would not have been enough food for you in any case."

Jennet tried to hide her disappointment, but her unruly stomach defeated her by growling again.

Sarah sighed. "We can go to the kitchens to beg a few crumbs

from a friend of mine there, but only if you promise not to daw-
dle. I have been too long away from my mistress as it is."

"Agreed." But a moment later, an odd sight distracted her. She
sidled closer, scarce able to believe her eyes.

"Come away, Jennet." Although Sarah sounded exasperated,
Jennet heard an undercurrent of mirth. "That is one of the pissing
places."

"So the smell tells me." A row of lead-lined urine pots deco-
rated the courtyard wall.

"A necessary nuisance," Sarah said, straight-faced. "Otherwise
gentlemen would relieve themselves in any convenient corner. In
King Henry's time, red crosses were painted on some walls to de-
ter courtiers from pissing against them. 'Twas thought, wrongly,
that they'd not dare profane a religious symbol."

Stifling a chuckle, Jennet allowed herself to be guided toward
yet another small, inconspicuous door. "Never tell me there are
no garderobes or privies!"

"Most of the principal lodgings have a separate room called
the stool house because a close stool is housed there, and there is
a large common privy." A grin blossomed. "The one here at
Greenwich is not as big as that at Hampton Court—it seats but
twenty-eight at one time."

"Paltry," Jennet declared, "and no challenge to Whittington's
Longhouse in London." Built with funds left to the city by a
former lord mayor, it boasted seats for sixty-four.

Shared amusement served to ease Sarah's worries. Although
they continued to move swiftly through a maze of corridors and
rooms, Jennet no longer sensed so much urgency.

They emerged from a service wing into a great vaulted kitch-
en. Awed, Jennet tilted her head back until she could see to the
very top of the high ceiling. This proved a great mistake, since Sarah
continued on, towing Jennet after her. Jennet stumbled over her
own feet and pitched forward into her sister-in-law, causing Sarah
to let out a startled squeak when she was rammed from behind.

Jennet managed to right them both before they toppled to the stone-flagged floor, but it was a near thing and the clamor attracted unwanted attention. Jennet glared at an impertinent scullion for staring at them. Twitching her skirt straight, she thrust out her chin, as she had often seen Lady Appleton do, daring anyone else to object to her presence.

Sarah turned a brilliant shade of pink. Jennet thought she knew why when she took a good look at the sergeant cook bearing down on them. He was a most handsome fellow, tall and thin with blue-black hair and a blade of a nose. His broad shoulders were tensed in the manner of a man going into battle and his face wore a ferocious scowl...until he recognized Sarah. In an instant the severe expression melted into a benign, almost doting smile. The color in Sarah's cheeks deepened at the transformation.

"Back to work," he barked at his minions, and followed suit himself, but not before he sent a conspiratorial wink in Sarah's direction.

"A guard. Now a cook," Jennet murmured. Either would make a suitable husband for a tiring maid.

"Six hundred people feed at Greenwich daily," Sarah said in a blatant attempt to divert her sister-in-law's attention.

Jennet resisted the urge to pepper the young woman with questions. She'd have time later, in private, to discover how many suitors Sarah had collected since she'd been at court. Instead she allowed herself to be led on a whirlwind tour of the service rooms.

"Kitchens, scullery, bakehouse, larder, pastry, pantry, poultry, and acatary—for meat and fish—each is staffed with a dozen men in the charge of a sergeant."

"I never imagined so much space could be devoted to naught but the preparation of meals."

"Close to two hundred people work in the kitchens. The officers live next door to or above the area where they work."

"And your friend?"

"He is the sergeant for the queen's mouth, the sergeant cook who sees to the food for the queen's own platter."

"A most distinguished position."

"Across that kitchen courtyard are the spicery, saucery, confectionery, and wafery—an office that makes only wafers."

For the moment, Jennet stopped teasing and paid attention to what she was seeing. Hard by the food stores, including a separate fish larder, were the buttery, a pitcher-house, and the entrance to several enormous cellars for storing barrels of wine. At a greater distance, Sarah pointed out the royal laundry, the chandlery, the brew-house where ale was made for the domestic staff, and an avenery, for storing fodder for the horses. As they went, she also appropriated bread and cheese and a pitcher of ale, and with them in hand led Jennet up a narrow flight of stairs and into a small room furnished with a bed, a table, two stools, and a storage chest.

Jennet wondered if this was the lodging assigned to a certain sergeant cook, but Sarah allowed her no time to inquire. She pointed out the tiny window.

"From here you can see the slaughtering and scalding houses."

Jennet peered through the panes. "They are passing inconvenient to the main buildings."

"It distresses some courtiers to listen to their dinner squawk or bellow as it is killed."

"Pampered popinjays." Country-bred, Jennet had little patience with squeamish attitudes.

"Distance also reduces the smell of wet feathers."

That excuse sat better. Few things stank worse than a freshly killed chicken dipped in boiling water to facilitate plucking.

Munching on the softest manchet bread she'd ever tasted, Jennet plopped down on one of the stools, stretched her legs out in front of her, and wiggled her toes inside her sturdy leather shoes. She felt as if she had walked miles, all of them inside the palace. "Your sergeant cook—does he have a name?"

"Cormac."

"An Irishman?" The Irish were a troublesome race and not much trusted in England. Jennet was surprised to hear of one holding a post so close to the queen. Why, he was in an ideal position to poison Her Majesty, if he had a mind to.

"His mother was Irish born and named him for her father, but he is as English as you or I."

Jennet took note of the way Sarah leapt to his defense. "And your guard? Who is he?"

Before Sarah could answer, rapid footfalls sounded from the other side of the door. A moment later, Mistress Jeronyma Holme burst upon them in a flurry of brown velvet skirts and a flood of words.

"Here you are, then, just as I supposed you would be! Such a to-do today! I vow I am quite light-headed from all this rushing about. Where is my black hat with the high crown? The one with two black ostrich feathers set with gold crowsfeet covering the crown at one side."

The gentlewoman was no more than twenty. Shorter than Sarah but taller than Jennet, she had plump cheeks, hair the color of ripe wheat, and green eyes flecked with amber. Jennet saw no trace of anger in them, and no reprimand to Sarah for shirking her duties was forthcoming. Rather, Mistress Jeronyma's small mouth settled into a pretty pout as she waited for an answer.

Using swift, efficient movements, Sarah made minor adjustments to her mistress's attire. The brown velvet bodice had ridden up at the waist, twisting a black leather girdle askew and exposing the points that tied bodice and skirt together. "You have no need of that hat until Lady Cobham leaves the palace." On the morrow, Sarah and her mistress and her mistress's mistress journeyed to Cobham Hall for a few days' visit.

With a practiced, professional eye, Sarah surveyed the partlet and sleeves of light brown silk, searching for wrinkles. Jennet's gaze followed the same path, sweeping over the braided shoulder

pieces and the trellis-work of narrow brown velvet strips that covered the sleeves, then shifting to a skirt, also braided, that opened over a black satin underskirt decorated with black velvet bows and tiny roses. To complete the ensemble, Jeronyma Holme wore a necklace of jet beads. From her girdle, which was decorated with cut steel, she'd hung a small mirror and a black velvet pouch.

In shocked disbelief, Jennet saw Sarah slip one hand inside the pouch.

If her mistress noticed she'd been robbed, she gave no sign. "You are a great comfort to me, Sarah," Mistress Jeronyma said. Bestowing an affectionate pat on her tiring maid's cheek, she left without a backward glance.

"What did you take?" Jennet demanded.

Sarah opened her fingers to reveal an ornate circle banded with mother-of-pearl and rubies.

"You stole your mistress's ring?" The bread Jennet had eaten turned to a rock in her belly.

Sarah sighed. "No. *She* stole it." She rolled the elaborate piece of jewelry over on her palm until they could both see the raised portion—diamonds arranged in the shape of a tiny letter *E* and beneath, in blue enamel, an even smaller *R*.

"Elizabeth Regina. Elizabeth the queen."

"Just so." There was a note that blended horror and awe in Sarah's voice. "She's never dared take something from the queen before."

Unable to help herself, Jennet reached for the glittering object. It had been designed to open. Within, she discovered two little enameled busts. One, wearing a tiny ruby brooch, was clearly meant to represent the queen. Jennet had seen other likenesses of Her Majesty, both on coins and in portraits. The second woman's visage was unfamiliar to her but she wore a diamond speck. Someone important, then.

Sarah peered over Jennet's shoulder at the minuscule portrait. "That is the queen's mother," she whispered.

Queen Anne Boleyn. Jennet knew the story. Queen Anne had been beheaded for adultery when her daughter was a child of three. No doubt Her Majesty had many jewels, but this image-in-small, representing a mother she could scarce remember, was certain to have a great deal of sentimental value.

Jennet swallowed hard. "Why did Mistress Jeronyma steal the ring? How did you know she had? What——?"

Hands covering her face, shoulders slumped, Sarah sank down on one of the stools and rested her elbows on the table. "I do not know why she does it, but she takes things all the time." Weariness and defeat laced Sarah's voice. "It is left to me to return them before anyone discovers they are missing. In the ordinary way of things, it is not a difficult task. People are fond of Mistress Jeronyma and have no desire to cause her trouble. But how am I to get into the royal apartments?"

Jennet crossed to her sister-in-law's side and placed one comforting hand on her shoulder. "The same way you get into other lodgings here at court. The guards are accustomed to seeing you, are they not? Besides, we both know servants tend to be invisible."

"The queen's personal guards are most vigilant." Sarah lifted her head and met Jennet's gaze with sorrowful eyes. "I do much doubt I can get past the presence chamber, where audiences are held."

"There must be another way."

Sarah rubbed the bridge of her nose and closed her eyes in apparent defeat, but after a moment she rallied. "The queen's chief gentlewoman and keeper of the queen's jewels is a woman named Blanche Parry. She is getting on in years. It is possible she will retire to her own lodgings rather than attend the ceremony in the great hall."

"Do you mean to confess all to her?"

"I see no other way out of this dilemma. The queen is sure to miss this ring. Will you help me, Jennet? There is no risk to you."

She managed a weak smile. "All you need do is wait outside Mistress Parry's lodgings and prevent anyone coming close enough to overhear what is said within."

2 ~

IN PREPARATION for the traditional ceremony in which the queen washed the feet of a number of poor women, to commemorate Christ's washing his disciples' feet on the first Maundy Thursday, one long table and a bench had been set up on each side of the great hall at Greenwich. Carpet covered the terra-cotta tiled floor in front of these benches. Nineteen cushions had been placed at intervals on top of the carpet on one side of the hall, twenty on the other.

Susanna, Lady Appleton, regarded these arrangements with mild interest, but in truth she'd have preferred to remain in her host's private study at Westcombe Manor discussing the revisions he meant to make in the manuscript of his *Perambulation of Kent*. She'd not been given any choice. She'd scarce arrived at William Lambarde's house in East Greenwich, a short ride from the inn in Deptford where she'd spent the night, when he'd announced they must be off to the palace without further delay. It would not do, he'd insisted, to miss a chance to witness what he deemed "an interesting antiquarian survival." According to him, its origins went back nearly a thousand years.

"Do you wish to stand closer?" Lambarde asked.

Since it was clear he did, Susanna allowed herself to be eased toward the front of the cluster of courtiers and townspeople crowded into the back of the hall. A sleeve, heavily embroidered with metallic thread, raked against her velvet-clad shoulder,

catching the fabric for a moment before its wearer pulled free with an impatient curse. What he had to swear about, Susanna did not know. Her garment was the one now marred with a long, jagged scratch.

Lambarde guided Susanna to a halt next to an elderly woman in an old-fashioned gable headdress. Although most at court regularly washed their faces, hair, and beards, at the least, this woman plainly relied upon the heavy fragrance of civet to mask the unpleasant odors clinging to her person. Her clothing did not appear to have received attention from a laundress since King Henry's time. Susanna edged away until she found a less noisome spot behind a cheerful little matron doused in the scent of marjoram.

"It would be a great honor to be presented to Her Majesty," Lambarde said.

"No doubt," Susanna replied in a neutral voice. "I fear I was never invited to attend upon her at court, either as Sir Robert Appleton's wife, or as his widow."

"A pity." For a moment, Lambarde let his disappointment show in a sad-eyed expression.

Susanna said nothing. She had no desire to have the queen's attention focused on her, and was glad Queen Elizabeth did not know her on sight. The closest they had ever come to meeting had been some ten years past, when Susanna had been but one face among thousands standing at Thameside as the royal barge passed by.

The queen was no more likely to notice her today unless someone pointed her out. Several people regularly at court knew her, Lord Robin and Lady Cobham in particular, but Susanna did not see either of them among the spectators. Indeed, she recognized no one in the crowd.

"Her Majesty must be aware of who you are, Lady Appleton. You are famous for your work on poisonous herbs."

"She has heard of my existence," Susanna acknowledged.

On several occasions, the queen had made use of certain spe-

cial skills Susanna possessed. And, in at least one instance, Susanna had taken it upon herself to keep silent about information that should, by rights, have been passed on to both queen and council. On the off chance that Elizabeth Tudor knew of her duplicity and had ignored it for reasons of her own, Susanna preferred not to attract the queen's attention, but she could scarce explain her reluctance to Master Lambarde.

To her relief, the entrance of thirty-nine nervous, barefoot, hand-picked paupers, one for each year of Her Majesty's life, distracted his attention. A hum of anticipation greeted the arrival of a man carrying a silver basin.

"Sweet herbs in water." Master Lambarde's whisper quivered with excitement. "That fellow is the yeoman of the laundry. He will cleanse each poor woman's feet, dry them with his towel, make the sign of the cross above each set of toes, and kiss them. When the queen's sub-almoner has repeated the same tasks as the yeoman of the laundry, his place will be taken by the lord high almoner, who washes each woman's feet a third time. When he is done, it will be the queen's turn."

Three washings, to remove the worst of the grime before the queen's lips had to touch a pauper's flesh. Susanna's cynical thoughts and the repetitive nature of the ritual itself soon caused her attention to wander.

A vague uneasiness had begun to stir when she'd first surveyed the sea of faces around her. She did not know any of them. A moment ago, that had seemed a good thing. Now it worried her. Where was Jennet? When they'd parted company a few hours earlier, the other woman had been aglow with excitement at the prospect of going to look at the queen.

Puzzled, Susanna searched the great hall for her friend and companion, but Jennet was nowhere to be found.

3 ᴄ⌣

NERVOUS as a pigeon stalked by a cat, Jennet paced in the empty passage. Every sound made her start. She no longer took pleasure in the richness of her surroundings or in the fact that a yeoman's daughter had gained entrance to a royal palace.

At least a quarter of an hour past, Sarah had vanished into Mistress Parry's ground floor lodgings, conveniently located near the privy stair to the queen's apartments. Although Jennet had twice pressed her ear to the door, she'd not been able to hear a single sound within.

No reason to panic, she assured herself. Sarah had explained that Mistress Parry had a double lodging. An outer chamber led into an inner one. If the two women had retired thither, it was no wonder their voices did not carry to Jennet's ears, stretch them though she might.

This rationalization did nothing to calm her. Fear had made her mouth dry. Her stomach twisted as she thought of the dire outcome should Sarah be blamed for the theft. She could be hanged. Or spend the rest of her life imprisoned. That might be better than hanging, but not by much.

In her agitation, Jennet could not stand still. Fidgeting, she moved away from Mistress Parry's door. She'd strayed toward the end of the corridor farthest from the royal wardrobe and jewel house and the queen's guards when a male voice, rife with suspicion, challenged her.

"What business have you here, mistress?"

Heart racing, Jennet turned. She was prepared to claim she'd been visiting Mistress Parry, but the words stuck in her throat. The narrow eyes boring into her were cold enough to provoke an involuntary shiver.

"I am lost," she blurted. "My cousin gave me directions to her chamber but I must have taken a wrong turn." Jennet heard the nervous tremor in her voice and fell silent before she made

matters worse. She could lie very well when the occasion demanded it—if she'd had time to prepare what she would say.

At least she'd not been caught with her ear to the door. And this man was not a guard. By his dress, he was a courtier. She stared at him, wondering at the distrust she sensed from him. He did not know that she'd done anything wrong, so why should he regard her with such a suspicious glower?

He was plain of face—no beard, no freckles or pockmarks, a nose and ears of normal size and an undistinguished chin. Dull brown hair, unaccented with highlights of any other shade, had a receding hairline. Only his eyes were at all unusual. They were remarkable small and appeared to be set in a perpetual squint.

"Who is your cousin?" His voice now contained nothing more threatening than mild curiosity.

"Mistress Smith," Jennet said, still reluctant to reveal more than she had to. She felt certain a household of this size contained at least one person with that most common of names. "If you can tell me how to reach the great hall, I am certain I will find her there."

The man stared at Jennet, as if memorizing her features, then sent a slight smile in her direction as he offered her his arm. "Allow me to show you the way."

Jennet had no choice but to go with him.

She was surprised to discover how short the distance was. The sounds she'd been hearing made sense now. A crowd had been gathering in the hall across the courtyard. The ceremony had already begun.

She risked one glance over her shoulder before she entered the hall and picked out three windows in the opposite wing, two for the outer chamber and one for the inner, that must be Mistress Parry's lodgings. Nothing moved behind any of them.

Once inside the great hall, it was a simple matter for Jennet to elude her unwanted escort. She squirmed and elbowed her way through the crowd until at least a dozen people separated them. Only then did she have leisure to admire her surroundings.

Every surface was gilded, carved, painted, or hung with tapestry. Jennet scarce managed to keep her jaw from dropping as she beheld wonders beyond her imagining. She was so busy gawking and watching for the queen to arrive that she did not notice that Sarah had finally caught up with her until Mark's sister touched her shoulder.

"Mistress Parry was not in her chamber," Sarah whispered, "and I do not see her here."

"What kept you so long, then? I——"

"I tried to leave it in one of the jewel coffers, but they were locked." Sarah's low voice shook. "I pray I did not leave any scratches on the keyholes."

It was all Jennet could do not to groan aloud. She worried her lower lip with her teeth as she watched Sarah's agitated gaze rove over the crowd. Only one person seemed to take note of her interest, the man who had come upon Jennet in the corridor. As soon as he glanced away, Jennet grabbed Sarah's arm. "The courtier in the tawny doublet—who is he?"

"Where? More than one man wears that particular shade."

"Between the pockmarked fellow in black and the woman wearing the color they call 'dead Spaniard.'"

Sarah's breath hitched. "Brian Tymberley, yeoman of Her Majesty's chamber. The man in black is Tymberley's manservant, Miles Carter."

In as few words as possible, Jennet told Sarah what had happened in the passage outside Mistress Parry's lodgings. She was relieved to see that Tymberley showed no further interest in them, but she did not dare discount any potential menace. "He saw us together," she whispered. "Does he know your name?"

"Carter does," Sarah admitted.

Another conquest? The question danced on the tip of Jennet's tongue, but she never asked it. At that moment, the queen entered the hall.

The very air seemed to shimmer in anticipation, making

Jennet feel as if she'd stepped outside just before a lightning storm. All her concerns about Master Tymberley fled before Her Majesty's advance. She could do naught but stare, eyes aglow, at Elizabeth of England.

Accompanied by thirty-nine ladies and waiting gentlewomen, the queen went first to the upper end of the hall, where a stool and cushion of estate had been placed. There Her Majesty sat, and knelt when it was needful during the service, to hear singing and prayers and the Gospel read. When her chaplain had finished relating how Christ washed his disciples' feet, the ceremony resumed.

Each attending lady and waiting gentlewoman put on an apron and took up a towel and basin. Then, with one of them stationed by each pauper, the queen went from cushion to cushion. At each, she knelt to wash, dry, cross, and kiss a foot. She went down the ranks a second time to distribute four yards of broadcloth to each woman. She repeated the journey with a pair of shoes for each. On the next trip, she gave each one a wooden platter laden with Lenten fare—half a side of salmon, half a side of ling, six red herrings, and two manchet loaves. If it was the same bread she'd tasted in the kitchen, Jennet thought, the paupers were in for a treat.

On the queen's fifth circuit, she distributed white wooden dishes filled with claret wine. Jennet, by now a trifle bored, shifted her interest to the crowd. To her immense surprise, she recognized Lady Appleton. Tall for a female, she stood head and shoulders above the plump little woman in front of her.

Now what was she doing at Greenwich? Jennet inspected the gentleman standing beside Lady Appleton and concluded he must be Master Lambarde. No doubt it had been his idea that they attend the ceremony.

At that moment, as if she felt Jennet's eyes upon her, Lady Appleton looked up. Relief suffused her features. Jennet turned, intending to suggest to Sarah that Lady Appleton might help

them, only to discover that Mark's sister had vanished. Jennet's searching gaze raked the crowd. She hoped Sarah had caught sight of Mistress Parry and gone to speak with her, but she had no way of knowing if that was the case.

Since there was little else she could do, Jennet went back to watching the queen. While she'd been distracted, the ladies and waiting gentlewomen had surrendered their aprons and towels to the paupers and departed. Now a tall gentleman attended the queen, handing her a small white purse to give to each poor woman. On the next circuit, Queen Elizabeth gave every one of them a red leather purse. Jennet presumed both white and red contained gifts of money. She wondered if the paupers would also receive large empty bags. They'd need something in which to carry away the bounty heaped at their feet.

Sarah reappeared, her face flushed.

"Did you find Mistress Parry?"

"No, and I dare not keep this longer." Before Jennet could muster a protest, Sarah pressed the stolen ring into her hand and once more melted into the crowd.

Jennet felt as if an icy wind had just swept through the hall. Shivering, she clenched her fingers around the small, dangerous object. Her first impulse was to run straight to Lady Appleton, turn the entire matter over to her mistress, and be done with it. Common sense prevailed an instant later. She must not cause trouble for anyone else.

Taking a deep breath, Jennet struggled to order her thoughts. Murders within the verge, the area within a twelve-mile radius of whatever house the queen occupied, were the business of the coroner of the royal household, but Jennet did not know who was responsible for thefts. Just as well, she decided. If she turned in the ring, claiming to have found it, she'd likely end up in gaol herself.

A burst of song jerked her back to her surroundings. The queen had completed the ceremony and returned to her cushion of estate to listen to the choir sing.

The queen, Jennet thought, struck by an audacious idea. The queen was a law unto herself. If the ring could be put directly into Her Majesty's hands...

Having devised no better plan by the time Elizabeth of England withdrew from the great hall, Jennet followed the royal entourage into the presence chamber, the outermost of the royal reception rooms. No one challenged her. It was here that the queen granted audiences, and strangers often got this far.

While Jennet watched for her chance, she tried to blend into the crowd. She was distracted by her surroundings. Rich, thick, colorful tapestries covered the walls. Even the ceiling was decorated with intricate carvings and brightly gilded, too. Jennet brushed against soft fabrics, inhaled exotic perfumes, heard the babble of voices all speaking in the refined accent of courtiers. The scene seemed unreal, insubstantial as gossamer...until she turned too rapidly and slammed full force into a hard male chest.

Jennet lifted her head, expecting to see a stranger's face. Instead the features were familiar. Her eyes widened. Her mouth dropped open. Her wits scattered.

"Lord Robin," she whispered before she could stop herself. Then, horrified to have been so familiar with a peer of the realm, Jennet lost the ability to speak altogether.

Robert Dudley, earl of Leicester, was the queen's long-time favorite. His brows knit together in puzzlement and he tugged on the point of his beard as he studied Jennet's face. "I do not know you," he said at last, his voice flat with disapproval. "Why do you presume to intimacy?"

She bobbed a curtsey and forced herself to answer. "Your pardon, my lord. It was not well done of me. 'Tis how I've heard you spoken of, my lord, but with no disrespect."

"Who calls me Lord Robin?"

For once, Jennet did not even consider lying. "Lady Appleton, my lord. And with fondness always."

Lady Appleton, when she had been Susanna Leigh, had gone

to live in the duke of Northumberland's household after her father's death. Lord Robin, one of Northumberland's sons, had also been part of that household. Although Jennet had encountered the nobleman only once, while attending on Lady Appleton after her marriage, he was the sort of man who made a deep impression on young servant girls.

Could Lord Robin help return the queen's ring? Jennet hesitated. He had influence with the queen, but there had been that one time when his unfounded suspicions of Lady Appleton had caused her a great deal of difficulty. Mayhap he was not a wise choice for an ally. Sweat beaded on Jennet's upper lip as she waited for the earl to speak, but she had not a bit of moisture left in her mouth.

"Who is this woman, Robin?"

Hearing that low, pleasant female voice drained all warmth from Jennet's face. She stared, goggle-eyed, as the queen came up beside her and, in a playful gesture, rapped Leicester's forearm with a closed fan made of huge, multicolored feathers.

"She is acquainted with Susanna Appleton." He jerked his head toward Jennet.

"Your Majesty!" Jennet dropped into a curtsey.

"How do you know Lady Appleton?" the queen asked.

"I am h-h-housekeeper at Leigh Abbey."

"A goodly house, is it?"

"Oh, yes, madam. A fine, fair house."

"And your name?"

"Jennet Jaffrey, madam."

"Do not tremble so, my good woman. Let me see your face."

Scarce daring to breathe, filled with wonder at her own daring, Jennet lifted her head.

Elizabeth of England wore no coif or bonnet but her red hair was tightly curled and adorned with a multitude of pearls. Her kirtle and gown were all of white damask, patterned in gold and edged with pearls, gold lace, and bows of colored ribbon. A large

jeweled pendant hung from a green ribbon at her waist. On her wrist was a tiny clock mounted in a bracelet.

"Mine eyes dazzle," Jennet blurted.

The queen glittered, not just from the jewels that decorated her clothing and hair, but from within. She accepted Jennet's words as a compliment. "Have you come to beg a favor, my good woman?"

"Oh, no, madam! I—I...that is..." Unable to find the words to tell Her Majesty that she wished to return a stolen ring, Jennet once more lapsed into tongue-tied silence.

"She came to look at her queen, Robin." Pleasure throbbed in the words, putting Jennet in mind of a cat's purr.

"As all loyal subjects long to do." Leicester ignored Jennet, his attention fixed on the queen.

Laughing as if he'd said something clever, she bade him fetch one of her maids of honor. She gave no reason. She did not need to. Nor did the earl hesitate to carry out Her Majesty's command.

Jennet stared after him as he backed away from them, belatedly recalling what she'd heard from Sir Robert Appleton but had not, until now, seen—that courtiers were obliged to follow an elaborate protocol whenever they left Her Majesty's presence. Lord Robin walked backward, bowing deeply as he went. Only after he'd reached the middle of the room and bowed again was he permitted to look where he was going.

Her heart beating far too rapidly and a lump the size of a pomander ball in her throat, Jennet glanced at the queen. It was now or never. "Madam, I cannot tell you how this came into my possession," she said in a rush, "but I know it belongs to you and it is my greatest wish to return it to you." She opened her hand to reveal the ring.

The queen's fan stilled for a moment before it resumed its rhythmic movement, sending a current of cool air over them both. Then fingertips sheathed in thin, butter-soft leather brushed across Jennet's palm.

She sucked in air and closed her eyes in a silent prayer. When she opened them she saw that, along with three others, the ring adorned Queen Elizabeth's right hand over her glove.

"I will remember you, Jennet Jaffrey," Her Majesty said.

When the queen returned to her ladies without further ado, Jennet was uncertain whether to feel thrilled or terrified. Fighting a pressing desire to bolt for the door, she backed slowly out of the presence chamber.

4 ⁓

Six Weeks Later

April 30, 1573

NICK BALDWIN needed no invitation to enter any room at Leigh Abbey, not even Lady Appleton's private study, for she was his sometime copesmate. He paused on the threshold to admire the tableau. Resplendent in dark green damask banded with black and trimmed with cream-colored lace, Susanna Appleton sat at the coffin desk he had given her the previous year. The drop front, open, created a sloped writing surface. Beyond Susanna's bent head, he could just make out the series of long, narrow drawers whose shape gave the piece of furniture its name. One held quills, another ink, and a third parchment.

A piebald cat, curled into a tight ball, slept on top of the desk. A second, its fur decorated with a series of fine narrow stripes, sprawled in the carved oak armchair inlaid with holly—Susanna's favorite—taking up most of the soft blue seat cushion.

If Susanna heard Nick enter, she gave no sign of it. Intent upon her accounts, she continued to total columns of figures. It gave Nick pleasure to watch her work, knowing she enjoyed both the beauty and the practicality of his gift. If he had his way, he

would give her many more useful things, including a generous jointure.

He understood why she rejected any suggestion that she remarry, even if he did wish he could change her mind. Under the law, a married woman ceded all she owned, even control of her own person, to her spouse. The result for many women was a condition little better than slavery. Susanna insisted she believed Nick when he vowed he would never discount her opinions or seek to enforce his will upon her, but despite that, and despite the fact that both church and state disapproved of unmarried lovers, she remained adamant in her refusal to consider his suit. The real truth, he suspected, was that she enjoyed her widowhood, a state that gave her a goodly number of rights no mere wife could ever claim.

Susanna looked up, saw him, and rose in a graceful movement to greet him with arms outstretched. She intertwined their fingers as her lips brushed his. The mint-flavored kiss was too brief, but when she stepped away, she gave his hands an affectionate squeeze before releasing them.

"Nick." The warmth in her mellow voice conveyed her pleasure at seeing him, as did the sparkle in her light blue eyes and the loving smile she bestowed upon him.

"Hard at work? I am loath to interrupt you when you are busy."

"Nothing that cannot wait. But what brings you to Leigh Abbey at mid-morning?" They stood eye-to-eye, for she was the breadth of an almond taller than he. The sudden rapid flutter of her lashes signaled the moment she guessed he'd come for a reason that had naught to do with his desire to spend time in her company. "Is there trouble? Tell me."

"I do have news." Nick hesitated, uncertain how to broach the subject.

"Come and sit beside me and tell me all." She caught his sleeve, pulling him toward the broad wooden bench in front of an

east-facing window. Nick went willingly enough, amused by the thought that, even if he tried to resist, she would likely prevail. Hours of hard work in her herb garden had strengthened Susanna's arms and hands.

"You sit," he told her. "I am content to stand and enjoy the view."

Through the glass he could see a pleasing vista—orchards filled with fruit trees in flower and fields newly planted with barley and other grains. But what filled the foreground appealed to him more. Misty morning sunlight had created a halo around Susanna's head, setting off her dark hair.

As usual, a few strands had slipped free of the mesh caul designed to confine her tresses. Nick resisted the urge to tuck the flyaway locks back into place. She'd once confided to him that the gesture had been characteristic of her late, unlamented husband. Nick had no desire to remind Susanna of Sir Robert Appleton. Besides, touching her would distract him from his purpose. They could not afford an hour's delay for dalliance before he warned her what was to come.

Nick propped his right foot against the base of the bench on which Susanna perched. She sat angled sideways, her face tilted toward him. Her mouth dipped in the beginning of a frown as she studied him with worried eyes. "Bad news?"

"News from court. The queen intends a summer progress."

Susanna shifted on the window seat. For a moment, the sky behind her distracted him. Out of nowhere, clouds had appeared on the freshening breeze. Storm clouds.

"It is wise of her to show herself to the people," Susanna said. "Such displays insure their loyalty."

"And it is a great honor to be dispossessed by the queen. Or so I have been told."

Susanna grimaced as she caught his meaning. "The queen plans to visit Whitethorn Manor?"

"My house is but one of many she may appropriate during her

visit. Master Brian Tymberley, a yeoman of Her Majesty's chamber, has arrived in the area to inspect likely lodging places."

"And wherever Elizabeth Tudor chooses to stay for a night or two on one of her progresses, householders are sent packing."

"Unless they are rich or important." As a mere merchant, Nick expected to be told to find accommodations elsewhere.

"It is an honor." But Susanna did not sound convinced. Certes, none of Elizabeth Tudor's subjects had any say in whether the queen decided to displace them or not.

"I fear it is also a disaster in the making. The queen travels with hundreds of people, all of whom must be housed and fed and entertained. The cost is enormous, if only for cleaning up after them."

"Perhaps Master Tymberley will find Whitethorn Manor unsuitable."

"You'd best pray he does not. I saw his list. Leigh Abbey and Holme Hall are also on it, and every other house of any size in a five-mile radius."

They exchanged a troubled look. "Is there no way to discourage selection?"

Nick felt his lips quirk. "I did leave Tymberley with my mother."

The comment teased a reluctant smile out of Susanna. Winifred Baldwin was a sore subject between them. Nick's mother did not approve of his courtship of the widowed Lady Appleton. She wanted him to find a young, fertile bride. Not quite two years ago, when Nick had believed his mother was on her deathbed, he'd made the mistake of promising to look for one.

Abandoning the window, he plucked the striped cat from the chair and sat, transferring the feline to his lap. At once it began to knead the skirt of his doublet, digging sharp little claws into the dark gray brocade.

"You'd best go home and rescue Master Tymberley, Nick," Susanna said. "But be of good cheer. I have heard the queen grants

knighthoods to those who do her good service. Mayhap that is
why she wants to come to Whitethorn Manor."

"Yet another honor I do not seek."

The clanking of the keys she wore at her waist heralded the
arrival of Jennet Jaffrey, Susanna's housekeeper, a second before
she burst into the study. "Madam! Madam! The queen is coming
to visit this part of Kent."

"So I have heard." Susanna nodded in Nick's direction. "To
stay at Whitethorn Manor, mayhap."

Jennet scowled. "Not here? Alan Peacock said that Her Majes-
ty would most assuredly come to Leigh Abbey."

"There is talk in the village so soon?" Susanna smiled and
shook her head over the inevitable spread of gossip.

Alan Peacock was the miller's son. His late sister had been
married to Fulke Rowley, Susanna's master of horse. The miller's
second wife, Alan's stepmother, was Jennet's mother-in-law, for
Joan Peacock's first husband had been John Jaffrey, steward at
Leigh Abbey until his death. Jaffrey's son and Jennet's husband,
Mark, held the post now. It no longer surprised Nick how quickly
news traveled in these parts, only that the rumors varied so great-
ly in their accuracy. Tymberley, he thought, must have visited
Holme Hall before descending upon Whitethorn Manor.

"One of the queen's minions will inspect the house to deem it
suitable or not," Susanna said.

"Even if he approves, Her Majesty is notorious for changing
her mind at the last minute." Nick intended his comment as much
to annoy Jennet as to reassure her mistress. Susanna might consid-
er Jennet more than a servant, but Nick did not share her fond-
ness for the outspoken Goodwife Jaffrey.

"We will be paid a visit by a Master Tymberley," Susanna told
her housekeeper.

"Tymberley? A squint-eyed knave?"

"Aye." Nick heard the tremor in Jennet's voice and was puz-
zled by it. "How is it you know him?"

"I know naught but his name."

Nick frowned, certain Jennet was lying, but she rushed off before either he or Susanna could pose further questions.

"I must supervise the maids," she called over her shoulder as she fled, "to make certain they do a proper job of shaking out all the stored clothing."

"A routine task, surely?"

"Jennet is very...conscientious." At his lifted brow, Susanna laughed. "My dear, you have no notion how much labor is involved in keeping woolens and furs through the summer."

She resumed her place at the coffin desk, ready to take up her own work again, but she continued to lecture, teasing him with his ignorance of a housekeeper's obligations.

"Every week from April to November, every garment, and drapery and skinnery, too, must be brushed and shaken to assure no moths have got into the folds. Any fur trim that has grown hard from dampness must be detached, sprinkled with wine, left to dry, then rubbed until it is soft again. Powdered herbs stored with the clothing help, but those, too, must be changed often. To my mind, dried orange peel, mixed with powdered and dried elecampane roots, works better than wormwood or lavender."

"I yield," he broke in, holding both hands in front of him, palms out. "Enough. Jennet's precipitous flight is not in the least suspect."

But when Nick took his leave a few minutes later, he was still mulling over Jennet's reaction to the name Brian Tymberley. Something about the fellow troubled her and he could not quite shake the uneasy feeling that he should be worried as well.

5 ~

"MY SON has traveled far and wide," said Winifred Baldwin as she led the queen's man down the gently sloping approach tunnel. "He has observed wonders in many lands. Muscovy. Persia. Have you ever seen the like?" She stopped to indicate a place ahead where the floor abruptly vanished.

"It is a hole in the ground." A contemptuous sneer made Brian Tymberley's opinion plain.

"It is an ice-well," Winifred corrected him. Around it were a series of deep indentations, shaped like little basins. "A fathom deep, and filled to the very top with ice, it will supply this household all the year round."

"What use is that?"

"The cold keeps food from spoiling. Other folk collect snow to stuff inside a chicken to preserve it. We use ice. It is also an ingredient in an exceeding delectable drink the Persians call sherbet." Winifred's mouth watered just thinking about that delightful mixture of ice, honey, and sugar.

"I've never heard of it."

"Simon, pull up the sherbet jug."

At Winifred's command, a gaunt scarecrow of a man knelt by the pit and retrieved the crock keeping cold in one section of the ice-well. The other servants who'd accompanied them inched closer—Nick's man Toby, sporting a newly bushy yellow beard, and Tymberley's man, Carter, who walked with a slight limp.

Tymberley tasted the sherbet, then seemed to consider the ice-well with more favor.

"All this my son built," Winifred boasted.

With a proud smile she indicated the small bricks laid in perfect circles above their heads to form the roof. A removable brickwork access trap had been installed near the top of the dome, for in addition to making ice inside the ice house, Nick had also experimented with outdoor freezing ponds. Open sluices

allowed water to flow from two deep pools into a larger, shallower freezing pond shaded by evergreens. Ice made there was cut and transported along a cart track to the hatch above and tumbled through into the ice-well.

"Imagine it, Master Tymberley. If the queen chooses to stay here, she can taste this ambrosia for herself. 'Twill please her, I warrant." Enough to reward the man who'd introduced her to such a rare delicacy. Winifred's greatest desire, after grandchildren, was a knighthood for her son.

"Mother?" Nick's voice echoed down the passage. A moment later, he appeared.

He was a fine-looking man, Winifred thought. Sturdy of build. Regular features behind a fine beard. Serious of mein. And with his father's deep, dark brown eyes.

"Explain this to me, Baldwin," Tymberley demanded.

Nick complied, but to his mother's experienced eyes, his genial expression looked forced.

"Look you, Master Tymberley, at these smaller holes that surround the pit. When the first frosts come, they are filled each night with fresh water. In the morning, when all is frozen, it is broken into bits and all these pieces are put into the larger hole. The more ice is broken, the better it is. Then every night thereafter, the small pools are filled with fresh water and the ice in the larger hole is watered. In less than eight days working after this manner, the ice will be five or six foot thick. In six weeks' time, the ice-well is full to the very top. At that point the ice is covered with rushes and left till summer."

"A Persian invention?" Tymberley sounded dubious.

"No one knows its origins, but it is no newfangledness. Alexander the Great had pits dug and covered with twigs and leaves to store ice when he went on campaign and I have seen similar structures in Italy. Conical pits about fifty feet deep and half as wide, with a wooden trestle fixed at the bottom in the manner of a gate, to allow water to drain from the ice. Here I combine Italian and

Persian designs and moreover have lined my ice house with brick. I am in hopes this ice will keep for as much as two years."

"It is remarkable for its beauty and clearness," Tymberley conceded. "I cannot see the least dirt nor gloominess in it."

"The Persians use ice in all their drinks. It must be pure."

"Mayhap when the next frosts come, I will try something similar," Tymberley murmured.

Listening to him question Nick, Winifred realized she'd miscalculated. The last thing Tymberley wanted was to see anyone else attract Queen Elizabeth's favor. He was not about to advance Nick's standing with Her Majesty by allowing him to introduce her to the taste of sherbet. Tymberley would wait to bring this novelty to the queen's attention until he could duplicate the means of keeping it frozen. No doubt he meant to claim both ice-well and sherbet were his own inventions.

Winifred scowled. She should have anticipated this. The signs were plain enough. He looked to be of a choleric temperament and his eyes were too small. In the distant past, when she'd associated with astrologers and their ilk, she'd have seen through his devious nature at once.

By the time Winifred emerged into watery sunlight, following after the men, Tymberley had already ordered his servant to fetch their horses. "Whitethorn Manor will do to house the queen's principal ladies," he informed Nick just before he rode off in the direction of Leigh Abbey. "You will be expected to vacate the premises."

"Dragon water," Winifred muttered, borrowing her son's favorite expletive. She was not certain what it meant, and for that reason alone it expressed her frustration surpassing well.

Evict them, would he? Not likely. Not once Winifred Baldwin put her mind to thwarting him.

6 ～

"SOME HOUSES," Brian Tymberley said, "will be used to lodge the ministers and courtiers who travel with Her Majesty. Officials and servants also require beds, although they can be put up in inns or even in tents with the horses, if need be."

Susanna cringed at the thought of how many horses it would take to transport members of the royal court, not to mention haul the carts in the baggage train. Four hundred? Five? She wished she'd paid closer attention in the old days when Robert had been wont to ramble on about travel with the queen.

Nick had issued his warning and left two hours earlier, beset by worries about what his mother might be up to. Winifred was an ambitious woman, and a devious one. Susanna suspected her brush with death some two years previous had been naught but a ploy to force Nick's permanent return from the Continent. If so, Susanna could only be grateful, for her own sake, but Winifred's recovery had been a mixed blessing for Nick. The old woman tormented him mercilessly, urging him to abandon Susanna and marry. Her current candidate was the daughter of another near neighbor, Mistress Jeronyma Holme, a young woman half Nick's age.

"Have you inspected Holme Hall?" Susanna asked.

Tymberley sniffed. "An inferior hovel."

The response surprised Susanna. She'd not been inside the Holme house since the death of Jeronyma's mother several years earlier, but it had always been well-run in her day.

Lifting her skirts above rushes fresh-strewn with quantities of bay leaves, Susanna trailed after Tymberley as he examined every nook and cranny of Leigh Abbey's great hall. The manservant acting as Tymberley's clerk followed behind like an obedient hound, his wax tablet and stylus at the ready.

"How many rooms?" Tymberley snapped the question at her.

Swallowing a sharp retort, Susanna ignored his rudeness. "Forty, not counting the hall or the service rooms."

There was something of the badger about Tymberley, she decided as she watched his gaze skim over the tapestries decorating the hall, rest briefly on the table on the dais, then return to her. The fancy that he was a burrowing creature, unaccustomed to light or laughter, with a vicious streak just beneath the surface of his condescending smile, was not dispelled when he spoke, though his words were ordinary enough.

"Your hall is large enough for the queen to dine," he said, "but only just."

"Most gentlemen's halls have no more width." Susanna had to allow that a few were longer, but to her this room had always seemed immense. She did not often use it, preferring to take her midday meal in the adjoining dining parlor and sup in the inner chamber beyond, or in her withdrawing room on the floor above.

"How many servants have you?"

"Eighteen for the house and six laborers on the home farm."

"Stabling?"

"Enough for ten horses in separate stalls. Eight are filled at present."

The look he gave her said plainer than words how unimportant he considered the welfare of any horse that did not belong to queen or court.

They continued through the dining parlor and out again into the covered walkway that ran around the inner courtyard, a holdover from the design of the abbey cloister that had once occupied the same spot. A series of rooms opened off this passage. One contained a bedstead.

"The infirmary," Susanna said before he could ask.

"Have you illness here?"

"No more than anywhere else."

"Plague?" Tymberley asked.

"No." She was certain he knew already that there was no epidemic in the area. Had there been, the queen's man would have been looking elsewhere for royal lodgings.

Circling the courtyard, Tymberley inspected Leigh Abbey's private chapel without comment, passed the way to the gatehouse, and paused at an open door. Squeals of girlish laughter floated out to them.

"My steward's lodgings," Susanna said.

Tymberley pursed his thin lips in disapproval. "You are generous with your servants."

"No more than they deserve. My steward and housekeeper and their children live here, Master Tymberley. As in many country households, upper servants are as well respected in the neighborhood as the lord or lady of the local manor."

Susanna wondered where Jennet was hiding. She was conspicuous by her absence, making it obvious that she wished to avoid Master Tymberley. Faced with the man himself, Susanna could understand why someone might take an instant dislike to the fellow, but Jennet's odd behavior puzzled her. When had she encountered Tymberley before? And where?

"Ahead is the steward's office," she said aloud, urging the two men past Mark and Jennet's domain. Tymberley's clerk, she noticed, favored his right leg. She sympathized. An old injury to one of her limbs was wont to give her trouble, especially when there had been a sudden shift in the weather. The day had turned damp and cold just prior to Tymberley's arrival at Leigh Abbey.

Beyond the office lay the cook's lodging, but since a good cook was worth his weight in gold and deserved comfortable accommodations, Tymberley made no comment concerning Susanna's generosity to him.

They completed their circuit of the courtyard at the small parlor situated between the great hall and the kitchen wing. There her servants took meals when Susanna fed in private. In addition to a trestle table, the furnishings included a Glastonbury chair placed close to the south-facing window. Most evenings, either Susanna or Jennet held court, reading aloud to the other women of the household.

Master Tymberley was thorough. Susanna had to give him credit for that much. When he finished with the service rooms, he ascended to the first floor by the outer stairs in the kitchen yard and peered into the maids' dormitory above the larder. A narrow corridor led to an empty bedchamber kept ready for unexpected guests and another in use as a wardrobe and linen room. At the head of the stairwell that ended beside the small parlor he paused to eye a closed door. It led to lodgings occupied by Susanna's sister-in-law.

Catherine must have heard them coming, for she stepped out into the passage to block Tymberley's way. A tall, slender, dark-haired woman all in black, she made an imposing picture. Hovering behind her mistress was Avise Hamon, Catherine's servant. The moment Avise realized there were strangers with Susanna, she took shelter behind a convenient screen. Susanna was not surprised. Avise scarce spoke two words together to anyone but Catherine and her children.

"My babies are asleep." Catherine's voice was low but commanding. "You must go back the way you came before you wake them."

"Madam," Tymberley protested, "I—"

"This is my late husband's half sister, Master Tymberley," Susanna cut in. "Her son is the tenth Baron Glenelg."

Sadness shadowed Catherine's face at Susanna's choice of words. Young Gavin had inherited the title at the age of two, upon the death of the ninth baron. More than a year and a half later, Catherine was still in deepest mourning for her husband, a victim of a minor outbreak of the plague. Unlike the marriage between her brother and Susanna, Catherine's had been a love match.

Fawning, Tymberley backed away. The nobility, even the lesser nobility, even those with naught but a Scots title, were not to be trifled with.

"What else must you determine, Master Tymberley?" Susanna asked when she'd led him back downstairs and across the great

hall to mount the stone staircase at the east side of the hall. It curved gracefully upward and ended at her withdrawing room.

"Comfort, Lady Appleton." His glance warmed with approval as he surveyed her private lodgings. "The convenience, outlook, and surroundings of Leigh Abbey are acceptable. The size and position of the house seem adequate. Indeed, Leigh Abbey is the largest dwelling in the neighborhood." He approached the door to the passage. "What lies in this direction?"

"The former schoolroom, which now serves as a library. A child's bedroom, at present empty."

Susanna could not help a twinge of regret as she spoke. Her foster daughter Rosamond lived in Cornwall now, but there were still times when Susanna could swear she heard the child's laughter echo through the house.

"And beyond?" Tymberley inquired.

"My study and the upper rooms of the steward's lodgings."

"No music room?"

"I had no skill with lute or virginals and my father considered the acquisition of books more important in any case." She hated the idea that Tymberley might invade her study, prying into things that were none of his concern, but she felt even more disconcerted when his attention settled on her bedchamber instead.

He entered the inner room, nodding approval at the bed and other furniture. "Your lodgings are constructed near enough to court-style, one chamber leading into the next, to answer the queen's needs. Then, too, you have the greatest stature of any of your neighbors."

Did she? Or did Catherine? Susanna kept that question to herself. She had a more important one to ask. "Is the matter settled, then? Will the queen come here?"

"The gentleman controller of Her Highness's works must first inspect the house, and even if he approves, better locks will be brought in and fitted to the doors of every room the queen is to occupy."

"That seems a great deal of trouble." Susanna hoped she sounded diplomatic. "Would not Her Majesty be more comfortable at Penshurst Place? Or in her own house at Knole?"

Queen Elizabeth, Susanna recalled, had given the latter to Lord Robin early in her reign, no doubt because his father, the duke of Northumberland, had once resided there. Susanna had lived at Knole herself for a time, in the duchess's household. She'd not been surprised to hear that the queen had later traded another of her houses to Lord Robin for the property. It was a place fit for royalty, spacious and in the middle of a deer park—everything, certes, that Leigh Abbey was not.

"The queen," Tymberley said with a disdainful sniff, "expressed a particular desire to lodge at Leigh Abbey, if the house could be rendered fit to inhabit."

Susanna opened her mouth, then closed it again. Why here? And why now? When Robert was alive, he'd have killed for the privilege of entertaining the queen, for such an honor might have led to advancement at court. But Susanna had no interest in political machinations. She'd have preferred to avoid the queen's attention.

Tymberley poked about in Susanna's possessions, opening the clothes press to scrutinize the contents and inspecting the drawers in her dressing box. He even examined her reading material, peering suspiciously at one of the volumes of Master Turner's three-volume *New Herball.* He scowled at the translation she had made of *One Hundred and Fourteen Experiments and Cures* by Theophrastus Philippus Aureolus Bombastus von Hohenheim, the German philosopher and physician who used the pseudonym "Paracelsus" when he wrote of medical matters.

"What language is this?" Tymberley had picked up yet another book to leaf through its pages.

"Italian. That is a treatise on poisons, published in Verona. There is a most fascinating section on poison fungi." The study of poisonous herbs had long been of particular interest to Susanna.

She had once written a book of her own on the subject, a cautionary herbal warning cooks and housewives which plants to avoid.

"Mushrooms, do you mean?" Tymberley's lips twisted into a sneer. "I have heard some folk cook and eat them. An unnatural food, surely."

"Of a cold and moist humour," Susanna agreed, "and yet several different varieties are commonly consumed in Italian dishes."

"I suppose Italians have no fear of being *Italianted*," he quipped, using a recently coined synonym for *poisoned*.

"Just because certain members of the Borgia and Medici families are suspected of having used poison against their enemies, is no reason to tar all their countrymen with the same brush."

"If the shoe fits…" Tymberley chuckled at his own wit.

As Susanna watched him peruse the notes she'd made, in English, from the Italian treatise, she recalled a phrase Paracelsus had used to describe academics beset by overweening pride and an unwarranted faith in their own biased conclusions. Such men, he'd written, had as little wisdom as his shoe buckle. Brian Tymberley had less.

When he'd set aside the pages, he turned to face her. "A few days before Her Majesty arrives, look for a team of ten men led by one of the queen's gentlemen ushers. They will arrange our sovereign lady's accommodations. She must be made to feel as if she were in one of her own houses. To ensure this, the usher and his men create a royal suite—presence chamber, privy chamber, and bedchamber."

Susanna nodded. Robert had once described the royal apartments to her. They were almost always on the first floor, approached by a private stair from the ground floor. In the presence chamber, the queen gave audiences. The privy chamber was where she fed. The bedchamber beyond was for sleeping but in the daytime was also used for private conferences. A number of small rooms called closets were scattered about, although Susanna was not certain just where they were located, and the queen

also had a gallery where she could engage in more casual encounters with selected courtiers while she took her daily exercise.

"They bring furniture, hangings—all that is necessary for her comfort," Tymberley continued.

Susanna frowned. Why, then, had he taken the trouble to inspect her clothes press?

"Then an officer of the wardrobe of robes and his smaller team bring Her Majesty's clothing and other personal belongings."

"And what must I provide?"

"Nothing, madam. The court travels with everything it needs, from wax for seals and skin for parchment to furniture. The groom of the wardrobe of beds will arrange for transport of a royal bed, complete with straw mattress, feather bed, blankets, heavy curtains, and ermine coverlet."

"A great many horses must be involved," Susanna murmured, recalling her earlier worries.

"The master of the royal tents and his staff have charge of the horses. Some five hundred must be unloaded and stabled at each stop."

It would be as bad as she'd feared.

"The royal chaplain brings a portable altar and the clerk of the market carries with him his own set of weights and measures."

"And who is in charge of minstrels, jesters, and palace pets?"

If Tymberley heard the sarcasm in the question, he did not acknowledge it. Nor did he answer her.

"Shall I move out for the duration?" A visit to her manor in Lancashire, at present managed by her one-time gardener, Lionel Hubble, appealed to Susanna more with each passing moment. It would be interesting to see how that handsome young man had settled into marriage and fatherhood.

"The queen requests that you remain here. If she stays but one night, then she will expect entertainment in the evening. If she abides two or three, then the court will require spectacular shows

on each. It is customary for her host to give the queen a personal gift upon her arrival. Smaller gifts to certain courtiers and officials are also advisable."

"In other words, even without taking into account the inevitable losses caused by accidental property damage and casual theft, the cost to me will be enormous."

"Have you game?" Tymberley inquired, ignoring her impertinent remark. "The queen is fond of hunting."

The queen was fond of shooting animals with a crossbow as they were driven past a purpose-built stand in the forest, but Susanna managed to keep that critical thought to herself. "I have no deer park, Master Tymberley. My land is given over to crops."

"A pity." He stood at the window of her bedchamber, hands on hips, taking in the view to the south of the house. Silhouetted against a leaden sky, his head moved right, away from the fishponds and toward the ornamental gardens.

As Susanna watched, Tymberley's gaze shifted to follow the line of the graveled path to a semi-circular space planted with shrubs, flowers, and fruit trees. Of a sudden, his attention caught, he bent close to the panes.

"Is that an oak at the end of the walkway?"

Wary of the intensity she heard in his voice, Susanna reluctantly agreed that it was. A large and ancient tree stood atop a little knoll, shading the stone bench she'd placed there. It was a pleasant, peaceful spot, one of her favorite retreats.

Tymberley straightened. "Excellent. The perfect spot for a banqueting house."

"You mean to build a banqueting house beneath my tree?"

Susanna doubted there would be sufficient space. The banqueting houses she'd seen were purpose-built structures designed in a fanciful manner to provide a place where a considerable number of people could consume sweets and other delicacies following the main part of their meal.

Brian Tymberley's sly, thin-lipped smile was closer to a self-

satisfied smirk than an expression denoting pleasure. "No, Lady Appleton," he said. "My banqueting house will be constructed *in* that tree."

7 ～

CATHERINE GLENELG glanced over her shoulder when she reached the stable, but saw only shadows looming behind her in the evening darkness. Even though the threat of a violent storm had passed unfulfilled, the air felt thick. An aura of impending danger lingered.

It was that man, Catherine decided. Tymberley. A vague yet potent threat emanated from him, swirling like fog in a mountain pass, unsettling to people and guaranteed to frighten horses.

She listened to the night noises, alert for anything out of the ordinary. Aside from the restless movements of a wakeful pal-frey—a *whuffle* and the muffled *clop* of a hoof against a stone floor strewn with straw—she heard naught but her own breathing.

Without warning, something streaked past her to vanish into the gloom of the stableyard. Catherine bit back a startled cry. It was only one of the cats, bent on fulfilling its duties as a mouser, but her head needed a moment to convey that intelligence to the rest of her body. Shaky, she braced one hand against the wall to steady herself while her heartbeat settled. She could feel the roughness of the boards through her gloves and when she lifted her hand, she saw a splinter in the soft leather. Gingerly, she plucked it out, relieved to see that it had not sunk in deep enough to prick her skin.

Catherine continued on, finding the horsemaster's cottage without the aid of lantern or candle. She had only to feel her way along a well-worn track. In another month, she realized, she

would be able to follow her nose to the woodbine twining around the doorsill, but it was too early yet for that plant to be in flower.

As she lifted the latch, she heard the cries and whimpers of a fussy baby.

Fulke Rowley's attention wavered from his eight-month-old son when Catherine entered, but only for a moment. His jowly countenance and the pouches beneath his eyes, together with the long-suffering expression he so often wore, always put Catherine in mind of a mournful hound. Tonight the resemblance seemed more pronounced than usual.

"It is not meet that you be here, Lady Glenelg," Fulke said.

She heard the hint of disapproval in his voice but ignored it. "I came to see Jamie."

The sight of such a strapping fellow so dedicated to the needs of an undersized, sickly infant brought a lump to Catherine's throat. Hester, Fulke's wife of less than a year, had died giving birth to the boy. Like Catherine, Fulke was in mourning for a much-loved spouse.

"What did Susanna say when she examined him?"

"Runny ears. And he is teething." Fulke sat with Jamie on his lap before a fitful fire.

"Poor lamb."

Catherine threw off her cloak and removed her gloves, tucking them into the embroidered band she wore at her waist, the only decoration she'd allowed herself since Gilbert's death. Then she took the boy from Fulke with a deftness born of long practice handling both babies and their fathers.

He scowled up at her. "Catherine, you must go back to the house."

"We have this foolish discussion every time I come here and my answer is still the same. I may visit an old friend if I choose to do so."

She and Fulke had known each other for many years, since long before she'd married Gilbert. Their love of horses had

brought them together when Catherine first came to live at Leigh Abbey as a girl and there were times, like this evening, when she felt an overwhelming need to spend time with someone who remembered her from those more innocent days. Fulke made no demands. His affection for her had nothing to do with how wealthy she was, or her station in life, or even her gender.

"You should have your maid with you."

"My children need Avise's attentions more than I do. Besides, if no one knows I am here, what harm can come of it?"

She had not been followed, she assured herself. No one at Leigh Abbey would have any reason to do such a thing.

As she expected, once Fulke had made his token protest, he accepted that she would not leave. He stood and stretched cramped muscles until his shoulder joints popped.

"You do too much," she scolded him. "If you have no care for yourself, how are you to tend Jamie?" She talked right over his protest that he had a woman come in during the day. Children were not normally weaned until they had passed their first year, but the wet nurse had fallen ill a month ago and Jamie had, perforce, been brought home, unswaddled, and put on a diet of pap made with goat's milk, chicken broth, minced meats, cereals, and pulses. "What did Susanna suggest to ease Jamie's pain?"

Fulke showed her the plug inserted in the child's ear. "'Tis soaked in a mixture of honey, red wine, and powdered alum."

"And full of fluid." Shifting the squalling baby to her shoulder, she glared at Fulke. "Fetch a fresh one."

His forehead creased with renewed worry. "Are you certain it is only fluid? If the ear runs pus, Lady Appleton said to use a plug soaked with boiled honey and water instead."

"When Gavin was troubled by runny ears, a London physician recommended gallnuts mixed with vinegar. I used Susanna's remedy instead and my son recovered with no permanent damage to his hearing." Catherine removed the plug in Jamie's ear and examined it. "No pus."

She rubbed comforting circles on the small, thin back as she waited for Fulke to bring the medicine. Jamie still fussed but had stopped crying. By the time she'd changed the plug, Fulke had the feeding can ready. The small lidded jar had a sucking spout with a handle opposite.

"He is ready for sleep," Catherine whispered a short while later.

Together they placed Jamie in his cradle near the hearth and tied the strings to the knobs at its sides so he could not fall out when he was rocked. When Catherine had settled herself by the fire, Fulke poured them each a beaker of ale.

"What is it disturbs you, Catherine? You do not usually visit so late."

She sighed as she accepted the libation. "The queen's man invited himself to stay the night."

"It is the custom at country manors to keep open house for travelers."

"This fellow has many more houses to visit. Why linger here?"

Fulke sipped his ale without answering but the lines of worry in his forehead deepened. Catherine rocked the cradle with her foot until Jamie drifted into peaceful slumber. She envied him, for she doubted she'd get a wink of sleep this night.

The throbbing in her shoulder and at the back of her head, a discomfort that had increased at a steady rate throughout the evening, had now attained painful proportions, prompting her to discard her French hood and pull out the pins that held her hair in place beneath. She attempted to knead the afflicted area but the angle was awkward.

Callused fingertips brushed her hands aside. Fulke's touch was gentle and sure. With the same skill he used to minister to the horses, he applied just the right amount of pressure. Catherine bit back a sigh of pleasure as her tension eased.

"What is it about Master Tymberley that makes you so uneasy?" Fulke asked.

"I wish I knew. Mayhap it is just that he seems so convinced the queen will choose to stay at Leigh Abbey."

"It is a suitable house, is it not?"

"Small, by royal standards. I suppose," Catherine said slowly, reasoning the matter out for herself as she spoke, "that I would prefer to find some reason why Tymberley himself is determined upon its selection."

"Tymberley rather than the queen?"

"Yes. If it is the queen who wishes to come here, then I fear the visit will end with my son taken from me."

She did not need to explain further. Fulke knew already how that old harridan, Gilbert's mother, had fought Catherine's decision to move to Leigh Abbey with the children. It was not that Jean Russell wanted to return with them to Scotland. She did much dislike the land of her birth. But she resented Catherine's removal of her grandchildren from London, where Jean resided. She had complained to both the Scots regent and the Scots ambassador, and threatened to turn the question of Gavin's custody into a diplomatic battle.

"Glenelg is a minor Scots barony," Fulke reminded her. "Why should the queen of England concern herself with where our young lordling lives?"

"You think I make too much of this?"

"No one seemed to care when your husband neglected his estates to live year round in London."

With a sigh, Catherine closed her eyes, the better to enjoy the blissful pleasure engendered by Fulke's strong hands. No doubt he had the right of it. The queen had never before taken an interest in Catherine or her children and she had no real reason to suppose that was about to change. There was something about Brian Tymberley that made her uneasy, but for a little while, here in the peace and tranquility of Fulke's humble home, she willed herself to dismiss the queen's man from her thoughts.

8 ~

Twelve Weeks and Three Days Later
July 26, 1573
DURING THE mile-and-a-half walk to the village of Eastwold for Sunday morning church services, Jennet kept a wary eye on both Brian Tymberley and his man. Lady Appleton had questioned her about Tymberley after his first visit to Leigh Abbey. Jennet had admitted to meeting him before, even confessed that it had been at Greenwich. She'd expected him to recognize her when next he came, but he'd never, by so much as a lifted eyebrow, indicated that they'd met before.

Tymberley had returned to the neighborhood twice since the end of April, arriving on this third visit just three days earlier. In June the controller of works had also descended upon them, "improving" all the door locks at Leigh Abbey and giving orders to authorize the construction of that thrice-cursed banqueting house in the branches of Lady Appleton's oak tree. For that folly alone, Brian Tymberley had forfeited any liking among members of the household. The workmen sent to build it were loud-mouthed louts who had trampled part of the garden and seemed determined to leave chaos and confusion in their wake.

When they came in sight of the pretty little church of St. Cuthburga, built four hundred years earlier of flint and Caen stone, Tymberley exchanged a few brief words with his man. Jennet could not make them out. Carter's voice was naught but a rasp. He always sounded as if he suffered from a catarrh.

The somber clang of the church bell calling the congregation to worship also prompted every dog in the village to bark. They quieted again as soon as the tolling ceased, but the human clamor continued unchecked. Gathered in clumps and clusters before the church porch, parishioners speculated about the sermon to come or talked about their crops. Children engaged in a game of barley-

break punctuated the steady murmur of older voices with squeals and laughter.

The vicar, Nathaniel Lonsdale, emerged from the rectory in his black Geneva gown and square cap and stalked toward the south door of the church. He wore no vestments, not even a white linen surplice when ministering, proof he had radical leanings even if he had not already banned card playing on the Sabbath and forbidden the children to play fox-in-the-hole or tick or all-hid in the boneyard. Disapproval writ large on his hawklike features, he descended upon his parishioners, the shepherd gathering in his rebellious flock.

Lonsdale had come to Eastwold six months past. He leaned too far toward fire and brimstone for Jennet's taste, but Lady Appleton, who was the largest landholder in the parish and controlled the clerical living, had appointed him because he was a distant kinsman on her mother's side. On the assumption he'd become less stringent in time, she insisted he be given a fair chance to moderate his views.

Like obedient sheep, hushed and properly cowed, most of the congregation followed the vicar into the church. Jennet took her time, in no rush to enter a place where it stayed drafty and cold even in high summer. She thought she was the last to reach the porch until she looked back and saw that Tymberley's man had waylaid Lady Glenelg's servant. As Jennet watched, he backed Avise up against the lych gate. The woman stiffened, clenching both fists, but she was trapped between Carter's bigger body and the solid wood behind her. With bold disregard for where they were or what day it was, he gave her breasts a careless fondle before he stepped away. Once free, Avise bolted toward the church, her face crimson. Carter's jarring and unpleasant laughter followed her.

Master Lonsdale, Jennet thought, would not approve of that.

She followed Avise inside and entered the pew to which she and her daughters had been relegated. Before Master Lonsdale

came, families had worshiped as a unit. Now men and women were obliged to sit on opposite sides of the church and members of the gentry were separated from their servants. There was also a special maidens' bench, presided over by a widow paid by the parish to assure that no flirtations would be carried on during divine worship. Not for the first time, Jennet wondered at what point her mistress would reach the limit of her tolerance and send Master Lonsdale packing.

The service had just begun, with the reading of a psalm, when Jeronyma Holme swept into the church. She looked much as she had at Greenwich, except that she was now wearing the high-crowned black hat she'd spoken of there. Ostrich feathers bobbed as she nodded and smiled at people she knew. Her father escorted her and Sarah followed behind them. The other Holme Hall servants knew their places in Master Lonsdale's church, but Sarah ignored the maidens' bench. She likewise passed by the pew where Jennet sat without sparing her a glance. Oblivious to the vicar's glare, she seated herself at her mistress's side.

Throughout the long church service that followed, Jennet fumed. After abandoning her at Greenwich, the least Sarah could have done was acknowledge Jennet's presence. Determined to confront her wayward sister-in-law, she made haste to get outside. Even so, the group from Holme Hall had already passed the gate to the schoolmaster's house before Jennet caught them up. She grasped Sarah's arm.

Glaring, the other woman tried to pull free. "I have no time to talk to you now. Dinner awaits us at Holme Hall."

"You will make time." Holme Hall was only at the other end of the village. A few minutes' delay could scarce make much difference. Jennet hauled Sarah into a the shade of a nearby elm. Partly concealed from prying eyes by its thick trunk, she turned on her sister-in-law. "You owe me an explanation. And an apology. It is only by the grace of God that I am not rotting away in the Tower of London for stealing the queen's ring."

Sarah broke Jennet's grip but stayed where she was. "Keep your voice low, I pray you." She cast a wary look over her shoulder.

Jennet followed the direction of her gaze. The blacksmith, on his way to his messuage just beyond the village school, stared back, eyes bright with curiosity. Jennet sent him a dazzling smile, hoping to embarrass him into flight. Ulich Fuller was harmless enough, but he was married to Mark and Sarah's oldest sister. They could do without attracting the interest of the entire family.

Fuller speeded up and passed by without a word to either of them.

"We cannot talk here," Sarah objected.

"Why not? What more natural than that we should speak together for a while, old friends as we are, and kin as well?"

"Master Tymberley might see us together."

Startled, Jennet once again peered out from behind the tree. Her only concern had been the family meddling. "No doubt both Tymberley and his man are somewhere in the churchyard."

Those who lived at any distance from the church brought baskets of food with them and ate their dinner in the open air. Since it would have been wasteful to walk all the way back to Leigh Abbey and return again before the afternoon service began at two, Lady Appleton's cook customarily packed enough food for everyone in the household. Even the interlopers come to prepare for the queen's visit had been provided for. Reassured that none of them were anywhere in sight, Jennet turned back to Sarah and lifted a questioning eyebrow.

"He is out to make trouble." The urgency in Sarah's voice made Jennet uneasy.

"That is no news."

Nor was it any accident that officers who went ahead of the court looking for lodgings were called harbingers. Master Tymberley and his minions had thrown everything at Leigh Abbey into turmoil. Jennet narrowed her eyes, taking note of the way Sarah

fiddled with the points at the front of her bodice and repeatedly moistened her lips.

"What trouble can Tymberley make? He has already seen us together. At Greenwich. If he meant to talk of that, he'd have done so by now."

"Has he approached you? Has his man?"

"No. I've not exchanged so much as a word with either."

Sarah frowned. "Something must have warned him off, then. Or else he's awaiting opportunity."

Jennet said nothing.

"You must say nothing to anyone of my mistress's... affliction."

"No."

Misunderstanding, Sarah's eyes went wide with shock. "You intend to tell?"

"No. Nor have I told anyone what happened at Greenwich, not even your brother."

Jennet's gaze slid toward the churchyard. Mark was still deep in conversation with his mother, as he had been a bit earlier when she'd looked about, seeking Tymberley's whereabouts. This time, however, he seemed to feel her gaze upon him. He lifted his head, a puzzled expression on his face, and studied his surroundings until he caught sight of her. Jennet shook her head to warn him not to approach them. To her relief, he stayed where he was.

"You managed to return the ring," Sarah said. "I recognized it on Her Majesty's finger. I am grateful."

"Then tell me the truth. Why are you afraid of Tymberley?"

"He has been at Holme Hall three times since I arrived there with Mistress Jeronyma, twice when Master Holme was absent. On both occasions he drew her aside. Both times she was in tears when he left and she will not tell me why."

Jennet frowned. "Three visits? When did you return to Holme Hall?"

"Four days past. Her Majesty began her progress into Kent on

Tuesday with a visit to Sir Percival Hart's house at Orpington. She was to stay three days before moving on to Knole."

Jennet nodded. They had been told the route. Birlingham, Mayfield, Eridge, and Bedgbury were next. Each stop brought the court closer to Leigh Abbey. After a four-day visit to her own house at Westenhanger, the queen would dine at Sandown Castle, then arrive in Dover on the last day of August. She'd travel to Lady Appleton's house, by way of Sandwich, on the first of September.

"Why was Mistress Jeronyma sent away?"

"Sent? She was not sent." Sarah sounded offended. "The traveling court is of necessity smaller than when Her Majesty stays at one of her larger palaces. Lady Cobham is with the queen, but Mistress Jeronyma was given leave to visit her father."

"What sense does that make? Holme Hall is to house the queen's lesser ladies while Her Majesty stays at Leigh Abbey." That meant all excess persons would be asked to vacate the premises. At Leigh Abbey, Jennet and Mark were to crowd into Fulke's cottage with the children for the duration of the queen's visit.

"We will leave then," Sarah said, "and go to Cobham Hall, unless disaster strikes. Can I trust you to continue to keep my secret?"

"I can scarce do otherwise when you've so deeply involved me in the matter." Jennet found it difficult to keep the condemnation out of her voice. She'd risked her freedom to return the queen's bauble. Jennet shuddered, remembering how she'd felt when she'd fled the palace. She had still been shaking when she reached the safety of Lady Appleton's chamber at the inn in Deptford.

A stricken look had come into Sarah's eyes. Alarmed, Jennet reached for her, but this time her sister-in-law eluded her grasp. Jennet considered pursuit but was loath to call more attention to

herself. Eastwold was a small, tight-knit community. It kept its secrets from outsiders, but offered little privacy to its own.

Jennet's mother-in-law, a tall, slender, white-haired matron, materialized at Jennet's side while Sarah was still in sight. "What did you say to my daughter to upset her?" Joan Peacock asked.

"No one ever asks if someone has upset me," Jennet grumbled.

"That is because you deal so well with every petty annoyance that comes your way."

"I've more than usual on my plate today." But Jennet did not confide her troubles to Joan, who was on her way back to her second husband's house for dinner.

Miller Peacock, the wealthiest man in the village after Master Holme, stood a short distance away, foot tapping with impatience as he waited for his wife. He was not a man to offend, for he owned both the horse mill and the windmill and collected tolls for the use of his mill as a bridge. Additional income came from the sale of eels from his mill pond, and of the trees and plants that grew on its shores—willow for wands, grass for fodder, and flax to make cloth.

Joan had done well for herself when she'd married him, Jennet thought as she returned to her own husband and their daughters.

"Trouble with Sarah?" Mark asked.

"No." The ring had been returned. The episode was over. If Sarah had a problem with Tymberley, or with Miles Carter, she would have to handle it herself.

9 〜

Two Weeks and Two Days Later

August 11, 1573

SUSANNA APPLETON woke early, troubled by a vague sense of foreboding. She remembered its cause as soon as she rose from her bed. Master Brian Tymberley and his man had returned the previous day after an all-too-brief absence of only two weeks. They planned to remain until the queen arrived.

With a sigh, she called to her tiring maid, who slept on a pallet in the adjoining room.

Twenty-one days remained before a team of the queen's men would descend upon Leigh Abbey—a gentleman usher, three yeomen of the chamber, two grooms of the chamber, two grooms of the wardrobe, and a groom porter. They'd arrive with furniture, hangings, pillows, and bolsters, even the royal bathtub—everything necessary to equip the queen's rooms.

Susanna glanced around her. These rooms. She would have to remove all her worldly goods, from her blue damask bed hangings to the saye curtains at the windows to the clothes press and dressing box and the bed itself. Relegated to a guest chamber, she would rise to greet a day on which Elizabeth Tudor would bring a horde of proud, ill-mannered courtiers into her home. A hundred Robert Appletons and the sort of women who admired them. Was it any wonder she could muster no enthusiasm at the prospect?

"Grace," she called again, her voice sharper this time.

Belatedly, Susanna's pretty, dark-haired maidservant appeared in the doorway, eyes red-rimmed and shoulders slumped. "Your pardon, madam," she mumbled. "I slept ill."

Concerned, Susanna studied Grace's flushed face. That she would not meet Susanna's eyes suggested that worry or guilt, rather than sickness, had been at the root of the young woman's insomnia.

Grace had been in service at Leigh Abbey for more than six

years. Susanna had grieved with her when her father died and again when she'd lost her mother. With both of them gone, her only remaining relative in the village was her uncle, Ulich Fuller, a nice enough man but one uncomfortable with any woman save his wife. Susanna had no qualms about stepping in to assume the role of a parent.

"You can come to me, Grace, whatever the trouble. I look after mine own." The most likely cause of a maid's distress was a man. At worst, Grace was with child, but she should know Susanna would never dismiss her for that, not even if the father refused to wed her.

Tears welling in her eyes, Grace acknowledged Susanna's words with a nod, but she did not offer any confidences.

Susanna let the matter drop for the nonce, reasoning that when Grace was ready, she would speak. To force the young woman to yield her secrets now would serve no purpose save to create greater disharmony in the household.

Instead of asking more questions, she resumed her usual morning routine by washing her hands and face in rosewater. When she poured it from the Majolica-ware pitcher into a matching basin, Susanna was pleased to find it almost warm from sitting on the small table beneath the east-facing window. Bright sunlight was just the thing to ward off gloomy thoughts. She dealt with her ablutions quickly and dried off with a soft towel.

"No bum roll today," she said when she noticed that Grace had opened the clothes press and was reaching toward a shelf containing a lump of fabric stuffed with wool.

She expected a smile in response to her use of the slightly bawdy name, but Grace did not seem to be listening. She turned with the padded roll in one hand.

"No French farthingale," Susanna said, this time using its proper name. "I mean to ride later."

Riding was possible with the device tied in place around one's hips, but Susanna preferred to leave it off. Its only function was to

make a kirtle drape in a cylindrical shape when its wearer stood upright. Susanna had to admit that the bum roll was more comfortable to wear than its predecessor, the Spanish farthingale, a bell-shaped structure of hoops made from wood, rushes, wire, or whalebone, but it was still a nuisance. One of the greatest advantages of country living was the freedom to dress more simply. Some days, in winter when she did not mean to leave the house, she went so far as to spend the entire day in naught but a loose-bodied gown.

"I will lay out your safeguard," Grace said.

Susanna started to tell her she would do without that garment as well, then thought better of it. With all the rain they'd had of late, she supposed she did need to wear the extra skirt over her clothing, though she did much dislike the heaviness of the canvas garment. Designed to protect the finer fabrics beneath from spatters of mud thrown up by the horse's hooves, it was both awkward to maneuver and ugly to look at.

Once Susanna exchanged the chemise she slept in for a freshly laundered one that smelled of the bay leaves she placed among her clothes, Grace went to work on her hair. Grace had been as quick as ever on her dainty feet when selecting clothes for the day, but the hands that were ordinarily so fast and clever faltered and fumbled. Susanna held her tongue with an effort under Grace's painful ministrations.

The clumsiness got worse after Grace slipped a kirtle and bodice into place over Susanna's ankle-length chemise. She knotted the points as often as she tied them properly and broke two. By the time the last sleeve was secured to its armhole, Susanna's teeth were clamped with the effort it took to keep from snapping at her maid.

"The food to break your fast is in the withdrawing room," Grace announced as she stepped away.

"Pour the barley water," Susanna told her. "I will be there in a moment."

She held in a sigh until Grace passed through the door to the other room, then glanced ruefully at the bare toes peeking out from beneath her hem. Rather than call Grace back, Susanna found her own stockings, garters, and boots in the clothes press. She carried them to the bed and sat on the edge to put them on. The wooden busks inserted into her bodice to stiffen it poked the undersides of her breasts every time she bent too far forward.

Fully dressed at last, she was about to leave her bedchamber when she caught sight of herself in the small looking glass Nick had given her. She moved closer, shaking her head as she realized she already had a harried look about her when it was scarce an hour after dawn. Not even crystal in a painted frame could improve upon her appearance. Making a face at her reflection, Susanna poked an escaping lock of hair back beneath the little cap Grace had chosen for her and headed for the withdrawing room.

Bread and hot pottage awaited her but Grace, still distracted, had yet to pour the barley water. She would first fortify herself with food, Susanna decided, then delve deeper into her tiring maid's troubles. The moment she finished eating, however, Grace whisked away her cup and bowl and vanished with them in the direction of the scullery.

At a more sedate pace, Susanna descended the stair to the dining parlor. She expected to find Master Tymberley there and felt more cheerful when she saw no sign of him. If he was still abed, she might yet be able to enjoy some small part of her morning.

She went first to the herb garden, inspecting each of the sixteen parallel beds. The larger garden just beyond had been laid out in a similar pattern. The dill was just coming into flower and the pleasant aroma of ripe coriander wafted toward her on a light breeze, a vast improvement over the disagreeable odor that herb gave off in early summer.

Under Susanna's personal care, the contents of both gardens thrived, despite the depredations of Master Tymberley's careless

workmen and the difficulties caused by weeks of unusually wet weather. As had long been her habit, Susanna left the second garden and followed a path that meandered through banks of wildflowers, gently swaying larkspur and low-growing pimpernel among them. She stopped short at the sight ahead of her. An abomination had been built in what had previously been one of her favorite spots, the little knoll and the tree that surmounted it. Just looking at what had been done to it had her clenching her hands into fists and grinding her teeth together.

Moving closer, she glared at the wooden stair that circled the trunk of the ancient oak. When she tilted her head back she could see that a series of platforms had been layered in among the thick branches. Each appeared to have a fence around it for safety, but she noticed something odd at the highest level. Shading her eyes, she squinted upward. Twisted askew, one section of railing broke the symmetrical pattern.

Susanna stared at the anomaly for a long moment, then slowly lowered her searching gaze. She dreaded what she might find but was not surprised when she came to it. Chest tight, breath shortened by distress, she approached the dark mass lying at the foot of the tree. From a distance, it looked like a discarded blanket. Susanna knew it was not even before she came close enough to determine who had fallen.

The body of a man, most assuredly dead, sprawled face down below the banqueting house.

10 ～

FROM HER well-padded chair, pulled close to the window of the winter parlor, Winifred Baldwin had an excellent view of Susanna Appleton. The other woman reined in, jerking her knee out of the purpose-cut hollow in her pommeled saddle even

before her mount came to a stop. She descended in a flurry of skirts, using the velvet sling, on which both feet rested when she rode, as a stair step. She landed with an awkward hop, stumbled, righted herself, and resumed her headlong rush toward the kitchen entrance to Whitethorn Manor.

"The Devil himself must be after her," Winifred murmured, "to make her hurry so."

Nick glanced up, one eyebrow lifted in a question. He sat before a carpet-covered table, sorting a shipment of imported ivory.

"Your doxy just rode into the dooryard," Winifred said to her son.

Nick left the table, a small, carved statue forgotten in one hand. "I've told you not to call her that."

"Do you prefer bawd? Strumpet?"

"Mother."

She paid no mind to the warning in Nick's voice and intended to ignore any effort he made to get rid of her after his paramour joined them. He was much mistaken if he thought she'd leave two lovebirds unchaperoned.

Eager for the conflict to begin, Winifred shifted so she could watch the door. Pain lanced through her as she moved but she managed not to grimace or cry out.

Nick did not notice. Susanna had appeared in the doorway. She was flushed and out of breath but not as agitated as Winifred had expected. Something in her manner seemed to alarm Nick, however. He crossed the chamber to her side, his feet swift and silent on the carpet from Antwerp that covered the floor instead of rushes. The tenderness with which he took Susanna into his arms made Winifred wince.

She glared at them as they spoke together in low whispers. To be forced to watch this affection between them caused her more pain than the ulcerated tumor in her breast. She had wanted distraction, but this was not entertainment. This was torture.

"What brings you to Whitethorn Manor, Lady Appleton?" Winifred's sardonic greeting was sufficient reminder to both Nick and Susanna that they had a witness.

"I did not see you there, Mistress Baldwin." Susanna slipped free of Nick's embrace and approached the window. "I trust you are well."

"I am in excellent health and spirits, but you appear to be passing overwrought." She dipped one hand into the comfit box on the sill.

The truth was, Susanna had already regained her normal composure. And Nick, although worry lines creased his forehead, had not called for his horse or done anything else to indicate a crisis brewing.

Susanna managed a faint, ironic smile. "I have had an unsettling morning," she admitted.

Winifred looked at the handful of sweets she'd extracted from the box, which contained a mixture of seeds, nuts, and berries, all well coated in sugar, ginger, and cloves. "Pine kernel?" She selected one from among the assorted treats and held it out.

Her eyes met Susanna's with sly challenge. Nick might not realize it, but Susanna was well aware that pine kernels were used to aid conception. Although Susanna's barrenness was only one of the reasons Winifred thought her unsuitable as a daughter-in-law, Nick's mother could not resist the opportunity to taunt the other woman with her failure to achieve what was, after all, every wife's first duty to her husband, the production of an heir.

"I fear my appetite fled when I found a body under the oak tree."

Winifred hid a first reaction of guarded delight. Any trouble at Leigh Abbey pleased her and a dead body could cause a good deal of it indeed. Still, she knew she must be cautious in her enthusiasm and learn the specifics before she gloated.

"Murder?" she inquired, popping the pine kernel into her own mouth and following it with a juniper berry.

Nick came up beside her. "That is what I will determine, Mother. As justice of the peace for these parts, I needs must accompany Susanna back to Leigh Abbey."

"The poor man broke his neck," Susanna said. "He seems to have fallen from an upper platform of the queen's banqueting house."

"Seems?" Winifred paused with another comfit halfway to her mouth. "So it is possible he was pushed. Or mayhap poison did him in, making him dizzy enough to fall to his death—the same fate, I recollect, did befall your late husband, Lady Appleton." She munched a sugared almond, savoring both the crunch and the sweetness. Her favorite treats were almonds coated with honey, but these were an acceptable substitute.

"Enough, Mother." Nick spoke sharply and the hand that came to rest on her shoulder squeezed hard enough to cause mild discomfort. "I'll not have you taunt Susanna with irresponsible speculation."

Winifred leaned forward in the chair, intent on letting Susanna see the light of malicious mischief in her eyes. "I take my pleasures where I find them. I am old."

She was also dying, but Nick and Susanna did not need to know that. In truth, her son was unlikely to believe her if she did try to tell him. He'd think it a ruse, like the trick she'd played on him two years past.

"When I said he seems to have fallen, I meant no one saw him fall," Susanna said.

"And just who was this unfortunate victim?" Nick, Winifred supposed, had already asked that question and been given an answer during their brief, whispered consultation by the door.

"The dead man is Miles Carter." Susanna's voice was even, betraying nothing of what she might have thought of the victim when he was alive. "Master Tymberley's servant."

"Tymberley's servant?" Winifred echoed in genuine astonishment. "Why would anyone want to kill *him*?"

11 ⌒

LIVING, Miles Carter had been one of those servants no one noticed. Nick could not recall a single occasion when he'd taken a close look at the fellow. Now he studied a face that had been surpassing pockmarked and splotchy even before it made sudden, violent contact with the ground. Blotches, however, seemed to be all that distinguished it.

For a small mercy, there was no question what had caused his death. Nick glanced at the several platforms above their heads, then turned to face Brian Tymberley, who had been waiting when Nick and Susanna rode up, furious that Susanna's grooms would not let him see Carter's body until she returned.

"He fell out of the tree and broke his neck," Nick said. "A careless step descending, mayhap." A gentle breeze stirred the hair at the nape of his neck and the feather decorating his bonnet.

Tymberley's mouth thinned into a hard line. "This banqueting house was constructed with the safety of queen and courtiers in mind. The railings around each level were designed to be sturdy enough to prevent any accidental fall."

"There are only two other possibilities—that Miles Carter was pushed, or that he jumped. I should think you would find either of those conclusions unpalatable." Nick glanced at Susanna. "When is the queen due to arrive?"

He knew the answer as well as she did—three weeks—but he was curious to see Tymberley's reaction. The accidental death of a servant would not deter Her Majesty from visiting Leigh Abbey. But murder might.

Tymberley stared up at the broken railing, his face set in a grim expression. "It is never wise to inconvenience the queen."

"But what was he *doing* up there?" Susanna asked.

Nick heard the hesitation in her voice and thought he could guess its cause. She was torn between her longing for a good reason to cancel the royal visit and an understandable aversion to the idea of murder at Leigh Abbey.

"A woman. It is an ideal place for a clandestine meeting."

The bitterness in Tymberley's tone surprised Nick, but before he could ask for clarification, Susanna spoke.

"My womenservants are above reproach." Her eyes glittered like sapphires as she glared at Tymberley.

"Are you certain of that, Lady Appleton? Do you lock them in at night?"

Nick turned to the grooms. "Take the body to the chapel."

The terse order silenced both Susanna and Tymberley. Neither spoke again until the remains had been carried away, although Nick could sense Susanna's irritation simmering in the summer sun. Her body all but vibrated with the effort to keep her opinions to herself. Tymberley's manner—watchful, his eyes cold and calculating—suggested he was aware of her resentment and looking for a way to use it to his own advantage.

"Tragic," he murmured when the grooms had gone off with their lifeless burden. "But, then, the results of intemperate passion so often are." He glanced from Susanna to Nick and back again as his words hung in the air, slowly coalescing into a veiled threat.

"I see nothing to indicate that Goodman Carter's death was anything but an accident." Nick chose his words with care. "Unless you have a specific accusation to make, you'd do best to keep unfounded speculation to yourself."

Tymberley feigned contrition with an insincere sigh that only underscored the duplicity of his next words. "I am most adept at keeping silent, even when the subject is untamed desire, and all the more so when I am well compensated for my restraint. I will leave you to consider how much my cooperation is worth to you."

With a puzzled frown, Susanna watched him walk away. "Did he just threaten us, Nick?" She turned troubled eyes to him. "I thought he wanted the queen to come here—to show off this architectural wonder." Her exasperated wave indicated the tree house. "Her Majesty will surely go elsewhere if she thinks we harbor a killer on the premises."

Lines of worry creased her forehead, making Nick wonder if Susanna suspected one particular maidservant had met Carter during the night. He considered asking for a name, then decided to wait. His appointment as a justice of the peace weighed heavily on him, but his first loyalty was to the woman he loved.

"I do not think it is murder Tymberley just threatened to expose."

"What, then?"

"Your…affection for me."

"Impossible. We have been most discreet."

"That has never stopped the servants or our neighbors from speculating. I warrant Tymberley has heard something scandalous about us, for his words were nothing less than a blatant attempt to extort money."

"He is much mistaken if he thinks we will pay him a single farthing." That matter disposed of, Susanna knelt where the body had been and pressed the palm of one hand to the grass. "Still damp. Carter fell during or after last night's rain."

Nick considered the ground beneath the oak. "Had he begun to stiffen yet when you first found him?"

"His upper body was rock-hard." Using the tree trunk to support herself, she rose, but her eyes remained fixed on the spot where Carter had lain. "I found him less than two hours after sunrise. When I touched his shoulder, his clothing felt dry. The sun was bright and warm by then, but if he'd been lying out in the rain, the cloth would still have been damp."

Nick nodded. "So, he could not have died much before midnight. But how much after?" Nick had not changed his mind about the nature of Tymberley's threat, but before he decided on his own course of action, he wished to be certain Carter's death had been an accident.

"Closer to midnight than dawn," Susanna reckoned. "Stiffening ordinarily takes five or six hours to reach the stage it had when I first saw him."

"We have between us seen entirely too many dead bodies," he observed. Susanna seemed to have a knack for landing in the middle of coroners' inquests. He glanced into the branches of the oak tree above. "If there are any answers, they will be found inside the banqueting house."

A narrow, curving staircase circled the trunk of the tree, climbing ever higher until at last it ended on a platform level with the rooftops of Leigh Abbey.

"Oh, my," Susanna murmured. Fabric rustled as she stepped out behind him.

"You had not been up here before?" The banqueting house commanded a splendid view of the gardens at the back of the manor house and the fields and orchards on either side of it.

"No." She glanced at him and grinned. "When I was a child, I climbed trees with my cousins, but never this high."

Nick studied the broken section of rail. It swayed, creaking, in the light breeze. A stumble. A hard hit. A fall. Mayhap, but smudged footprints covered the platform, sufficient to make him wonder if more than one person had recently trod these boards. He indicated the splotches of dried mud dotting the wooden floor. "It rained in the hour before midnight. The fields, already saturated from this uncommon wet summer, would have been a quagmire until the sun began to dry them."

"Until a few days ago," Susanna said, "when the workmen installed the railings, Tymberley discouraged anyone from ascending above the first level. Too dangerous, he said." She sank to her knees to better study the faint and incomplete tracks left by muddy boots.

"Someone who did not want to risk being seen on the graveled paths, someone with something to hide, would take the long way around through the fields. Carter, but at least one other. Mayhap more." Several prints seemed smaller than the rest.

"At least two people, one a woman." Susanna's shoulders slumped as she reached that conclusion.

Nick crouched beside her. "Carter had surpassing large feet." He gestured toward one of the biggest patches, then pointed out a smaller print. "Any number of men could have made these. I wear shoes that small myself. So does my man, Simon. And there is little difference in the shape of soles between the sexes, in either shoes or boots."

Susanna placed her own foot next to the smaller print. Nick followed suit. The results were inconclusive.

"The presence of another person, male or female, does not necessarily mean Carter was pushed," Nick said. "Carter could have met someone here, then fallen after that person left. Or jumped. I do not see any sign of a struggle."

Together, they rose and surveyed the platform.

"There," Susanna said, pointing to one corner where a large square patch seemed cleaner than the rest of the flooring.

When Nick bent to inspect the boards at close range, he spied a bit of fabric in a crack. "A dagswain blanket," he murmured, rubbing the rough fragment between his fingers and thumb. "He, or they, may have taken their ease here. A midnight repast. A tryst."

Was Tymberley right? Had Carter arranged to meet a woman here? If she'd proved unwilling, struggled, pushed him away from her with more strength than he'd anticipated, could he have struck the rail hard enough to break through and fall to his death? Not deliberate murder, then. But Nick could understand why the girl might have fled. The law did not always take extenuating circumstances into account.

He looked up to find Susanna watching him. He did not need to tell her what he thought. She saw the possibilities as clearly as he did. Carter's death might have been an accident. It could just as easily have been murder. That being the case, they could not afford to stop looking for answers until they were satisfied they knew the truth.

Nick said nothing more until they were back on the ground. "Tymberley was quick to hint he could be bribed for his silence. He may make trouble." They both knew that exchanging bribes for favors was a way of life at court, but in such circumstances as these, the fellow showed himself an unscrupulous brigand.

"Mayhap an investigation into his background would be worthwhile," Susanna suggested.

"That thought crossed my mind also. I suppose it is too much to hope that Tymberley will turn out to have killed his own man."

"Why should he have?"

"Why should anyone want to murder Carter?" Nick took Susanna's elbow to guide her back toward the house. "My first order of business is to interview everyone at Leigh Abbey who had contact with Miles Carter."

"Only at Leigh Abbey?"

Nick sent a sharp look in her direction. "Is there reason to think someone from Whitethorn Manor or Holme Hall or the village came here to meet Carter?"

"There is no reason to think anyone in my household did." She paused near the garden wall to pluck an aromatic sprig of rosemary. As if to ward off the stench of suspicion, she lifted the pale blue flowers to her nose.

"Point taken. Here is what I propose. Let me deal with Tymberley."

"Gladly."

"I will send for the coroner, as the law requires." Julius Port, an amiable fellow, was easily led and would give them no trouble. "Then, while you compile an account of the whereabouts of everyone at Leigh Abbey during the night and early morning hours, I will make inquiries in other parts of the parish. I'll return tomorrow, that we may compare notes."

Susanna's nod was firm, her gaze steady. She might think she knew who had been with Carter last night, might be reluctant to

make an accusation until she'd investigated further, but the look in her eyes reassured Nick that no one would be allowed to get away with murder.

12 ∿

THE MEMORY of her tiring maid's red-rimmed eyes and nervous manner had made Susanna increasingly uneasy as she and Nick examined the scene of Miles Carter's "accident." She had no reason to suppose those were Grace's footprints in the banqueting house. She told herself there were many possible explanations for Grace's odd clumsiness, including the one she'd already considered—a child on the way. She had suspected for some time that Grace was interested in someone, most likely Nick's manservant, Simon. Certes, Simon doted on Grace.

Susanna hoped the explanation was that simple. If Grace had crept out of the house last night to meet her lover, she might have seen Carter's body on her way back to the house. Or heard a quarrel between Carter and his killer. Either, combined with her own clandestine activities, could account for her peculiar behavior.

She located Grace in the small parlor, sitting by the window with a pile of mending lying neglected in her lap. Instead of plying her needle, she stared vacantly out at the view. She started violently when Susanna spoke her name.

"Madam! I did not hear you come in." When she attempted to rise, her thimble tumbled to the floor. She dropped a half-hemmed smock in her awkward attempt to retrieve it.

"Sit down, Grace, before you hurt yourself." Susanna made sure the door was on the latch before she advanced into the room.

Hunched in the chair, as if she expected a blow, Grace watched her approach with wary eyes.

"You look pale, Grace. Are you ill?"

"I did not sleep well, madam." Her voice was so soft, it was difficult for Susanna to make out the words.

"So you said earlier. What kept you awake?"

"I know not, madam. A dog barking in the night?"

"Something disturbed your sleep, then?"

"Aye, madam. And once I was awake, why then I did naught but toss and turn."

"Did you get up, Grace? On those occasions when I have had difficulty sleeping, I have often found that a bit of exercise encourages sleep."

Grace stared at her hands, which were clenched hard around the smock she'd been hemming, twisting it beyond recognition. When she made no answer, neither denying that she'd left Susanna's antechamber during the night nor admitting she'd been out and about after dark, Susanna tried another approach.

"Did you hear anything once you were awake?"

"Only the rain."

"And were you awake when it stopped raining? Did you hear anything then?"

Grace shook her head but avoided Susanna's eyes.

"Miles Carter met with an...accident last night."

Grace twitched and what little color had been left in her face leeched out. "Aye, madam. There's been talk of naught else since you came running into the stable this morning with the news."

Susanna could imagine what was being said. To save time, she'd ordered the two grooms to stand guard over Carter's body while she saddled her own horse for the ride to Whitethorn Manor. Alerted by one of them, Fulke had appeared in time to finish the job and help her mount.

A proper gentlewoman, she supposed, would have sent Fulke to Nick with a message instead of going herself. At the least, she

should have taken the long way around by the road. To the consternation of those in her household who had ventured outside to discover what the commotion was about, she had ridden her mount straight to the footpath that connected Leigh Abbey to Whitethorn Manor and halved the distance between them by the main road.

"We are anxious to learn at what time he left the house. If you were awake, you may have heard something. No matter how small a sound, no matter how unimportant it seemed, you must tell me. Anything could be important."

"I heard nothing, madam. And I scarce knew Goodman Carter." The whispered denial only increased Susanna's suspicions.

"Are you with child, Grace?"

Grace shook her head with such violence that her cap came loose. After a moment a tear plopped onto the mending, then another.

Before they could turn into a flood, Susanna seized Grace's hands and pulled her to her feet, scattering the sewing supplies. "Let them fall where they will. Whatever has overset you, Grace, we will speak of it anon, when you have rested."

Grace came without protest, allowing her mistress to settle her in a bed in the maid's dormitory with a soothing posset of vervain, hop, chamomile, nettle, and comfrey root to induce sleep.

Preparing the mixture reminded Susanna that she had neglected, in all the confusion of the morning, to take her own daily tonic, an infusion of St. John's wort, chamomile, and ginger root. She returned to her own chamber for it, then considered how best to pursue inquiries within the household.

She would start, she decided, with Jennet.

13 ❧

JENNET assumed Miles Carter had been murdered. By the time Lady Appleton summoned her, she'd already considered several suspects, her thoughts flying as fast as the dance steps in a cinquepace in an attempt to find an explanation she could accept.

"I see by your avid expression that you have heard about Carter's accident." Lady Appleton returned a leather-bound book to the single shelf mounted on the wall above her coffin desk, placing it flat and with the spine inward so that the title she'd inscribed on the fore edge of the pages could more easily be read.

Jennet snorted. "I was in the spare guest chamber, sorting linens, when Master Tymberley got the bad news. I could hear every curse as clear as if there were no wall between us."

"He was angry?" She retrieved a sheet of paper, a quill, and an inkpot from separate coffin-shaped drawers and placed them at the ready.

"Say rather, enraged. He'd reached mere anger a quarter of an hour earlier when he accosted me in the corridor, complaining that his servant was nowhere to be found."

Jennet removed a stack of books from a chair in the sunny corner study, placed them on the floor, and sat down in their place. She was forbidden to let the maids clean her mistress's favorite room, where maps rather than painted cloths or arraswork decorated every wall and chests of a variety of sizes filled most of the open space, storage for the bulk of an enormous collection of books and manuscripts. The clutter, Lady Appleton insisted, had an order to it.

"The first time I mentioned Brian Tymberley's name," Lady Appleton said, "you spoke against him. You told me later that you'd encountered him at Greenwich, but you never said how, or why that gave you such a dislike of the man."

With a sigh, Jennet accepted that she would have to tell her

mistress the whole story, but not just yet. "It is not Master Tymberley who's dead."

"Did you expect someone to murder him?"

"I'd not have been surprised if someone had. You've only to watch how people shy away from him when he comes into a room."

Lady Appleton went very still. "Are they afraid he will do them some physical harm?"

"More likely he threatens them with disgrace and ruin." She thought of what she'd seen in the churchyard not so long ago. "Carter, though, might have used what his master knew for his own reasons. He made all the womenservants nervous."

"Have you proof either of them did anything untoward, Jennet? Or do you but speculate?"

Lady Appleton's skepticism stung, but Jennet knew she had only herself to blame. "You can scarce have avoided noticing, madam, that during their first visit I went out of my way to avoid both men, but that does not mean that I found no opportunity to observe them unseen."

A faint smile flickered across her mistress's face. "Go on."

"They asked questions. Pried into things that were none of their concern."

"They were sent here to evaluate the house and grounds in anticipation of the queen's visit."

"That they did openly. They also skulked about at night and crept in and out and all about like thieves."

Lady Appleton waited. Jennet sighed. "I believe Master Tymberley makes a practice of demanding money, or mayhap favors, in return for silence."

She suspected he had at least two victims in this parish, and that Lady Appleton knew naught of either's secret. She hesitated a moment longer, then decided to begin with the story in which she had herself played a role.

At first, telling the tale of what had happened at Greenwich

felt uncomfortably like a confession, but by the time Jennet had revealed Mistress Jeronyma's bad habit of taking things that did not belong to her and explained how she, Jennet, had come to meet the queen, and was about to detail Sarah's latest fears concerning Master Tymberley and Mistress Jeronyma Holme, she knew that Lady Appleton understood why she'd said nothing of her adventure ere now.

Lady Appleton had abandoned her attempt to write down the key points in the story in favor of pouring out two generous portions of a libation she swore had the power to quicken one's wits, spirit, and memory. The goblet she handed Jennet brimmed with cloudy liquid.

"What is it?" She sniffed cautiously, but detected no unpleasant aroma.

"Juice of *lang de boeuf* in water."

It had a mild taste. Jennet took another sip and decided she'd have much preferred to be dosed with a cup of beer or ale than this insipid stuff.

Or with wine. In Sir Robert's time, she remembered, this study had been furnished with a small, carpet-draped table holding Venetian glass goblets and a fine Rhenish wine in a crystal flagon. Lady Appleton preferred pewter and possets.

"I've spoken to Sarah only once since Greenwich," Jennet said, setting her drink aside.

"At church?"

"Aye. The first Sunday after Mistress Jeronyma's return." Sarah had successfully avoided Jennet ever since. "She told me then that Master Tymberley had thrice been to Holme Hall and twice spoken privily with her mistress. Both times, he left her in tears."

"So, you think Tymberley threatened to make Jeronyma's sins public if she did not pay him for his silence?"

"Aye. And nervous as Sarah was, it seemed to me that someone might have threatened her as well. If the master demanded

money from the mistress in return for secrecy, is it not possible his man asked for another sort of payment from her maid?"

"You come perilous close to suggesting that Sarah had reason to push Master Carter out of that tree."

"Impossible," Jennet said in what she hoped was a firm voice. "It must have been someone else Carter and his master threatened." Truth be told, she found it all too easy to imagine Sarah in an altercation with Miles Carter. She'd have resisted any unwanted amorous advances. She might well have pushed him away, and as a result, he *could* have fallen to his death.

"Anyone can kill," Lady Appleton murmured, echoing Jennet's thoughts.

"Yes, madam." But she had possibilities other than Sarah to suggest.

Lost in thought, Lady Appleton plucked a faded blue velvet cushion from the window seat. She ran idle fingers over an intricate pattern of small roses. The red-and-gold crewelwork was already well-worn from such treatment. "What troubles me is why anyone would agree to meet Carter in such a peculiar spot. And why would Carter choose it in the first place?"

"To ensure privacy, madam?"

Jennet did not see that it mattered. She had long since stopped trying to find sensible reasons for the way people behaved. All too often, some foolish, impulsive act seemed to be all it took to set a terrible chain of events in motion.

"When I heard of Carter's death," Jennet said, "I did wonder if Master Tymberley might have sent his servant to collect payment from Mistress Jeronyma rather than go himself."

"You think Jeronyma killed Carter?" Lady Appleton set the cushion aside and sat down again at her coffin desk. "It is possible, I suppose, but if it was Master Tymberley who threatened Jeronyma, what point in killing his man?"

"As a warning?"

"Your earlier theory has more merit. If we assume there were

others from whom Tymberley attempted to extort money, then there may also have been other servants Miles Carter intimidated. But how do we discover who they were?"

Without waiting for an answer, she wrote two names on the paper before her. Jennet could not stand the suspense. She left her comfortable chair and went to look over her mistress's shoulder. "Jeronyma Holme," she read. "Sarah Jaffrey."

"Who else?" Lady Appleton asked her.

"Mistress Jeronyma's father is reputed to have an explosive temper," Jennet said. "What if he followed his daughter and saw her meet with Carter? Mayhap he killed the fellow in a fit of rage."

Jennet rather liked this explanation, although she had already found the flaw in it. If Master Tymberley's threat had been to tell Mistress Jeronyma's father her secret, then she'd have been vigilant when she crept out of the house to make her payment. She'd have made certain it was impossible for anyone to follow her.

Lady Appleton added Denzil Holme's name to her list, then threw down the quill.

"Speculation is a waste of time when we can ask questions direct. Let us go to Holme Hall with all speed and discover what we can. I will talk to Jeronyma while you question Sarah. And while we are at it," she added with a faint, enigmatic smile, "I will attempt to determine the size of Master Holme's feet."

14 ～

DENZIL HOLME'S feet were long and narrow and one shoe showed evidence of a large bunion beneath the leather. They stirred dust from the filthy rushes that covered the floor of the great hall, releasing the rancid scent of spoiled meat.

"You are not welcome here, Lady Appleton." Holme's normal complexion was ruddy, but temper had set two bright flags flying

across his squirrel-with-a-nut cheeks. "I'll not have my daughter sullied by association with your kind."

At her mistress's side, Jennet drew in an indignant breath, but Susanna was more puzzled than offended by Holme's ungracious words. She could think of no reason for such ill-will, not when she had yet to tell him why she'd come to visit.

"My kind?" she asked.

"You are guilty of keeping company dishonestly with Nicholas Baldwin. It has been general knowledge in the parish for some time."

Susanna felt the color drain from her face. She and Nick behaved with all outward propriety. She knew there had been speculation, but she was stunned by the conviction in Holme's voice. With an effort, she mustered her scattered wits.

It was the sheer illogic of Holme's attitude that struck her first. Outrage because she might prove a bad influence on his daughter? When Jeronyma had been these last few years at the royal court? Susanna knew a few things about the morals there, and none of them to the credit of the parties involved.

"You condemn me, Master Holme, for something you cannot possibly know." Not unless he made a practice of perching on the sill outside her bedchamber window.

"What I know, what all of East Kent knows, is that you are the private whore of an upstart London man."

More than his words, what she saw in her neighbor's eyes—censure and a dislike so intense it bordered on hatred—shook Susanna's confidence. "I am no man's kept woman, Master Holme."

The truth of that statement seemed to annoy him even more. "No. You have not the excuse. A wealthy widow like yourself has no need of a man to pay her bills. You are no fit associate for my daughter, Lady Appleton. You commit your uncleanness and wickedness of life for the sake of the sin itself. Harlot!" A bit of froth appeared at the corner of his mouth as he spewed insults.

When Jennet tugged on her sleeve, Susanna let herself be led away. An icy mass settled in her stomach, chilling her from the inside out. This was a more serious situation than she'd first supposed.

In the courtyard they had to wait for their horses, which had been taken to the stable. Susanna sucked in a few more deep, calming breaths.

"He's gone mad," Jennet muttered, glaring at the house. Her eyes narrowed. "The place is much run down since Mistress Holme's death. No wonder the queen's harbingers rejected it as lodgings for any but the least important ladies."

Two bad-tempered geese, hissing, chased a dog across the stableyard. When they had vanished behind the chicken house, Susanna spoke. "It appears that Master Holme has embraced the preaching of the most radical of the religious reformers, those who insist salvation requires that the church meddle in the private business of every parishioner."

"He'd have done better to embrace a new wife."

Susanna scarce heard her, distracted by another thought. Holme had employed a telling epithet, referring to Nick as a "London man." The term could be used for any newcomer from the city, but in particular was applied to those "upstarts" who, having made a fortune in trade, bought up land in a rural area from the impoverished local families who'd owned it for generations. She could not deny that Nick had done this, but he'd also made improvements in the estate and had deprived no tenants of their holdings. If long-time residents resented it when he'd been appointed as a justice of the peace the previous summer, none had said a word to Susanna on the subject at the time.

Then she remembered. A few months ago, Winifred Baldwin had suggested to Nick that he court Jeronyma. Had she gone so far as to discuss a potential match with Holme? Nick might be a merchant, but he was a wealthy one, acceptable as a prospective son-in-law to a member of the local gentry.

Did that explain the accusation? Did Holme's animosity stem from the misconception that Susanna and Jeronyma were rivals for Nick's fortune?

A stableboy led the horses out. Susanna was about to step up onto the mounting block when she caught sight of a flash of color and movement.

"Sarah!" Jennet exclaimed, startled by her sister-in-law's sudden appearance.

"Hush, Jennet," Susanna warned, noticing Sarah's agitation. She got the impression that the young woman did not want Holme to see her.

"Let the lad help you into your saddle," she told Jennet. In a quiet voice, she addressed Sarah: "Has Master Tymberley threatened to expose your mistress's secret?"

"Jennet promised not to tell anyone!" Sarah's yelp of outrage made the stableboy jump.

"That was before Miles Carter was killed."

"Dead?" Sarah's face, already pale, turned ashen. Her eyes went wide and her jaw slack.

At the same moment, a bellow sounded from the direction of the house. Denzil Holme charged toward them like a maddened bull, nostrils flared and blood in his eyes. He stopped a foot away from the women and horses and shook his fist at Sarah. "Faithless wench! Traitor! If you wish to consort with their sort, then away with you. Get you gone."

Sarah attempted to reason with him but none of her pleas or excuses had any effect. He would not even permit her to return to the house to gather up her possessions.

Fearing Holme was about to expire of an apoplexy, Susanna allowed the stableboy to help her mount, then instructed him to put Sarah up behind her. The young woman would have an uncomfortable ride without a pillion to sit on, but just now a quick getaway seemed the best course of action.

In their haste, Sarah's kirtle rucked up, exposing both ankles

and calves. Holme made a strangled sound. His eyes bulged.

"Hold on to my waist," Susanna said, and urged her horse forward.

"Slut!" Holme shouted after them. "Next thing you know, she'll be holding a man's pommel while she rides apillion."

Holme Hall sat at the edge of Eastwold, but its gatehouse faced away from other habitation on the road that led straight to Leigh Abbey. Although Susanna could hear the splash of the waterwheel at the mill and the clang of a blacksmith's hammer as they rode away, the village was out of sight. Within moments, the *clop* of their horses' hooves was the only thing that broke the silence of the warm August afternoon.

They'd gone a quarter of a mile before Susanna belatedly realized what Holme's parting shot had meant. "What a disgusting thing to say!"

"He sees evil in the most innocent of actions." Sarah sounded resigned.

"And yet he has a look about him of a man sore in need of a new wife," Jennet quipped. "Or else a bigger codpiece."

A bark of laughter escaped before Susanna could stop it. She knew this was no time for mirth, and yet it was a relief to be able to laugh. After a startled instant, Sarah joined in.

A moment later she burst into tears, ending any hope of getting sensible answers out of her on the way back to Leigh Abbey.

15 ～

NICK BALDWIN conducted interviews with members of his household in the upper room where he kept oddities he'd brought back from his travels. While he waited for Simon Brackney to

answer his summons, he ran loving fingers over the intricately carved ivory case that held his watch-clock, a small, remarkably accurate portable timepiece he'd acquired in Hamburg, where he'd spent several years working on behalf of the Merchant Adventurers to establish new trade routes between England and the Continent. He displayed the case, along with treasures from Muscovy and Persia, atop a Turkey carpet on a little table placed before the chamber's single large, square window.

Simon appeared in the doorway, cap in hand, just as the last of the afternoon sun struck the casing of a sea compass. The brass sparkled with enough brilliance to put Nick in mind of the chain of diamonds and emeralds he kept tucked away in the hidden drawer of a nearby cedar-wood chest. Once he'd thought it would be his bride gift to Susanna.

Putting aside such personal thoughts, Nick greeted his manservant with a reassuring smile. Simon had been part of the Baldwin household since before Nick's father's death. Nick knew him well and could think of no reason why he'd have killed Miles Carter. Indeed, Nick was inclined to consider these interviews a mere formality, as much a waste of time as his earlier conversation with Brian Tymberley. Tymberley, upon reflection, had decided his man must have fallen to his death by mischance.

"You will have heard, Simon, that a body was found at Leigh Abbey this morning."

"Aye, sir. Gentleman's servant fell out of a tree." Nick thought he detected a hint of sarcasm in the word "gentleman."

"That seems to be the case, but with the queen expected here soon there must be no doubt about the matter." He made himself comfortable in a chair upholstered in black silk and gestured for Simon to sit on a nearby stool.

"You suspect 'tis murder, sir?" This time there was no mistaking the emotion in Simon's voice. It was dismay.

"That is one possibility. Now, Simon, it has come to my attention that of late you have made frequent visits to Leigh Abbey."

Easy enough to do, since the two properties were less than two miles apart by the footpath that ran from the kitchen wing of Whitethorn Manor through a small wood and came out in one of Susanna's orchards.

"To see Grace Fuller, sir." Simon squared his shoulders. "I mean to marry her."

"An excellent match, Simon, and I wish you well in it, but I must ask you if you went to meet her last night. Were you on Leigh Abbey land at any time between dusk and dawn?"

Simon's tall, lanky frame seemed to sink in on itself. He mumbled his answer. "Mean to court the woman, sir, not deflower her."

"A man is dead, Simon," Nick said in a mild voice. It had not escaped his notice that Simon had not answered his question. Protecting Grace's reputation, no doubt. An honorable sentiment, but ill-timed. "If you know aught of the matter, you must tell me."

Simon responded with sullen silence, all the while twisting his cap into a misshapen lump. He stared at one of the charts on the wall rather than meet Nick's eyes.

All too familiar with the power love had to turn a man into a fool, Nick was inclined to be lenient with Simon. He could get the answers he needed elsewhere. It occurred to him that if Simon and Grace had met, they might have sought a private place to be together. If they had, by sheer coincidence, selected a certain lofty platform in a banqueting house for their lovers' tryst, that would explain the muddy footprints, some smaller than others, and the blanket spread over the planks for the comfort of those who met there.

Had they left before Miles Carter arrived? That seemed likely. If they had seen what happened to him, surely Grace would have gone straight to Susanna with the story.

"I must have the truth, Simon."

"I know naught," Simon insisted.

"Very well." Nick stood. "You may go, but we will speak of

this again on the morrow." Simon, he suspected, wished to talk to his beloved before he admitted to anything. "Send the cook to me next."

In his haste to get away, Simon bumped against a ten-foot-long cross-staff and sent it clattering against a wall. Nick sighed and waved him out. Grace had a lot to answer for.

16 ∿

UPON THEIR return to Leigh Abbey, Susanna led Jennet and Sarah straight to her stillroom. It was the most private place at Leigh Abbey. Even if Master Tymberley had seen them enter and crept out to listen at the door, he would hear nothing. The stone walls and oak door were far too thick.

While Jennet settled her sister-in-law on a three-legged stool, Susanna studied the rows of containers. She had thirty large vessels and nearly a hundred smaller jars and pots to choose from, variously stoneware, ceramic, glass, horn, pewter, or iron. Some had parchment tied over the mouths, others covers of thin skin, according to the contents. She had taken the additional precaution of affixing a label to each, setting out what was within and the date it had been prepared. Those that did not hold mixtures of herbs were filled with the juice, or the crushed and dried leaves, or the flowers of a single plant.

Sarah could not help but be upset over being turned out, Susanna thought as she prepared a tonic at the long worktable at the center of the room. As for herself, she seemed to spend a great deal of time pouring out reviving infusions and soothing elixirs these days. A few minutes later, after filling three pewter drinking cups with the chamomile blend—to revive the spirits since she had nothing, more's the pity, to induce a person to tell the

truth—she handed one cup to Sarah, the second to Jennet, and sipped from the third herself.

"Now, then, Sarah," she said. "I have heard already of certain events at Greenwich, but I suspect there is more to the story."

She perched atop the black chest filled with recipes, books on distilling, and notes on the properties of several exotic plants Nick had obtained for her from abroad. Tib, one of the gray-and-white-striped cats, had slipped into the stillroom with them and now made himself comfortable on her lap.

Jennet poked her sister-in-law in the ribs. "Tell her everything. Otherwise you may end up charged with Miles Carter's murder."

"I did not—"

"Prove it! Tell the truth now, Sarah. Start with why you left it to me to return the queen's ring." Jennet remained on her feet but propped one ample hip against the worktable. Her position made it seem as if she loomed over the younger woman.

Grim-faced, Sarah set aside her drink without tasting it. "I could not find Mistress Parry, the keeper of the queen's jewels." Sarah waited to see how this was received before she added more. When she found no sympathy in Jennet's face, she abandoned the attempt to defend her actions. "I slipped away from you to look for her. That much is true. Then Miles Carter bumped against me and the ring fell from my hand to the tiles. He saw it plain before I could retrieve it. He meant to intercept me. I am certain of it now, but at the time I thought the encounter mere ill luck."

"Why ill luck?" Susanna asked. "What did you know of Carter and his master that made you uneasy? And what reason did you find, in hindsight, for his man to accost you?"

"His master sent him."

"Why?"

Sarah leaned forward in her earnestness. "When Master Tymberley saw Jennet with me he must have realized she lied to him about who she was and what she was doing in the passage

by Mistress Parry's lodgings. He'd have wanted to know why."

"You must explain yourself more fully, Sarah. Why should you think this would interest him?"

At the challenge, her assurance faded a little. She shifted on her stool and her eyes no longer met Susanna's. "I remember how much you dislike taking what some anonymous 'they' have said as Gospel, madam, but sometimes there is truth in rumor, and the whispers at court predict Master Tymberley will be a rich man one day...unless he makes the mistake of attempting his wicked games with the wrong victim."

"Do you mean to say he is known to be threatening courtiers?" Jennet's voice rose a notch as she straightened.

"Whispers," Susanna repeated. "Did you hear any details? Any names?"

"No, madam, but I believed the stories. And there were times when I thought Master Tymberley was watching my mistress, as if he knew about her unfortunate habit."

"Is that what you call it?" Jennet's derision contorted her features. "I call it plain theft."

"It is possible," Susanna mused, "that Tymberly did know something before his man saw you with that ring. From what Jennet told me, Sarah, you made it easy for Jeronyma to avoid discovery when she took items that did not belong to her. You've returned a great many stolen objects, have you not?" A quick calculation told her that when Sarah had entered her service, Jeronyma had been a girl of fourteen.

Sarah nodded, her misery evident in her slumped shoulders and sorrowful mein. "What else can we do? Mistress Jeronyma ...it is difficult to explain. She takes things she has no need for, and then she loses interest in them, just leaves them to be found and never inquires after them once they are taken away to return to their rightful owners. I do not know what else to do but keep on as we have been. Except that I cannot now. Who will look after her, Lady Appleton?"

"She must have other servants who know her secret."

"But they are not as clever as I am. What if she is caught?"

"Does Lady Cobham know? Jeronyma has been part of her household for some time now."

Sarah shook her head. "Mistress Jeronyma has taken things she should not since she was a girl. She's clever at hiding what she does, for she has sense enough to realize that such behavior must not be spoken of."

"But not sense enough to stop stealing." Jennet's disbelief was almost palpable.

The uncertainty that had crept into Sarah's voice when she spoke of Jeronyma changed to frustration. "She cannot stop herself." Sarah's inability to make them understand, her obvious sense of the futility of trying to explain in words something for which there could be no logical explanation, had her fisting her hands and glaring at her sister-in-law.

"Does Denzil Holme know his daughter steals?"

"I do not think so, madam. Master Holme is most strict about the behavior of those in his household. He has become even more rigid since his wife died. Evening prayers are a torment. They last for hours and 'tis plain he thinks the church should be more strict concerning moral issues. If he knew what his daughter did, he'd confront her and question me as well."

Sarah's earnest manner and the evidence of her own recent encounter with Holme combined to convince Susanna that the young woman had the right of it. "Either he knows nothing, or he does not believe what he's been told."

"If he even suspected Mistress Jeronyma was guilty of theft, he'd beat the truth out of her, then insist she atone in public for her sins."

"If Tymberley threatened to tell the queen or one of her officials," Susanna continued, "at the least it would cost Jeronyma her post with Lady Cobham." At worst, she'd be imprisoned. The queen had an aversion to executing women. "So, Jeronyma might

have paid Tymberley to keep her secret from her father, or from the queen."

Susanna hopped off the chest, dislodging the cat, and began to pace.

"Who approached your mistress, Sarah? Carter or Tymberley?"

"Two days after Easter, Master Tymberley waylaid me in a narrow passageway at court. He had been waiting for me, madam." Sarah's distress had her tugging at the laces that held her skirt to her bodice. "He gave me a note to take to Mistress Jeronyma."

"What did it say?"

Thanks to monies provided by Susanna's father, every child in the parish was taught to read and write. Now that Susanna thought about it, she realized that Sarah could be no more than two or three years older than Grace. She'd have received her earliest instruction in company with Grace Fuller and Hester and Alan Peacock, even though Sarah had entered service at Leigh Abbey much sooner than the other two village girls.

"I do not know, madam," Sarah said.

Jennet gave her sister-in-law a disgusted look. "How could you not look at the message before you delivered it?"

"I was afraid to know what it said."

"Why, Sarah? Did Tymberley behave in a threatening manner toward you? Did he make any reference to the ring or to Jennet?"

Sarah shook her head. "It was something in his tone of voice that made me afraid. For Mistress Jeronyma and for myself."

"What did Jeronyma say when she read Tymberley's note?"

"She laughed and threw it into the fire."

Jennet snorted. "Then for all you know, it might have been a love sonnet."

"Mistress Jeronyma never told me he'd demanded payment for his silence, but a few days later I saw her with Miles Carter. She gave him a small leather purse. I was near enough to hear the jingle of coins."

Susanna studied Sarah's open face. What a tangle.

"I thought that was the end of it," Sarah said after a moment. "She paid him and then he was sent away from court to scout locations for the queen's progress. We did not know until we arrived at Holme Hall that he was in the neighborhood."

"Did Tymberley or his man make any demands on you, Sarah?"

"Oh, no, madam." The denial came promptly. Too promptly, as if Sarah had been expecting the question and prepared herself to answer it without flinching. "The only dealing I had with Master Tymberley involved the delivery of that one message to my mistress."

Susanna toyed with the mortar and pestle on her worktable, wondering what Sarah was keeping back. As the silence lengthened, the young woman grew increasingly nervous, at last seizing upon the cat as a distraction. She caught Tib up and held him tight, burying her face in his soft fur. When his deep, rumbling purr filled the room, she loosened her grip and began to stroke him.

"Where was your mistress last night, Sarah?"

Sarah started. "Why, at Holme Hall, madam. Where else should she be?"

"Were you with her?"

An earnest nod answered her. Then Sarah's eyes widened as she grasped the reason behind the question. "You cannot think Mistress Jeronyma killed Miles Carter!"

"Someone did." It was still possible his death had been an accident, but with every new detail Susanna learned about Carter and his master, she doubted it more. "If you know anything, Sarah, no matter how unimportant it seems, you must tell us."

"It is no use trying to hide the truth," Jennet warned. "Everyone's secrets come out when there's been murder done."

"I know nothing more. I swear it."

For the moment, Susanna decided to accept Sarah's word.

"Settle your sister-in-law in your lodgings," she instructed Jennet. "Then meet me in my withdrawing room."

She needed a few minutes alone to think. She went first to her bedchamber and tried to see the room through Tymberley's eyes. She'd wondered at the time of his first visit why he'd paid so much attention to her personal possessions when he knew the queen would bring all her own furnishings with her.

Had Tymberley hoped to extort money from her? Had he been looking for something to use against her, some hint that she dabbled in forbidden subjects? She remembered he'd taken particular interest in her Italian treatise on poisons.

To the ignorant, any arcane knowledge was suspect. Some poor fools thought mathematics was one of the occult sciences. And astrology, upon which many physicians relied to diagnose illnesses, provoked still greater fears in the superstitious. Her expression grim, Susanna told herself she should be grateful she'd never had any interest in horoscopes. There had been none lying about for Tymberley to find because she did not believe the future could be accurately forecast. How could it be when scholars did not even agree on the proper method of measuring solar and lunar cycles? Easter, which was supposed to fall on the first Sunday after the first full moon after the spring equinox, had long since ceased to occur in the proper season, prompting some to propose an entirely new calendar to correct the situation. That, thank the good Lord, was not a problem she had to solve.

But finding out the truth about Carter's death *was* her responsibility. Susanna squared her shoulders. If Tymberley meant to cause trouble, she'd know soon enough. In the meantime, she had work to do. She left the bedchamber to settle herself at the small writing table in the withdrawing room. Dipping her quill into a pewter inkpot, she unrolled a blank scrap of parchment and began a new list.

17 ∾

"STAY OUT of Master Tymberley's sight," Jennet warned her sister-in-law.

"I am not a fool!"

"I wonder." Jennet was not at all convinced that Sarah had told them everything she knew. "Was Carter one of your suitors?"

"As if I'd let such a one as him touch my hem!"

"He wanted to do more than that, I warrant."

Sarah's smile was smug in spite of the seriousness of the situation. "Cormac would have chopped him up for chewits if he'd tried."

"If he had a threat to hold over your head, you'd not have told your Cormac. Besides which, Cormac is not here."

At Jennet's tart reminder, Sarah's face crumpled. "He travels with the queen." She sighed. "He has his own troubles, too. There are some say a man half Irish should not be so close to Her Majesty."

Since she'd had the same thought herself, Jennet let that pass. "I hope one of you has some employment if you plan to marry."

"Ah, Jennet—ever practical. Do not fret about me. Cormac can always open an inn if he leaves the queen's service."

So much for Sarah's loyalty to Mistress Jeronyma! Jennet started to leave, then turned back. "Why did you come out of Holme Hall just as we were leaving? You must have known Master Holme would object."

"I thought I could warn Lady Appleton without being seen."

"Warn her of what?"

Sarah sank down atop a storage chest, disconsolate again. That and a pallet to sleep upon were the only furnishings in the chamber Jennet had given her. It had last been used by Jennet's son, Rob, before he'd been enrolled in the King's School in Canterbury.

With nervous fingers, Sarah jerked at her laces, this time

nearly ripping them out of the eyelet holes. "Master Holme wanted to marry your mistress, Jennet. He had hopes she'd accept him after Sir Robert died. He was only waiting for her year of mourning to be over to start courting her. But he was too late. First there was Sir Walter Pendennis. Then that business of Sir Robert not being dead at all. Except that he was murdered."

"And that discouraged Master Holme?" Lady Appleton, although innocent, had been accused of killing her husband.

"Not at all. And when Sir Walter married someone else, Master Holme got his hopes up again. But there was another year of mourning to get through and by then everyone in the village knew that if Lady Appleton remarried at all, it would be to Master Baldwin."

Jennet almost felt sorry for Denzil Holme. He'd never have had a chance with Lady Appleton, even without Master Baldwin as a rival. Holme was naught but the upstart son of a yeoman of the king's wardrobe of the beds under old King Henry. And before that, until the dissolution of the monasteries, the family had been bailiffs for the abbey.

"She has no inkling of this romantic interest," Jennet mused. "How could she?"

Sarah sighed. "I did not suppose she had. That is why I wished to warn her. Master Holme sees himself as thwarted in love. He rails against her now, although his condemnation of Master Baldwin is less severe."

"All bluster." Jennet dismissed Denzil Holme as a petty annoyance. He'd had no call to take out his ill humor on Lady Appleton, but just now he was the least of their concerns. "The queen is coming to Leigh Abbey," she reminded Sarah. "Because of that, the matter of Miles Carter's death must be resolved without delay."

"I have told you all I know of him." A sulky look overspread Sarah's face. "And because I tried to do Lady Appleton a small service, I have lost a good post."

Jennet regarded her without sympathy. "You just finished telling me that Cormac will take care of you."

"He has yet to ask me to marry him. Or to buy that inn."

"If he fails you, I am certain Mistress Jeronyma will take you back when she returns to Lady Cobham's service. In the meantime, we can use an extra pair of hands to make Leigh Abbey ready to receive royalty. There are floors to be scrubbed, silver to polish…all manner of ways you can earn your keep."

Sarah's indignant squawk followed Jennet along the first floor passage toward her mistress's withdrawing room.

Lady Appleton looked up when Jennet entered, frowned slightly, then took the time to sand what she'd just written before she spoke. "Tymberley attempted to extort money from me, too."

"Faith! Does he try such tricks on everyone he meets?"

"Why not? He can prey upon the fact that almost everyone has some guilty secret he or she wants kept."

"What secret does he think you have, madam?"

"His hints may be taken more than one way," Lady Appleton said in a wry and weary voice. "Among other things, he implied that Carter went to the banqueting house to meet one of my maidservants. I think it possible that Carter was a pale imitation of his master, preying on fellow servants, but as yet I have no proof. He knew something about you, Jennet. Did he ever approach you?"

"If he'd threatened to tell you about the queen's ring, madam, I'd have told you everything about that day at Greenwich myself." Unwilling to take any more chances, she offered her mistress the few embarrassing details she'd left out of her earlier account.

Lady Appleton's lips twitched as Jennet described Lord Robin's reaction to being addressed in such a familiar manner, but she did not give in to the smile. "You did well under trying circumstances, Jennet. But I fear you also reminded the queen of my existence."

"Do you mean that I am responsible for her decision to stop at

Leigh Abbey on progress?" Jennet felt absurdly pleased by the notion. "But surely that is not a bad thing, madam?"

"I do not know if it is or not, Jennet. Only time will give us that answer."

"You will deal well with the queen, madam. I am certain of it."

Lady Appleton glanced at the paper lying on her writing table. "I only wish everyone in this household had as much confidence in me as you do." In a few concise sentences she relayed to Jennet Grace's odd behavior that morning and her reaction to Lady Appleton's first attempt to question her.

"You cannot think Grace killed Carter?"

"Have we not just agreed that Carter might have met someone in the tree house? Why not Grace? Even a penniless woman has one means to buy a man's silence. And if she changed her mind, tried to fight him off—"

"But Grace has no secrets she'd pay that price to keep. I'd know of it, madam, if she had aught to hide." Jennet spoke with confidence but doubt niggled at her as soon as the words were out. These last weeks, with everything at sixes and sevens, she'd had more on her mind than mothering the maids.

"Let us hope you have the right of it." Lady Appleton tapped the parchment with her forefinger. "Any one of Carter's victims, or Tymberley's, past or present, might have killed Carter, who seems to have been the one who collected payments for his master."

"Could Master Tymberley himself have killed Carter?"

"Why would he?"

"To cause trouble? Or to stop him from revealing something about Tymberley himself?"

"Nick also suggested Tymberley's name," Lady Appleton said, "but I do not believe he put much stock in the possibility. When a solution seems too good to be true, it almost always is."

"What names have you writ down?" Jennet asked.

Lady Appleton handed her the list.

"Jeronyma Holme," Jennet read. "Sarah Jaffrey. Grace Fuller. Simon Brackney."

Yes, that made sense. Simon doted on Grace. If he thought Carter was a threat to her, he might have fought with the fellow, even killed him. If Grace had told him. If Grace was even involved. Jennet still could not think of a single thing Grace had to hide.

"Brian Tymberley," she continued, glancing again at the list. Then she smiled. Lady Appleton had written "person or persons unknown" at the bottom of the page.

Jennet considered for a moment. "I saw Carter once with Avise, Lady Glenelg's servant. It was the first time he and his master went with the household to attend church services in Eastwold." She described Carter's repugnant behavior, adding in a thoughtful voice, "Although he fondled her against her will, she did not complain of it to anyone afterward."

Lady Appleton took back the list and wrote down Avise Hamon's name. "Avise seems a passing timid creature."

"You never know about the quiet ones." Jennet found it easier to contemplate Avise's guilt than to suspect either Sarah or Grace. Lady Glenelg's servant had made no effort to make friends at Leigh Abbey.

"Have you any other suggestions?"

Jennet braced herself. She'd thought of another suspect even before their ill-fated jaunt to Holme Hall. Now she could no longer put off giving Lady Appleton that name. "Lady Glenelg."

"I know I've always said one must suspect everyone in cases of murder," Lady Appleton said with a faint smile, "but Catherine? What makes you think my sister-in-law had a reason to harm Miles Carter?"

"To prevent him telling Master Tymberley how he could cause trouble for her."

"What trouble?" She did not wait for Jennet's answer. "No.

What you suggest is impossible. Catherine is not a violent person."

"She'd do murder to keep custody of her son."

"But what could Carter possibly have learned that would worry Catherine to such a degree? She knows a generous gift to the queen will most likely be sufficient to keep our young lordling with us. I can augment Catherine's resources with my own, if need be, to secure the boy's wardship and bribe any officials. There is nothing Tymberley can make of that—it is the way such matters are always handled."

"Lady Glenelg fears the same charge Master Holme leveled against you, madam—keeping company dishonestly with a man not her husband."

Lady Appleton blinked at Jennet. "Catherine has a lover?"

"So it would seem, madam."

A dangerous glitter showed through Lady Appleton's slitted eyelids. "You know how I feel about rumor and innuendo."

"And I know that most rumors have their basis in fact, madam. Lady Glenelg has spent a great deal of time of late, after dark, in Fulke Rowley's cottage. She does not take Avise with her. She and Fulke are alone save for a babe less than a year old."

Jennet saw no need to elaborate. Lady Appleton knew better than most that a widow's behavior was supposed to be above reproach. She could face severe consequences if she flaunted propriety. In the case of Catherine, Lady Glenelg, however, the risks were even greater. A child was involved. The hint of scandal, delivered at the wrong moment to a queen notorious for her unpredictable decisions when it came to matters of the heart, might well prompt Elizabeth Tudor to remove young Gavin from his mother's care.

18 ∼

SOMETHING in Susanna's manner, more than her request for a word in private, persuaded Catherine Glenelg to leave Avise in charge of the children and invite Susanna and Jennet into the bed-chamber. It was crowded with furniture, as were the room they'd just left and its adjoining inner chamber. When she'd removed to Leigh Abbey, Catherine had brought along every possession she cared about.

After she offered Susanna the single chair, its seat softened by a black velvet cushion, and indicated that Jennet should take the window seat, Catherine pushed aside purple damask hangings and hoisted herself atop the high featherbed she'd once shared with Gilbert. "What has happened?"

"You know about Miles Carter's death?"

"I have heard he fell from the banqueting house and broke his neck. A pity it could not have been his master instead."

Past Jennet's head, framed by the casement, Catherine could just make out the thatched roof of Fulke's cottage. Looking at it always made her feel better.

"Have you some particular reason to wish Master Tymberley ill?"

Catherine regarded her late brother's widow in silence for a long moment, then let her gaze rove to the ornately carved wal-nut bedstead and the gold lace and purple fringe on the canopy above her head before glancing directly at Susanna again. How much did she know already? Too much? Or not enough?

"Are you familiar with the term *blackmail*, Susanna? I do not believe it is a common word here in England, but I have heard it used along the border in Scotland. There it is a wicked but well-established practice. Reivers demand tribute to spare victims an attack on their land or the theft of their cattle."

"A form of extortion, then?"

"Aye." Catherine straightened her shoulders and met Susanna's eyes. "Master Tymberley believes Fulke and I are lovers. I paid him fifty gold angels to keep silent about his suspicions."

"Catherine—"

"It was worth the expense to avoid trouble." She forced herself to smile and imbued her voice with a casual tone. "Do not take him to task for it, I pray you. Not unless you are certain of your influence with the queen."

"Carter was most likely murdered. This may be tied to his master's activities. You were not the only one he threatened."

Unblinking, Catherine considered the implications of Susanna's statements. That her dearest friend thought her capable of murder did not unduly distress her. Catherine knew she *could* kill, given sufficient provocation. To protect her children. In defense of Susanna or Fulke, or even Jennet.

"I had naught to do with Carter. Only Tymberley. On his last visit to Leigh Abbey, the wretched man intercepted me on my way back from a visit to Fulke's cottage and demanded payment for his silence."

"He threatened to tell the queen?"

"Aye. And he added that if I thought to ward off trouble with a hasty marriage to a groom, I'd be well advised to reconsider such a misalliance. Then he informed me he had the power to save my son from the court of wards."

A faint, ironic smile lifted the corners of her mouth. Tymberley appeared to believe that control of Gavin's wardship lay with the queen of England. She wished she knew why he thought so. In the interest of better relations between their two countries, the Scots regent might indeed grant Elizabeth Tudor the power to make that decision.

Catherine flopped back on the bed to stare at the canopy above. Glenelg lands were of no great value or importance to either government, for it was doubtful the Fergusons would rise up in support of their young laird. They were a troublesome pocket

of papists in a land officially committed to John Knox's version of Protestantism. But what if Tymberley knew something Catherine did not? She dared not take any chances, not when miscalculation could cost her her son.

"Why ever would Tymberley think you'd marry Fulke even if you were lovers?" Jennet demanded. "That would create even more scandal."

"Highborn women before Catherine have been known to find a master of horse irresistible," Susanna said in dry tones.

"Oh." Jennet's cheeks pinkened. "The queen and Lord Robin."

"She is not the only one," Susanna said. "The old duchess of Suffolk married her horsemaster, a double scandal since he was so much younger than she. Sixteen years her junior."

"The duchess of Somerset's choice for a second husband raised eyebrows, too," Catherine said from her horizontal position. "He was her steward. Although she must be near eighty now, she lives retired in the country for the most part, quite happy with the choice she made. I, however, I have no intention of re-marrying, not even to so fine a man as Fulke Rowley. He and I are friends, just as we were when I first came here as a girl."

Jennet started to speak but Susanna interrupted her.

"Let us leave the matter of rumors about you and Fulke for another time. We have more urgent things to discuss. Miles Carter's death may or may not be connected to his master's lucra-tive dealings in 'blackmail,' but there were muddy footprints on the platform, at least two sets. I believe the smaller prints were made by a woman. Nick is not so certain of that, but neither of us have ruled out any suspect."

"I cannot prove I did not go out last night," Catherine said. "What irony. Had I been with Fulke, we could have sworn to each other's whereabouts, but I was here from dusk till dawn. Cordell was restless and I stayed at her bedside." Her daughter, who had attained her third birthday the previous month, was prone to night terrors.

"And Avise? Carter took an...interest in your servant, Catherine."

Catherine sat up to glare. "Avise did not go out last night, either. When I went in to Cordell, she was asleep by the hearth in the outer room. She did not shift her position by so much as an inch all night long."

Susanna looked skeptical.

"I'd have heard her if she left the room. The outer door squeaks."

"I must ask Avise some questions, Catherine. Even if she did not kill Carter, she may know something of his activities."

Catherine hesitated, toying with the embroidery on her sleeve. "Avise will not talk to you."

"Will you question her for me, then?"

"Is it necessary that you know what Carter threatened to reveal?"

"Catherine, you try my patience. What do you know?"

Sliding off the bed, Catherine prowled the room, stopping to straighten Gilbert's portrait. It was a poor likeness of his beloved face, but all she had left. "I know where Avise came from and what she was. Carter could not have coerced her with a threat to tell me. But she'd not have wanted the other servants here to learn of her past. She'd not want you to know."

When Catherine first met Avise, the other woman had been a pitiful sight. She'd been beaten and left for dead in a London gutter. Unable to pass by, to ignore her as other horsemen and pedestrians were, Catherine had stopped. Once she'd realized the poor creature still breathed, she'd ordered her henchmen to carry Avise back to Glenelg House.

For weeks, Avise did not speak at all. It had been months before she'd trusted Catherine enough to confide in her. Once she'd heard the story, Catherine could scarce blame her. Avise had been forced to do things as a girl few decent women had even heard of. Her own mother had sold her into a brothel.

In the five years since, Catherine had never had any reason

to doubt Avise's loyalty to her. Avise's days as a whore in Duke Humphrey's Rents were over. She had a new life now, and no desire to go back to the old. Could she kill an enemy to protect it? Oh, yes. But that did not mean she had.

"Let me deal with Avise," Catherine said. "I will tell you anything that might help you discover who killed Miles Carter. I swear it."

Susanna stood. "Very well, Catherine. Have it your way. While you talk to her, Jennet and I will pay a visit to the maids' dormitory."

A few minutes later, Catherine returned to her withdrawing room and closed the door behind her. Avise sat on the floor with her legs stretched out before her and Cordell between them. The little girl had fouled her tailclout, necessitating a thorough wash with lukewarm water.

While Avise dealt with the mess, Catherine tried to recall her impressions from the day Tymberley and Carter first came to Leigh Abbey. Avise had almost done herself an injury in her haste to duck out of sight.

"Did you know Miles Carter in London?"

Avise tensed at the abrupt question but did not look up from her task. "No, madam."

"Mayhap it was Tymberley you knew before?"

"How would such as me know the likes of 'im?"

They both knew the answer to that. In Avise's former profession, she'd serviced all sorts of men. Many a fine gentleman, even some noblemen, did not quibble at seeking pleasure in the lowest sort of whorehouse.

"Mama! Up!" Gavin raced toward her, chubby arms outstretched, nearly bowling her over in his eagerness to be lifted high and hugged.

Catherine clung to her young son and forced herself to consider all possibilities. If it had been Tymberley who'd been murdered, would she be less certain of Avise's innocence?

If it had been Tymberley who'd been murdered, she realized,

she'd be concerned that Fulke might have done him in. Both Fulke and Avise were protective of her, devoted to a fault. If either thought such an act would prevent Catherine from losing her son...

No. She must not think that way.

She collected Gavin's brightly painted wooden building blocks from the chest where his toys were kept and settled him with them near the hearth. At this time of year, there was no fire. Sweet-scented boughs filled the opening.

Cordell, clean clout firmly anchored in place and a bib and apron tied over her long, belted gown, toddled toward her brother, eager to join in his play. The leading strings attached at the shoulders fluttered with each swaying step.

"Mind your sister, Gavin," Catherine said.

When the children were happily distracted by their play, she took Avise aside and revealed what Susanna and Jennet had told her.

Avise denied she'd left the house at any time during the previous night. Catherine believed her but could not help but notice a hesitation in her maidservant's manner.

"What is it, Avise? What have you not said about Carter?"

"'e tried to get me to tell 'im about you, madam. You and the 'orsemaster. Said you was light-heeled, the foul-mouth lurcher."

"And did you answer his questions?"

"Told 'im 'twas a lie. Told 'im to bring a waste."

"Bring a waste? What does that mean?" Avise had an unfortunate habit of falling back on thieves' cant when she was overwrought.

"Get out of 'ere with 'is lies. That's what I told 'im. Poxy cuffin. I cut bene whids, madam."

Cut bene whids, Catherine recalled, meant speak truly, but Avise was holding something back. "Did Carter recognize you, Avise? Is that what he threatened—to tell the other servants about your past?"

Her reluctance palpable, Avise nodded.

"If Carter was murdered, Master Baldwin must look for his killer. It is his duty as justice of the peace."

"The queer-cuffin," Avise muttered. Past experience had given her no reason to respect anyone who held that office. *Queer-ken*, Catherine remembered, was what she called prison, though a prison official was a tipstaff.

"He's a good man, Avise. You must help him if you can."

But Avise insisted she knew nothing more than she'd already told her mistress. She'd given Carter what he wanted in return for keeping her secret, just as Catherine had paid Tymberley for his silence.

19 ~

BRIAN TYMBERLEY, Susanna decided, could well provoke a saint to murder. He had waylaid her on the way from Catherine's lodgings to the maids' dormitory, which passed by the guest chamber he had appropriated for use during his visits to Leigh Abbey. Ten minutes later, he was still rambling on about the failure of Susanna's laundry maid to clean a stain out of one of his shirts, and the sour taste of the ale, and the inadequacy of her cook. If he had any concern for his murdered servant, it was not evident in his litany of complaints.

"I will look into all those matters," she promised, edging away, "just as soon as I have a free moment to do so."

"Where are you bound in such a rush?" He did not bother to hide his irritation.

Susanna bit back a sharp retort at his rudeness. "My tiring maid is ill, Master Tymberley. I am on my way to see how she does."

"Not plague?"

For an instant, she considered saying it was. Would that drive him away? But such a blatant falsehood would soon be exposed, unlike the lie she chose to use. "Grace suffers from a megryn. She is abed with a fierce headache and an unquiet stomach and moist banewort leaves laid to her temple, and it is past time to give her the next infusion of cowslip juice."

"Cowslip juice? I must remember that. I suffer from the megryn now and again myself."

"It is best taken through the nose. Most unpleasant." She fought a grin when he paled and could not resist adding, "A temporary cure only. If you truly wish to banish megryns, you must call in a physician to open the middle vein in your forehead and let the evil humours flow out with your blood."

When Tymberley had retreated in haste into his chamber, Susanna and Jennet continued on toward the maids' dormitory. Susanna's sense of triumph was fleeting. Tymberley was a menace. A threat. She'd silenced him for the moment, but unless she found a way to remove him from Leigh Abbey, he would surely cause more unquiet.

In the maids' dormitory, Grace still slept.

"She should be awake by now." Susanna shook the girl by the shoulder. Grace's only response was a snore.

Joyce, the laundress, bundled up the wad of bedding she'd just collected and came over to look down at the sleeping maid. As she approached, her foot struck something on the floor, sending it spinning toward Jennet.

"An empty vial," she murmured, stooping to pick it up. She passed it to Susanna.

The small container had been labeled in her own hand: *Poppy syrup, to induce sleep*. What had happened was suddenly painfully clear. Grace had gone into the stillroom and helped herself. She had not swallowed enough of the drug to do permanent harm—Susanna prepared only small doses as a precaution against just that

sort of accident—but every servant at Leigh Abbey knew the rules. The only one allowed to dispense remedies from Lady Appleton's stillroom was Lady Appleton herself.

"Do you think she meant to take her own life?" Jennet asked.

Joyce gasped, shocked by the suggestion.

After a quelling look in the laundry maid's direction, which sent Joyce scurrying back to her duties, Susanna answered her housekeeper's question. "If self-murder was her aim, she did not consume enough. It is my fervent hope she only meant to escape a while longer from the questions she knew I'd ask on my return."

She tucked the coverlet in around Grace and smoothed the young woman's dark hair away from her face. Was this the countenance of a murderer? She prayed she was wrong, but she very much feared Grace knew exactly what had happened to Miles Carter.

A short time later, after a second visit to Catherine's lodgings, Susanna and Jennet sat down to supper in Susanna's withdrawing room. Avise had added nothing significant to their knowledge.

Martha, the maid of all work, had already removed the books from atop a small table and covered it with a cloth. Now she set out the dishes—chicken and cheese and a cold pottage from which wafted the scents of ginger and cinnamon and saffron.

"Stay, Martha. A word with you." Susanna poured herself a cup of ale and motioned for Jennet, whose avid gaze was fixed on the food, to commence eating. "Did you sleep well last night, Martha?"

"Yes, madam."

"Nothing woke you?"

"No, madam."

Jennet seemed to find the pottage most excellent, but Susanna took no enjoyment from the mingled tastes of almonds and wine and spices. She'd never seen Martha so nervous. The plain-

faced and stolid woman, who rarely showed any emotion, was tense as an arched bowstring.

"Mayhap you heard Miles Carter leave the house?" Susanna suggested.

"How could I, madam?" She twisted her hands in her apron. "The maids' dormitory is separate from the guest chambers."

And yet, not that far away. The stair passed close at hand and the stable yard was just below the window.

"The banqueting house is on the far side of Leigh Abbey, and at some distance," Martha blurted, so disquieted by the silence that she felt compelled to fill it. This was an old trick, one Susanna often used. One that nearly always worked.

So much for hoping the maids thought Carter's death had been an accident, Susanna thought as she listened to Martha's repeated denials that she'd heard anything. To hear her tell it, she'd fallen asleep the instant her head hit the pillow and never wakened till third cock-crow.

"Well," Susanna said when she'd dismissed the maid, "that was not very helpful."

Jennet frowned. "Mayhap she lied."

"I am not sure how to go about convincing anyone to tell the whole truth. I can scarce threaten them with either jail or torture." She pushed her trencher aside, leaving most of the meal uneaten. "I doubt they will have anything to tell us, but I suppose I must talk to the other servants. Then I believe I will go early to bed. Mayhap a good night's sleep will make matters more clear."

"What of Grace?"

Susanna sighed, thinking of the pale-faced slip of a girl she'd left sleeping in the maids' dormitory. "Tomorrow will be soon enough to talk to her again. Even if she did kill Miles Carter, in her present state she is scarce a danger to anyone else."

20 ～

August 12, 1573

NICK ARRIVED early, impatient to speak with Susanna. He'd learned nothing of value from questioning his household and the villagers and hoped she'd had better luck. This matter was one he wished to resolve without delay. Whether Carter had been murdered or not, his death must be writ down in the parish register, an inquest held, and the burial dealt with. The body could not be left much longer in Leigh Abbey's chapel, not in mid-August.

Avoiding both guests and servants, he used the winding stair in the gatehouse to reach the upper level and the door to Susanna's study. Finding it empty, he made his way round to her withdrawing room and came upon her just breaking her fast.

"Have you news?" she asked as he let himself into the chamber.

He shook his head. "You?"

"My greatest accomplishment appears to have been terrifying my tiring maid into taking too much poppy juice."

She gave him a brief account of the previous day's questions and answers. He did not interrupt, not even to exclaim at the revelations about Jeronyma Holme and Catherine Glenelg. She skimmed over her visit to Holme Hall with suspicious haste, saying only that she'd not been able to question Jeronyma. Then she distracted him with her tiring maid's story to prevent him from asking why or from taking her to task for abandoning the plan they'd agreed upon—to let him deal with the rest of the parish.

"I interviewed all the other house servants," she added, "even talked to Mark and Jennet's daughters, but no one admits to seeing or hearing anything unusual that night."

"Yet you stop short of accusing Grace of Carter's death."

"Aye."

"Poor Simon," Nick said. "He'll be devastated if it turns out Grace went to Carter, then killed him while trying to fight him off." Still, what other explanation could there be?

"I know you have a duty as the local justice to question Grace yourself, but will you let me talk to her again first?"

"I will. And even if Grace did push Carter, I may be able to avoid charging her. I have the authority, if I can persuade a second justice of the peace to agree and the coroner makes no difficulties, to rule the death an accident." A few judicious bribes and the world might even believe Carter had been alone when he slipped and fell.

"If she did kill him—and I am not yet convinced she did—it must have been in defense of her virtue."

"Still murder, some would say."

"No one with any sense! Carter preyed on those with secrets they wanted kept. Tymberley still does."

"Has Tymberley asked blackmail of you?" An interesting word, he thought.

She put off answering by taking a bite of bread.

"If you marry me, no one can censure us."

"What of your promise to your mother?" Her voice was gentle, her expression bleak.

"I promised I would look for a bride, no more. I want you, Susanna." He tugged her to her feet and into his arms.

"I cannot give you children."

"I will adopt an heir. We can foster children. I am not a king that I need to carry on a bloodline, pure and unbroken." After all the time they'd been together, she ought to know she was more important to him than a child to inherit his fortune. Besides, there was no guarantee that a man's own flesh and blood would be any more loyal or loving to him than a boy he rescued from the streets.

He felt as well as heard her sigh. Slowly, she disentangled herself from his embrace. "The village gossips appear to know more than I thought of your visits here."

"That cannot come as a surprise." They'd been lovers for more than six years now. Only the long separations they'd endured had kept them from attracting undue attention sooner.

"And it seems that Denzil Holme is jealous of you, my dear. Jennet has learned, from her sister-in-law, who heard it from Holme's cook, that he intended to marry me once my year of mourning was complete."

Nick's first reaction was outrage at Holme's audacity. His second was concern. He thought back on his brief visit to Holme Hall the previous day. At the time, he'd attributed the wariness he'd encountered from the household to the nature of his questions—he'd been investigating a suspicious death, after all. Now he wondered if there had been another cause.

"Holme was...surly when I asked him about Carter. Said he'd never met the fellow. Jeronyma seemed on edge, but I thought that was because she'd been ordered to entice me into marriage." His mother had been blatant in her support of the match.

"Did Holme mention that I'd been there just a few hours earlier?"

"No, but now that I consider the matter, what I saw in his servants' eyes when I revealed the reason for my visit might well have been relief." His gaze sharpened as he saw the way Susanna sat, stiff and unmoving by the window, hands clenched on a small pillow. "Why would that be, do you suppose?"

"When I went to Holme Hall yesterday, hoping to speak with Jeronyma, Denzil Holme turned me away. He accused me of keeping company dishonestly with you."

"Those exact words?" A cold knot coiled in his stomach as he waited for her answer.

"Aye."

Nick swore. Tymberley had hinted that he would expose them to the queen. Holme's phrasing suggested he meant to report them to the bishop.

Susanna stared out the window. The pillow was now clutched to her bosom. "There is a solution other than marriage, Nick. We can go back to being mere neighbors."

"Is that what you want?"

"It might be the best course to follow." Her choked whisper betrayed her. She clung to her composure, but not without a struggle.

When he said nothing, she sighed, squared her shoulders, and slowly turned to face him. "We were friends before we were lovers. I would like to think that we can continue to enjoy each other's company even if we cease to share a bed." Her smile flashed, rife with irony. "Had we married at the start, we might be at that same pass by now. Or worse. Bored with each other. Living apart. Estranged."

Nick could not reply. His chest felt too tight to allow any words to escape. He'd treasured every stolen interlude, but of equal value were the hours they'd spent just talking. They never seemed to run out of things to say to each other, or of opinions they wanted to share. They had that rarest of commodities between man and woman—true friendship.

To continue as they had been risked public humiliation, mayhap even arrest. If Nick had to give up being in Susanna's bed to spare her that, he would, but he would regret for the rest of his life losing the comfort of holding her in his arms as she drifted off to sleep, of waking up with her next to him.

"Nick?" Susanna sounded worried but she did not leave her perch. The cushion was all but mashed flat in her arms.

"I will not sacrifice your companionship, come what may. What do you want me to do about Holme's accusation?"

"Nothing for the nonce." She seemed relieved to be able to change the subject. "Tymberley presents a more pressing problem. He threatened Catherine, Nick. I cannot allow that."

"You said she paid him."

"He will make further demands. He'd be a fool not to."

"Are she and Fulke lovers?"

"Does it matter? You know the ill will Gilbert's mother bears her. If Jean Russell hears of this, I shudder to think what she will make of it. Catherine could lose her son."

He frowned. "The way the law works, wardships are sold to the highest bidder."

"Aye. The feelings of the child and his mother are not considered important."

"Can she buy his wardship herself? She has money."

"And I would help, too, but the matter is in the hands of the Scots government and they've had other concerns of late." Edinburgh Castle had only recently fallen to the regent after a siege that had lasted nearly two years.

"Catherine might ask Queen Elizabeth to intercede on her behalf."

"The queen is notoriously unsympathetic when it comes to matters of family. You have only to look at Lady Cobham's situation. She was permitted to marry in the second year of Elizabeth's reign and set up her nursery, but the moment she is on her feet again after childbirth she is expected to abandon each new babe and hurry back to court."

"And if Her Majesty is told Catherine is Fulke's mistress, she'll have no sympathy for her at all." Nick suspected that there was little anyone could do to help Catherine Glenelg if the Scots government took an interest in the boy, but he made the only suggestion he could think of in an effort to ease Susanna's worry. "What if Tymberley thinks he is under suspicion for killing his own man? I can suggest to him that he discovered Carter was stealing from him, helping himself to some of the money his master sent him to collect."

Susanna's smile warmed Nick clear to his toes. "What a splendid notion! Demand blackmail of *him*. Force him to abandon his threats against Catherine in return for his own safety. And those against Jeronyma, while you're at it."

"And against you." Typical of Susanna to think of herself last.

"Against us," she corrected him.

"I will drop the first hint when I talk to Tymberley today. After I ask him where Carter's body is to be sent for burial and

if he had any kin who should be notified of his death."

Before he could say more, Jennet appeared in the doorway. Puffing audibly, too short of breath to speak, she thrust a paper at him. The expression in her eyes told him she'd already read it.

Nick unfolded the page, revealing a brief message in his mother's inelegant scrawl. His breath caught. He reread the words with a sense of disbelief.

Susanna's voice sounded very far away. "Nick? What is it? What has happened?"

"I must return home at once," he said. "There's a body in my ice house."

21 ⌒

ANOTHER MAN dead of a broken neck from a fall. It scarce seemed possible. Susanna stared down at Simon's small feet, then up to the hatch at the top of the dome. The brickwork access trap had been removed, allowing him to plunge through to his death.

Her shiver had nothing to do with the damp chill pervading the underground approach tunnel or the cold contents of the ice-well. Two bodies in two days—two accidents? Or two murders? Or was there another explanation?

Toby Wharton, who had been in Nick's service, with Simon, since before Nick bought Whitethorn Manor, started when she spoke his name. "Did he kill himself?" she asked.

That was the third choice, that he'd murdered Carter, then taken his own life because he'd been unable to live with the guilt.

"He never would," the young man insisted.

"It does seem unlike him," Nick said.

"The coroner will think of self-murder first." Already on his way to view Carter's remains, he'd now have to deal with both

deaths. If he followed normal practice in these parts, he'd hold his inquest on the church porch within the next day or two.

"But why?" Toby's voice rose to a wail of despair. "What would make Simon commit such a sin?"

Susanna exchanged a look with Nick, loath to suggest to Toby that his friend had killed another man. She doubted Toby would believe it, and she was reluctant in any event to explain the part Grace might have played in this tragedy.

"When did you last see Simon?" she asked the grieving servant.

"Last night." With visible effort, Toby strove for calm. "He was out of sorts, 'tis true. Short-tempered. But what reason had he to take his own life? I'll not believe it, madam. Not of Simon."

"Disappointment in love?" she suggested gently.

"He loves…loved Grace Fuller."

"Did she love him?"

"He told me he was sure he could win her. He had a way to earn enough money to buy a little farm for them. He meant to leave the parish."

Nick frowned at what was plainly news to him, no doubt wondering how Simon could have acquired funds sufficient to buy land. Susanna had more difficulty imagining Grace happy anywhere but the place where she'd spent her entire life. She was an Eastwold girl, born and bred, and had never shown any inclination to venture farther afield than the fair at Dover.

"He'd not kill himself even if he asked her and she turned him down." Toby's staunch defense of his friend had the ring of conviction. "He'd just keep trying to change her mind."

Grace's recent behavior hinted that she'd met someone on the night Carter died. Had it been Carter? Or Simon? Susanna had already considered the possibility that Grace and Simon were lovers and had been for some time. If Simon killed Carter in Grace's defense, had she known of it? Or guessed? Either way, if he'd killed himself out of remorse, she would take it hard.

But what if that was not what had happened? What if Toby was right, that it was not in Simon's nature to take his own life? Suicide was a sin, after all. He could not be buried in the churchyard if he'd killed himself.

That left Grace.

What if she had killed Carter, by accident, as Susanna had been inclined to believe before this latest development? The poppy syrup could have worn off sometime during the night. Grace might have left the maids' dormitory and come here, desperate to talk to her lover, especially if he had been a witness to Carter's fall. If Grace and Simon were long-term lovers, they'd likely have a way for her to signal him to come out to her after dark.

Susanna glanced at Toby, who had just finished helping Nick lift Simon's body onto a plank for carrying. Now, when the young man was upset and confused, might well be the best time to question him. He knew more than he'd said. She was certain of it. Servants always did.

"Are you a sound sleeper, Toby?" she asked.

He blinked at her in confusion. "I sleep well enough, madam."

"I mean, were you accustomed to wake when Simon went in or out?"

"I heard him sometimes, madam."

"Last night?"

"He did not come to bed at all last night."

Susanna wondered if that supported her theory of Grace as murderer or pointed once more to suicide. "What about the night before? It rained," she added when lines of concentration creased his forehead.

Toby brightened. "He got up and went out after the rain stopped. Took a long time just to piss."

"Mayhap something he ate did not agree with him."

"Aye. That must have been it. When he did come back and settled himself down again, he made a kind of moaning sound."

"As if he felt distress?"

"Aye. Belly ache, no doubt."

"No doubt." More likely it been remorse for what he'd done...or despair over what he'd seen done.

As the two men lifted the makeshift bier, Susanna tried to imagine Grace here, last night, meeting Simon. The ice house was some distance from the main buildings, hidden in the gardens. Here they could have talked without fear of being overheard. Had they quarreled? Perhaps Simon had wanted to confess. Perhaps Grace had known already that he would betray her.

Susanna looked back at the hatch. A woman could remove it. And it did not take brute strength to push a man to his death. If Grace had done that once, she could repeat the act to protect herself.

Had she then circled around and come down the entry tunnel to make sure he was dead? Or had she left him and fled back to Leigh Abbey, relying on the fact that everyone thought she was deeply asleep from the poppy syrup to free her from suspicion when he was found?

The answers Susanna worked out made her feel physically ill, but they convinced her she must confront Grace without delay. If she acted at once, she might be able to shock that young woman into giving herself away.

Susanna followed Nick and Toby and their burden into the late morning sunshine. With a sense of surprise she realized it was close to the dinner hour. Time had slipped away from her.

"I must go back to Leigh Abbey," she said.

"I will come for supper," Nick promised. "We will talk about this then."

She nodded, anxious to be away.

He must have seen something in her expression that alerted him to her distress. As she hurried toward the start of the footpath, he called after her.

"Send word if you need me sooner."

22 ⌒

WINIFRED TOOK a bite of fish, bit down on a bone, and spit it out. "As bad as when we were under Rome," she grumbled. "An extra fish day to help the fishermen. Who ever helped the merchants of the staple?"

Nick looked up from his dinner and regarded her with a jaundiced expression. "The merchants of the staple never needed a royal edict to make a profit."

"Hah! A lot you know about it. When I first married your father...well, never mind. Tell me what you mean to do about Simon's suicide."

"What makes you so certain he killed himself?"

She snorted. "Who sent the message to bring you home from Leigh Abbey? Did you think I'd summon you before I'd been to inspect the scene for myself?" She took a long swallow of Rhenish wine and glared at him.

"He might have fallen."

"Then who took the hatch off, I ask you?"

"There is that."

"Aye." She set the goblet down with a thump. "He was upset over that young woman he's been courting. Heard she'd killed herself."

Nick paused with a piece of manchet bread halfway to his mouth. "How do you know that, Mother?"

"How do you think? Simon came to me when he could not find you. You'd gone off to the village, asking your questions, and then you went to Leigh Abbey at the crack of dawn."

"And he thought Grace——"

"Took too much poppy syrup apurpose." Wonderful stuff, poppy syrup. Almost as useful as laudanum when the pain was bad.

"Why?"

"Are you simpleminded? She must have been the one you were after for killing that fellow who fell out of the tree."

"And why would Grace's death lead Simon to take his own life?"

"To be with her for all eternity, no doubt. What does it matter? The case is settled now."

"Not if Grace is guilty. She is not dead, Mother."

Annoyed, Winifred waved that inconvenient fact aside with a regal gesture. "You have more important things to be concerned with. The queen's visit, for one."

"We will not be here when the queen comes. We'll go back to London for the duration of her visit. Just as well. I've business to attend to there."

"Nonsense. We must stay to welcome Her Majesty to the parish. You are one of her justices. She'll expect you to be here."

"And you want to meet the queen." He watched her now the way a mouse regards a snake.

His wariness combined with his reluctance to see this for the opportunity it was made her snap at him. "How else am I to convince her that you deserve a knighthood for all your years of loyal service?"

"Mother, I—"

"I am an old woman, Nick. Humor me."

"Oh, yes, and doubtless dying, too."

She glared at him. He ignored her and gave his full attention to his meal. She ought to tell him the truth, she thought. She would, if it weren't for the certainty that he'd insist she consult more physicians, subject herself to all manner of indignities in the hope of a cure that would not be forthcoming. She'd had enough of hedge doctors and their useless remedies.

One had swabbed her suppurating breast with white wine, then applied burned lead. Another had suggested amputation. As if she'd let some puffed-up barber take a blade to her! She'd even gone to a woman practitioner, the renowned Alice Leeves, by whom Lord Hunsdon set such store. All for naught. She'd have done as well to waste her coin on the old cunning woman who claimed to be able to tell fortunes from the lines on a person's

palm. Lay a frog, washed and boiled on the afflicted area as a poultice? What foolishness!

There was naught anyone could do except die when lesions formed in the breast. But Winifred Baldwin meant to keep her wits about her as long as possible. She dosed herself with pain killers at night, but only did so during the day when the agony was unendurable. That way she kept control, and kept her secrets, too. She had much to do before she died. No one could be allowed to interfere in what she intended to accomplish. No one. Not even the son who loved her.

Winifred realized she was twisting one of her opal rings around and around on her finger. She stared at it, shocked by how loose it had become. If she did not take care, she'd lose it.

A tear rolled down one deeply lined cheek. Her once plump and pretty hands had shrunk to bone. How could Nick not notice?

Swiping at the moisture on her face, she spoke in a sharp voice. "Did you visit Holme Hall yesterday?"

He did not look up from washing his hands in scented water. "I told you I meant to question everyone in the village in search of information on Miles Carter's last hours. That included those at Holme Hall."

Exasperating man! She moderated her tone. "I hope you took the opportunity to speak to young Jeronyma about more pleasant matters as well."

Nick pushed away from the table and stood. "I have no intention of marrying Jeronyma Holme."

"By St. Frideswide's girdle, Nick! Why not? She's young and pretty—what more could you want in a wife?"

"Love. Honesty."

Winifred's eyes narrowed. The first requirement was not unexpected. She knew her Nick fancied himself in love with Susanna Appleton. But the second baffled her. What reason had he to think Mistress Jeronyma dishonest? Winifred opened her mouth to ask, then closed it again. It did not matter. She'd pay a visit to that

young woman herself. And speak to her father again. After all, it was the duty of loving parents to arrange their children's marriages. How else could property be inherited? How else could order be maintained? She'd worry about convincing Nick to sign the betrothal contract after it was drawn up and ready.

23 ~

SHOCK COULD BE an efficient weapon, and it was the best method Susanna could think of to get at the truth. She intended to inform Grace of Simon's death in a manner that would provoke a telling reaction. If the tiring maid were innocent, Susanna would offer apologies and comfort. If Grace betrayed guilt... well, Susanna was not sure what she would do then. She only knew she must discover if the young woman had been responsible for Miles Carter's death. Or for Simon's.

The maids' dormitory was deserted save for one huddled form on a pallet. At the sound of Susanna's footsteps, Grace rolled over and sat up, rubbing her eyes with her fists and giving every appearance of just having wakened.

"Your lover is dead," Susanna said.

Grace recoiled as if she'd been struck. Fluttering hands covered her face and she began to weep. Within moments, heart-rending sobs shook her entire body.

Susanna stared at her, astonished at this evidence of grief. She could no longer doubt Grace was innocent of killing Simon. And that, she supposed, meant Grace was innocent of Carter's death, too.

"I did not realize you cared so very much for him." Susanna sat on the bed beside her and put her arm around Grace's shoulders.

"I loved him more than life itself," Grace sobbed. "How can he be dead?"

"It appears he took his own life."

Grace's head shot up at that. "No! It is not possible. Not my Alan!"

Stunned, Susanna's hand went slack on Grace's shoulder. "Alan?" she echoed weakly. There was only one Alan in the parish, Alan Peacock, the miller's son. But if he was Grace's lover, then what of Simon?

Hope stirred in Grace's tear-filled eyes at Susanna's reaction. "Please," she begged, "tell me this is all a mistake. Tell me Alan is not dead."

"As far as I know, he is alive and well, and I have indeed made a terrible mistake."

Grace flung herself into Susanna's arms, but this time the tears were joyful. Susanna let her cry herself out, patting her on the back now and again. When the worst had passed, she put a little distance between them and offered Grace a handkerchief.

Once she'd dried her eyes and blown her nose, Grace slanted a wary glance at Susanna. "I do not understand, madam. Why did you tell me Alan was dead if he is not?"

Susanna took both Grace's hands in hers and waited until the young woman met her eyes. "I said your lover was dead, Grace. I meant Simon."

It seemed to take Grace a moment to absorb that. Then she frowned. "Simon killed himself? Why?"

"That is a very good question, Grace. Here is another. What upset you so much that you dosed yourself with poppy syrup?" She could still smell the sickly sweet odor of the drug where Grace had spilled some in her haste to consume it. Her breath was even more foul.

Grace's fingers tensed. She tried to pull away, but Susanna would not release her. Finally, head bowed, she choked out her

story. "I was ashamed to tell you what happened," she blurted. "I was afraid you would think I had something to do with that dreadful man's fall."

"Miles Carter?"

"Aye. I…saw him the night he died."

"Go on."

"It starts with Alan, madam. His father forbade him to court me. I am not good enough for the miller's son." The bitterness in her voice convinced Susanna that this part of the tale, at least, was true. "We were forced to meet in secret, and so I encouraged Simon's suit to hide what we were about."

"I see. And that night?"

Grace swiped at a fresh tear. "Alan and I took a blanket and climbed the tree to the top platform of the banqueting house. We thought it a spot where we'd be safe from prying eyes."

"But Carter discovered you," Susanna guessed.

Grace nodded. "He ordered us to dress and begone. He told Alan to go first. Then Carter seized me."

She began to cry in earnest once more and it was some time before Susanna could pry any sensible responses out of her. When she did, cold fury surged through her. Carter would have had a very angry gentlewoman to answer to if he were still alive.

He had tried to rape poor Grace there in the banqueting house. He'd stuck his tongue in her mouth and shoved his hand up beneath her skirt, groping and fondling. She'd managed to wrench free, but not without the loss of one of her garters. Carter's threatening whisper had followed her down the stairs that wound around the tree, promising he'd tell everyone in the village he'd caught her with Alan if she did not return within the hour and let him have his way with her. Overcome with revulsion at the memory, Grace curled into a ball on the pallet, her eyes squeezed tightly shut.

"Did you go back?"

A violent head-shaking denied it. After a moment, Grace added, "I ran away as fast as I could. I'd never let him touch me as a lover would. Never. I'd have died first."

"And Alan? Where was he?"

"He thought I was right at his heels when he climbed out of the tree. He ran away at once, sure I'd follow the usual route we took in order not to be seen. He reached the ornamental gardens before he realized he'd left me behind."

Susanna frowned. If Alan had felt any real concern for Grace's safety, he'd have waited for her at the foot of the tree.

"It was dark," Grace continued, still making excuses for her lover. "Alan could not see me very well. I did not tell him what Carter said or what he did."

"He could not tell how upset you were?" Had it been dark enough to hide her expression? Susanna wondered. After the rain, if the sky had cleared, a full moon would have been shining down on them. Alan must have noticed the twisted clothing, the signs of distress.

"I did not want him to know. It was enough that he took me to the door and promised to stand guard all the rest of the night through."

More contradictions. Why would the door need guarding if Alan did not know what Carter had done? Susanna checked a flood of new questions, aware that Grace was perilous close to another spate of weeping. In truth, there was only one thing she felt it needful to ask.

"If you left Miles Carter alive and well, why were you so afraid to tell me the truth when you heard that he was dead?"

Grace swallowed hard before she spoke. Her words rushed out in a tremulous whisper, accompanied by a new torrent of tears. "I was afraid you would think Alan killed him."

24 ❧

THE EMBROIDERED garter Nick found among Simon's possessions seemed to confirm he was obsessed with a woman. Doubtless it belonged to Grace Fuller, since she was the only one he'd ever talked about. The absence of any hoard of coins hinted at Simon's desperation. He'd told Toby he meant to take Grace away, but if he'd been unable to offer her escape...

There now appeared to be an explanation for both Carter's death and Simon's. Carter must have threatened Grace, as he had others, demanding favors in return for his silence. Grace had gone to Simon with her dilemma, rousing his protective instincts. Then Simon had met Carter in Grace's place and slain the villain. Nick supposed that when Grace heard about Carter's death, she guessed what had happened, and blaming herself, took poppy juice, setting in motion the chain of events that led to Simon's suicide.

When Nick saw Susanna again a few hours hence, he expected her to confirm what he'd deduced. He believed she'd agree that Simon, after receiving a distorted version of Grace's actions, might have decided to kill himself rather than live without her.

This sequence of events contained an excess of lovesick behavior, but was believable enough, given Simon's feelings about Grace. The only aspect of the situation Nick could not account for was Simon's inexplicable failure to confirm Grace's death before he took his own life. A pity he'd not tried for some grand and tragic gesture, such as flinging himself into her grave or stabbing himself on her bier. If he had, he'd have learned she still lived. Instead, he'd taken the word of whatever servant had spread the rumor of Grace's suicide and plunged to his own death through the open hatch of the ice house.

Nick had completed his search of Simon's belongings and was leaving the room Simon and Toby had shared when Brian Tymberley rode into the stableyard of Whitethorn Manor. Nick cursed under his breath, struggling to refocus his thoughts.

He'd intended to speak with Tymberley this afternoon, but the plan he and Susanna had conceived before they learned of Simon's death—to accuse Tymberley of Carter's murder in order to put a stop to his demands for blackmail—would not work now.

Arrogant as ever, Tymberley surveyed his surroundings before he dismounted. He did not notice Nick in the shadow of the servants' wing. He swung to the ground, tossed his reins to a groom, and strode toward the kitchen entrance to Whitethorn Manor.

"Master Tymberley," Nick called out. "Well met. I meant to call upon you today."

Tymberley froze, then turned only his head to stare at Nick over his shoulder. "What business have you with me?"

"I might ask you the same question."

Nick supposed Tymberley had come to Whitethorn Manor to pursue the matter of blackmail. The last time Nick had spoken with him, he'd agreed his man's death might have been an accident, but there was still the threat he'd accuse Nick and Susanna of "keeping company dishonestly."

Nick contemplated charging the fellow with extortion, but first he'd need to persuade one of Tymberley's victims to swear out a complaint. He doubted any of them would agree to do that. He would not himself, not if bringing Tymberley before the assizes also meant Susanna would end up in bawdy court, accused of immorality by the Church of England.

Of a sudden, Tymberley grinned. "You ask why I am here? The answer is simple enough. I thought to pay my respects to your mother. She was most gracious to me on my previous visits."

Nick saw no profit in calling Tymberley a bald-faced liar. Instead he crossed the yard until they were face to face. "And my business with you was this: your man's body must be disposed of, either buried or sent to kin as soon as the coroner has examined it."

Tymberley grimaced. "I have already told you Carter has no

family." His eyes narrowed. "Does this mean you will rule his death an accident?"

"That seems the best choice. The inquest is set for tomorrow morning."

"I am pleased to find you so reasonable. It bodes well for our dealings in other areas."

Nick lifted one brow. So Tymberley did intend to demand blackmail in return for his silence. "Do you mean the second... accident?" he asked on impulse.

Tymberley blinked and backed up a step. "There has been another death?"

"I presumed you knew." Careful to keep his own voice and expression bland, Nick observed the other man's reactions with keen interest. "There will doubtless be talk, given the similarities."

"Who has died?"

"One of my men. Simon Brackney."

Tymberley did not react to the name.

"It appears that upon the false report of his beloved's death, Simon took his own life. Or else, distraught, missed his footing and fell to his death by accident."

That sounded plausible, Nick decided. Mayhap he would write it down as the cause of death in the official record rather than "found *felo-de-se*." Then Simon could be buried in holy ground.

"False report? What false report?" Tymberley's little close-set eyes glittered as he scented scandal.

Nick leaned closer, looming over the smaller, thinner man. "Nothing that will profit you, Master Tymberley."

"Do you threaten me, Master Baldwin?" Tymberley's smirk made Nick want to strike him.

"I merely wish to remind you that the law must be served. Julius Port, the coroner I sent for, has been away from home on other business, but he will be here on the morrow and conduct

the inquests for both your man and mine. It is in everyone's best interests that these proceedings run smoothly."

With an abrupt movement, Tymberley stepped out of Nick's shadow, stalked to his horse, and seized the reins from the groom. The lad had lingered in the stableyard holding the beast, uncertain how long Tymberley intended to stay. As Tymberley swung into his saddle, Nick called to him.

"Have I your permission to bury your man in the parish of Saint Cuthburga after the inquest?"

Tymberley sawed on the reins, turning his mount so sharply that a flying hoof came within an inch of striking Nick in the leg. "No. I claim the body, Baldwin. I'll take Carter to London to be interred."

"As you wish," Nick told him, amused in spite of the venom in the other man's voice. It would not be a pleasant journey, two days on summer roads with a corpse.

His smile faded as he watched Brian Tymberley ride away. Instead of the satisfaction he should have felt at routing the enemy, he was beset by a nagging conviction that there had been more to their exchange than he'd understood. He was also certain of something else—Tymberley would be back, bringing still more trouble with him.

25 ∾

ON THE WAY into Eastwold, Lady Appleton repeated Grace's story to Jennet, who listened in fascinated horror to this new version of events.

"I thought Grace might have killed Carter and Simon," Lady Appleton said when, just past the fork in the road where travelers could choose between Dover and Eastwold, she concluded the

tale. "Now I must suspect Alan Peacock. He had reason, jealousy in both cases."

"He's not the sort to kill anyone for any reason." Jennet gave a derisive snort. "Why, it appears he lacks the courage to stand up to his own father."

"We cannot know what Alan would do when provoked," Lady Appleton said.

"His actions have always been passing simple to predict ere now." As a boy he'd been the first one to steal apples off the trees in Leigh Abbey's orchards.

Although Jennet had not been born in Eastwold—she came from the not-far-distant village of Barfreystone—she had been in service at Leigh Abbey since she was a girl of thirteen and had long been acquainted with all the local families. The same few had intermarried countless times over the years, or found spouses among the outsiders brought in to work at Leigh Abbey or its pre-decessor, Leigh Hall, or at Whitethorn Manor. Even if Mark's mother had not taken Edward Peacock for her second husband, Jennet would have known everything there was to know about Peacock's son. Alan's sister, Hester, had been a maidservant at Leigh Abbey for several years before she'd married Fulke Rowley.

"How is it, then," Lady Appleton asked, "that you did not already know Alan was courting Grace? It would appear she has been creeping out of the house to meet him for some time now."

Jennet was spared having to admit she'd failed to notice the lovers. They'd reached the village.

At the miller's house, Joan Peacock welcomed them inside with a smile. To the left of the door was a well-kept kitchen with a stone-flagged floor, to the right a parlor that smelled of rosemary. Two smaller rooms lay beyond and a steep wooden stair led up to another floor.

If Joan thought it odd that Lady Appleton at once asked her to send for Alan from the watermill, she was polite enough not to say so. She dispatched the summons with one of the children

who'd been playing in the street, offered Jennet and her mistress cups of barley water, then seated herself at her spinning wheel while they settled in by the open window.

"I had hoped for an opportunity to speak with you, Lady Appleton," she said. "The vicar needs a wife."

"I suppose he does," Lady Appleton said in a thoughtful voice.

Would a woman in his bed cause him to be less sour? Jennet doubted it, but she did not believe a wife would make Nathaniel Lonsdale any worse. She wondered if Joan had someone in mind. Sarah, mayhap?

"If he is to get one," Joan continued as she set her wheel in motion, "improvements must be made in his abode. Therefore it falls to the parish to provide funds, and what better way to raise money than to hold a church ale?"

"It is a long time till Whitsun comes round again."

Joan bestowed a bright smile on her daughter-in-law. "But by happy chance the feast day of Saint Cuthburga falls but one day short of the queen's visit. Were we to celebrate both together, we might take advantage of the generosity of Her Majesty's courtiers."

Jennet was uncertain how to reply and so said nothing. Sir Robert had never yielded to charitable urges when he'd been at court. All his money had gone for fine clothes and gambling.

A little silence fell. The only sound in the room was the steady rhythm of Joan's wheel as single strands from the mass of washed and combed wool on the distaff twisted together into one long thread, winding onto the spindle in a process so smooth it seemed effortless.

"You will need the approval of a justice of the peace before you can hold a church ale," Lady Appleton said.

"Master Baldwin has no reason to deny one." Muffled shouts of "Peeweep" and "Ho" reached them from outside the cottage— village children engaged in a game of hare-and-hounds.

"And the vicar?" Lady Appleton asked. "Will he object?"

"The ale is for his benefit."

"He will say, I do think, that Saint Cuthburga's day is not a recognized feast in the New Religion and therefore there is no particular reason to celebrate it."

"Save that we have done so from the earliest days of this parish." Joan spoke in a defiant tone, and as if to add emphasis, stopped spinning.

"Not every year." Lady Appleton knew, as did Jennet, that the practice had fallen off since Elizabeth Tudor came to the throne. Celebrations on All Saints' Day had replaced local holy days in most English communities.

Alan's arrival put an end to the debate. He entered smiling, until he caught sight of Lady Appleton. All forward momentum stopped. In haste, he pulled off his cap to run nervous fingers through a shock of wheat-colored hair. A schoolboy called to account for failing to do his sums could not have looked more ill at ease.

"You expected someone else," Lady Appleton concluded.

"Aye, madam. Master Baldwin."

"Alan was in Dover on an errand for his father when Master Baldwin came to ask questions about that poor foreigner's death." Joan resumed her spinning.

Jennet had to grin at her mother-in-law's choice of words. Anyone born beyond the boundaries of St. Cuthburga's Parish was a foreigner to those who lived here. Jennet had been one herself until she married Mark. Doubtless Master Baldwin still was.

"What can you tell me about the night Miles Carter died?" Lady Appleton asked Alan.

"Naught, madam." But he tugged at his collar as if it choked him. Awkward and big-boned, Alan much resembled his late sister. Hester, Fulke's wife, had often put Jennet in mind of a gangly young pup not yet grown into its feet.

"Grace has already confided in me." Lady Appleton fixed Alan with a steady stare.

For a moment Jennet thought the young man was about to cry. He squeezed his eyes tight shut. The muscles in his face seized.

When Joan started to speak, Jennet shushed her.

"Alan," Lady Appleton said with commendable patience, "I understand why you are reluctant to talk to me, but unless you can verify what Grace has already said, then I will have no choice but to suspect her of murder."

Alan's eyes popped open to goggle at her. "Whatever Grace told you is true!" He glanced at his stepmother, then jerked his gaze away from her to plead with Lady Appleton. "Grace would never lie to you, madam."

Lady Appleton rose from the window seat and crossed to Alan's side. Jennet stayed where she was, trying to make herself invisible. She leaned back, the better to become one with the woodwork, only to have a hard object press painfully into her waist. She'd forgotten, living at Leigh Abbey, that in less luxurious dwellings the window shutters slid up and down in grooves. A peg at the bottom and a rope at the top held them in place when they were closed. It was the rope that had poked her.

"Grace lied to Simon," Lady Appleton said. "She led him on. And she could have gone back to the banqueting house after you left her at Leigh Abbey."

Alan's lower lip trembled, but he did not abandon his defense of Grace. "She went in and stayed in, madam. I watched for a long time afterward, to make sure that bastard did not come anywhere near her."

So he had known what Carter did to Grace. Jennet leaned forward, eager to catch every word.

"Where did you stand guard, Alan?"

"In the ornamental garden, madam. I could see the door into the house, and the way from the oak tree, too. I was there till nearly dawn. Long enough to watch Fulke Rowley come out with his lantern and go into the stable to feed the horses."

"Did Fulke see you?"

Alan's face crumpled. Alarm flashed in his eyes as he seemed at last to understand that he, too, might be a suspect in the death of Miles Carter. "I came away before he could, lest he wonder why I was there."

"Mmm," Lady Appleton said.

Jennet could not tell whether she believed Alan or not. He might well lie in an attempt to convince her that both he and Grace were innocent.

"Let us go back to an earlier point," Lady Appleton said. "To when you and Grace were in the banqueting house."

Alan's fair skin flushed and he darted a guilty look toward Joan. Her hands stilled, yarn in one, the other on the wheel, to regard him with a mixture of speculation and disapproval. She'd overheard most of his exchange with Lady Appleton, just as Jennet had.

Lady Appleton signaled Jennet to remove her mother-in-law from the premises. With a sigh, Jennet rose to comply.

"What has Alan done?" Joan demanded when they reached the yard.

Jennet ushered her along a path that led to the well and the small stand of apple trees beyond. "I cannot tell you that."

"Then mayhap you will tell his father." Joan spun away, heading for the gate that led to the mill.

Jennet thought about following her, but she could scarce bind and gag her mother-in-law and nothing less would stop her from fetching Miller Peacock. Besides, Jennet wanted to hear Alan's answers to the rest of Lady Appleton's questions. Retracing her steps, she slipped back inside the house, leaving the door slightly ajar.

Alan now sat beside Lady Appleton next to the window. His face was still pale, but wore an earnest look.

"A shadow by the fishponds?" she prompted.

"Aye, madam. I am certain I saw something move when I

stopped at the edge of the ornamental gardens to wait for Grace. Someone else was there."

"You've no idea who?"

"Carter's killer."

"Mayhap." But Lady Appleton did not sound convinced.

Jennet tried to visualize the area as it would have been two nights previous. Why anyone would go out after sundown if they did not have to was beyond her ken. The night air was unhealthy to breathe. Spirits roamed the earth after midnight. And there had been a full moon. Magic and sorcery were at their most powerful then. Light enough to see shapes, she decided, but not sufficient to identify them.

"Well, Alan," Lady Appleton said, "you have confirmed all Grace told me except how you feel about her. A man who loves a maid would not resort to clandestine meetings in tree houses."

"My father—"

"You are old enough to marry without his permission."

"He swore he'd disinherit me if I wed Grace. He forbade me even to speak with her except at church."

"Most men think twice about severing all ties with an only son, no matter what they threaten in the heat of anger."

"He meant every word. You know him, Lady Appleton. He is not one to change his mind."

"Then you have treated Grace most dishonorably, Alan. You misled her and seduced her with promises you never intended to keep. What if you have got her with child?"

Alan blanched at the suggestion, seeming to shrink into himself. Oblivious to anything but his own misery, he did not seem to hear the sound of approaching footsteps.

"How did you mean to protect her if Carter had made good his threat?" Lady Appleton demanded. "Your father would have learned you'd disobeyed him." The footfalls paused outside the open door. "Shall I answer for you? You got rid of Miles Carter before he could tell anyone what he'd seen." Lady Appleton gave

Alan's chest a hard poke with one finger. "Then, seeking a scape-goat, you killed Simon Brackney."

Alan sprang to his feet, sputtering a denial, just as Edward Peacock roared into the house. "How dare you accuse my son of murder!" Face beet red with apoplectic fury, the miller shook his fist at Lady Appleton. "Were it not for you, my daughter would still be alive!"

The unexpected accusation rendered them all speechless.

Joan, who'd rushed in at her husband's heels, recovered first. "You are overwrought, Edward. Calm yourself."

"I know what I know," the miller bellowed. "She killed Hester."

"Your daughter died in childbed, Miller Peacock."

Although Lady Appleton sounded calm, Jennet saw the pain in her eyes. It was reflected in Joan's expression. Both of them had been present, as had Jennet and Lady Glenelg and Grace, when Jamie was born and Hester died. So had a proper midwife with years of experience in getting babies and their mothers safely through the ordeal. Nothing any of them knew how to do could save Hester. She'd gone into convulsions during labor and died with the child still in her womb. Had Lady Appleton not known how to cut the baby from his dead mother's body, they'd have lost him, too.

"Get out of my house!" Peacock bellowed. "I'll not allow you to harm the one child I have left!"

26 ～

"MY DEAR Lady Glenelg," Jeronyma Holme gushed. "I am so glad you asked me to visit."

Since Catherine had done no such thing, she needed a mo-

ment to banish the blank stare from her face and replace it with a sociable smile. "My dear Jeronyma," she managed to say, "what a delightful surprise!"

"I have brought gifts for your children," Jeronyma informed her, and ordered the groom who'd come with her to bring two bulging saddlebags to Catherine's lodgings. Only when he'd been sent back to the stableyard did she make any attempt to explain her sudden appearance at Leigh Abbey.

"You must forgive me," she apologized. "I could think of no other way to reach Sarah."

"Sarah?" Confused, Catherine eyed the items Jeronyma extracted from her bags. Caps and smocks and ribbons tumbled out, all well made but not of the quality Jeronyma herself would wear.

"My maid. Do you not remember her?"

Belatedly, Catherine made the connection. Mark's sister was only a few years younger than Catherine herself, but she'd still been at home with her mother when Catherine first came to Leigh Abbey as a girl. Susanna had not taken Sarah in to be trained until after Catherine's marriage to Gilbert.

"Sarah Jaffrey. Yes. But why—?"

"She left in such a rush that she could not pack her belongings, so I have brought them to her." She caught a glimpse of Catherine's confused expression. "Oh, I see. You did not realize she was here. She is staying with her brother until I return to Lady Cobham's household."

For a moment, Jeronyma seemed at a loss, and Catherine was uncertain what to say to her. It was obvious more had been going on at Leigh Abbey, and at Holme Hall, too, than Catherine was aware of.

As if unable to bear more than a brief silence, Jeronyma burst into speech. She remained in constant motion as she talked, first unloading the rest of Sarah's things into a haphazard pile, then examining the toys that lay scattered about Catherine's withdrawing room, picking up balls and tops and poppets and putting them

down again as she roamed. The children, in Avise's keeping, were outside, at play in the ornamental garden.

"Father and I saw Lady Appleton and her housekeeper ride past Holme Hall and since it was clear they had gone to the village, I was able to persuade Father to let me come here. Certes, if he realized I meant to speak with Sarah he'd have forbidden it. Most like, he thinks she is in Eastwold with her mother. But I told him I wished to renew my acquaintance with you, Lady Glenelg. How could he object to that? You are a noblewoman, after all." A nervous laugh accompanied this last statement.

"You wish to speak to your maid?" Catherine did not know why Sarah was at Leigh Abbey rather than with her mistress at Holme Hall and had no notion why Denzil Holme should object to Jeronyma paying a visit here when Susanna was at home, but if Jeronyma did not volunteer an explanation, Catherine knew she could get answers later, from Susanna.

Jeronyma flashed a bright smile that faded into a worried frown. "Might we meet here? I'd prefer no one see us together. You know how servants from one household gossip with those in the others, and I fear word would soon leak back to my father."

"Avise will bring Gavin and Cordell in at any moment," Catherine warned her. "It would be best if you waited for Sarah elsewhere." She gave the matter a moment's thought. "Gather up Sarah's things and come with me. I will leave you in the room Lady Appleton uses to store clothing and linens and send Sarah to you there."

"Oh, excellent plan." Jeronyma scooped up most of Sarah's belongings and followed Catherine out of her withdrawing room.

They heard raised voices as soon as they entered the corridor. Jeronyma paled and dropped an apron.

"Brian Tymberley," she whispered. Catherine cocked her head to listen to the sounds beyond the window. They came from the kitchen yard below. "He appears to be quarreling with Mark Jaffrey."

"I had forgot Master Tymberley lodged here."

"Aye, in yon chamber." Catherine indicated the one adjacent to the linen room.

Such a peculiar expression came over Jeronyma's face that Catherine could only conclude Tymberley had made some demand on her. She did not want to know what it was. She had enough troubles of her own without worrying about those of a shallow young woman like Jeronyma Holme.

Crossing to a window that overlooked the kitchen yard, Catherine leaned out to listen to Tymberley's complaint. He wanted the use of a cart to take his man's body to London. Mark had other uses for the conveyance. Then Fulke joined the other two and the shouting intensified.

Catherine withdrew into the passage. "I must go down and settle this," she told Jeronyma. "Gather up the rest of Sarah's belongings and take them with you into that chamber. I will send your maidservant to you as soon as I have dealt with Master Tymberley."

"I pray you, do not let him know I am here."

"I mean to have as little contact with him as possible," Catherine assured her. "I will tell Mark and Fulke what Susanna would were she here—to let Tymberley have whatever he wants so long as it will speed him on his way!"

"What if he comes up and finds me here?"

"He'll have no reason to enter the linen room. When you hear him moving about in his own chamber, you will know it is safe for you to leave."

Jeronyma's impulsive hug sent most of the clothing in her arms tumbling to the floor. "Gramercy, Lady Glenelg! I will be forever in your debt."

A trifle embarrassed by the intensity of the other woman's gratitude, Catherine left Jeronyma standing in a welter of material, a stocking in one hand and a handkerchief in the other.

27 ☙

NICK HAD envisioned a quiet supper alone with Susanna. Jennet, at least, was not present. Her husband and daughters had first claim on her. But Catherine Glenelg shared the meal and had already been with Susanna in the dining parlor when Nick arrived. By tacit agreement they left all discussion of murder until the final course.

"Have you reached any conclusions about Simon's death?" Susanna asked then.

"I am of a mind to rule both his death and Carter's accidental." Sensing he had their full attention, Nick sketched out all the details he'd accumulated and presented the theory he'd fashioned from those facts. "Disturbed as he was, Simon might have fallen to his death."

Susanna slid one hand along the table to squeeze his arm. "You propose a reasonable explanation, Nick, and it may even be the correct one, but I fear the truth is not quite so simple as you suppose. You'd best wait with your verdict until you hear what Grace and Alan have to say."

"Alan Peacock? What has he to do with this?" Alan, Nick recalled, had been one of the few villagers he'd not been able to talk to on the day Susanna found Carter's body.

He listened in astonishment to Susanna's account, in particular the part about Grace losing a garter in the tree house during her escape from Carter.

"This makes no sense," he said when she'd finished. "If Grace and Alan are telling the truth, then how did Simon end up with Grace's garter?"

He produced the item in question and placed it on the table between a bowl of fruit and a box of sugared almonds. As he'd expected, Susanna confirmed it was likely to belong to her tiring maid. Along with kirtles and aprons and shoes and the rest, Leigh Abbey's women servants were provided with garters as part of

their wages. "These look like Grace's stitches," she said, fingering the embroidery.

"What of the shadow Alan saw near the fishponds?" Lady Glenelg asked. "Could that have been Simon? 'Twould be a logical route to take from the end of the footpath to the oak. And from the footpath, anyone approaching the banqueting house might have missed seeing Alan." She popped a grape into her mouth and reached for another. "Simon *would* have seen Grace. Imagine his dismay if he watched her run away, then climbed the tree to see why she'd been up there and found Carter."

"But if Simon did not *expect* to meet Grace," Susanna cut in, "why leave Whitethorn Manor at all? For that matter, why did Carter go to the banqueting house?"

"If he suspected Grace had been meeting a rival, Simon might have gone to spy on her." Nick could imagine it all too well. Had Simon climbed that tree expecting to find Alan Peacock and encountered Miles Carter instead? When he saw the garter, would he have assumed it belonged to Grace and leapt to other conclusions, as well? Had he lost his temper? Charged at Carter? Nick shook his head. "With both Carter and Simon dead we may never know the whole truth."

"I would hope we can still learn a part of it." Susanna removed a piece of paper from her pocket and turned it over to draw on the back with rapid strokes of her pen. A crude sketch of the parish emerged, showing the relative locations of manor house, ornamental garden, stable, and oak tree. In less detail she indicated Whitethorn Manor and the village. She stabbed a finger into the garden. "From here Alan could not see both tree and stable."

"Did he also lie, then, about the lantern by the stable?" Lady Glenelg sounded relieved, which made Nick wonder if he ought to reconsider Fulke Rowley as a suspect in Carter's death.

"So it seems," Susanna said. "And that may mean he did not stay till dawn as he claimed."

"Even if he did lie, it could be no more than a misguided attempt to shield Grace from suspicion." Lady Glenelg plucked the sketch from Nick's grasp.

"Did Grace kill Carter?" Nick asked Susanna.

"I do not think so." She rolled the quill between her palms, her gaze inward. "She was still befuddled by the poppy syrup when I questioned her. I cannot believe she'd have had the wit to invent such an elaborate story. If she'd done murder, she'd have burst into tears and confessed."

"And Alan? Is he innocent as well?"

"Scarce innocent." Susanna managed a wry smile. "But his shock at the suggestion seemed genuine."

"Well, then," Nick said, relieved, "I see no sense in stirring up more trouble than we have already. Between his guilt over killing Carter and his loss of Grace, whether through death or to a rival, Simon had reason enough for self-murder, but it is also possible he took a careless step and fell to his death. I prefer the latter explanation."

"Poetic justice?" Lady Glenelg's sardonic tone made Nick scowl.

"If you will. By my authority as a justice of the peace, I mean to let the record show two accidents." He'd have to deal with the coroner on the morrow but anticipated little difficulty in convincing the fellow to see things his way.

Susanna dropped the quill in favor of worrying the ivory handle of her little eating knife. "The vicar may have something to say on the subject if he hears rumors of suicide."

"That is all they will be. Rumors. And to counter them I have Toby, who maintains to all who will listen that Simon would never have taken his own life."

"Rest assured that I will say nothing to contradict him." Lady Glenelg returned the sketch to Susanna, plucked the last grape from the bowl, and rose from the table. "And now I must leave you. I promised to help Gavin hunt for a missing ball. It is his

favorite—small and dyed bright red. I cannot imagine what became of it. No doubt it rolled under something."

When she'd gone, Nick relaxed. He liked Lady Glenelg well enough, but was never quite comfortable in her company.

"Tymberley has left for London," Susanna said.

"What? Before the coroner's inquest?"

Susanna nodded. "Late this afternoon. And good riddance."

"With Carter's body?" That would not please the coroner.

"Both bad smells are gone."

"I'd planned to ride with him to London, after the inquest, although I had not yet informed him of that decision."

"You meant to investigate Tymberley?"

"I thought it wise to know our enemy. I still do. I'll go tomorrow, after the inquest. No one will think it strange if I spend a few days in the city."

If neither Nick nor his mother were in residence in London to keep an eye on things, Nick was in the habit of paying brief visits every few weeks. He had no need to oversee day-by-day operations at the warehouse in Billingsgate, but a businessman who abandoned all decisions to his underlings lived to regret such carelessness.

"Where will you start?" Susanna asked. "We know very little of Tymberley's habits."

"He may have left a path for me to follow. Since he seems to make a practice of ferreting out the secrets of every person he meets, I warrant he asked questions about me after his first visit here in April. If so, he must have given some indication where he could be reached with answers."

"Do you have secrets, Nick?"

"None you are not already aware of."

She frowned at that.

"What?"

"There *are* things you might not want made public." She hesitated. "Your mother's background."

He felt his spine stiffen and forced himself to relax. True enough, he'd been devastated when he first learned that, in her youth, before she married his father, Winifred Marley had been an astrologer's assistant…and his mistress. "That was a long time ago. Embarrassing, but nothing more. What else?"

"The fact that you once worked for John Dee as a spy?"

Startled, he dropped a piece of marchpane he'd been about to taste. "Where did you get that notion?"

"From Walter Pendennis."

"Ah."

"Did Walter lie to me, Nick?"

"Say rather that he misled you." Pendennis had once considered himself Nick's rival for Susanna's affections. And he did not seem to be able to forget that Nick was a merchant rather than a gentleman born, something that had never mattered to Susanna. "For a brief time John Dee and I formed an alliance of sorts. We exchanged information about trade routes to the east."

That had been before Nick came to hold all figure-flingers in contempt. Dee was a prince among astrologers—the one the queen herself consulted to read the stars. But he was still a member of a profession Nick held in low esteem after uncovering his mother's sordid past.

"How long will you stay in London?" Susanna asked.

"A week. No more, although I must admit the idea of absenting myself from Kent until after the queen's visit holds a certain appeal."

As he'd hoped, the comment produced a wry chuckle from Susanna. "I wish I could go with you. Indeed, I wish we could run away together."

"Once I thought to win you by offering to take you to the far corners of the globe. Italy. Muscovy. Persia."

"Perhaps we will go, one day." She regarded him with a wistful smile. "But for now I fear I am obliged to remain here and play host to Her Majesty. There is no escape."

"I will be back before she arrives," he promised. He'd never abandon her to face Elizabeth of England alone.

In twenty days, the queen would arrive at Leigh Abbey. Pray God that in twenty-one she'd continue on her way again, leaving those who lived in this parish just as she'd found them.

28 ～

August 14, 1573

HOLME HALL was as fine a house as many in one of the bigger towns, with six chambers, a hall, two parlors, a kitchen, cellar, stables, and seven other service rooms. One comparable, with a similar garden, had sold for eighty-five pounds in Canterbury the previous year.

Ignoring a faint musty smell, Winifred Baldwin assessed the contents of what Denzil Holme curiously called his "draw-to chamber," a room he used for private conversations. The tiled floor was unremarkable. The tapestry hangings showed a common pastoral scene and evidence of having provided dinner for a family of moths. The room was also furnished with a backed chair padded with green wrought velvet; three joined stools with crimson velvet cushions; andirons, fire shovel, tongs, and bellows for the fireplace; a cupboard bare of plate; a long, shallow chest with no lock—worth no more than thirteen shillings and fourpence if Winifred was any judge—and a pair of pewter candlesticks.

Atop an oval table, Holme had combined a chessboard with the pieces from a game of tables in order to play draughts. Wondering how else he passed his time, Winifred surveyed the room again, this time without regard for the monetary value of the things she saw. A box of lutestrings. Five songbooks. But no lute. Winifred supposed it was elsewhere in the house. She frowned

at a red ball but dismissed the incongruity of its presence the moment she caught sight of an open box of ginger candy.

"Have you brought the betrothal agreement?" Holme slouched into the room with the air of a man cowed by misfortune.

Winifred stuffed a comfit into her mouth and regarded him with a contempt she did not trouble to hide. "By Saint Frideswide, Holme—look at you! 'Tis no wonder you never stood a chance of marrying the Widow Appleton."

"Your son—"

"My son is prepared to wed your daughter." Reaching into the small bag she'd brought with her, Winifred produced the legal document in question.

Acceptable young women of childbearing age were in short supply and this one had the advantage of being near at hand. Besides, Holme had real wealth in the tenements he leased. An average income of one to four pounds per annum apiece, she reckoned, since a garret went for eight shillings a year and a messuage with cellars, solars, outhouses, and gardens garnered six pounds. Nick had similar income-producing properties in London, inherited from his father. He'd know how to set Holme's estate to rights when it came to him. In the fullness of time, he would be the leading landholder in this part of Kent, a very rich man indeed. Winifred took what satisfaction she could from envisioning his future, since she knew for certain she would not live to see her dreams fulfilled.

Holme took the papers but did not look at them. "He has agreed to wed Jeronyma?"

"He has." What was one more little lie? Winifred had so many others, much greater, on her conscience. But of a sudden, she remembered the argument she'd had with Nick on the day before he left for London:

"She's young, unmarried, pretty—what more do you want?"

"Love. Honesty."

Honesty had more than one meaning, Winifred thought now. Had Nick meant Jeronyma Holme was untruthful? Or that she was not a virgin?

"I would speak to your daughter before we sign anything," Winifred said, "to be sure *she* is agreeable."

"She felt unwell this morning. She is resting." Holme looked unwell himself. The papers clutched tight, he shuffled to the chair and used his free hand to support himself as he lowered his bulk.

Winifred debated a moment longer. Some risks were acceptable. Others were not. "Is she with child, Master Holme? If so, there will be no marriage to my son."

"How dare you suggest such a thing!" He was on his feet again in a trice as outrage banished weakness. "My daughter's honor is not in question. Your son is the one who has broken God's laws. You ask me to accept a sinner as a son-in-law!"

"A reformed sinner, I do assure you."

A crafty look came into Holme's gimlet eyes. "But he did sin with Susanna Appleton? You know that for certain?"

"Nick is a man. He took what she offered. A young woman, however, owes it to her future husband to come chaste to the marriage bed." Winifred herself had not, and suspected she'd taken greater enjoyment from being wed as a result of her prior experience. But there were more important matters at stake here than personal pleasure. Property for one. Posterity for another.

"Eve tempted Adam," Holme muttered. "She deserved to be cast out of Paradise."

Winifred lifted an eyebrow and helped herself to another ginger candy. It was as absurd to blame a man for yielding to the temptations of the flesh as to throw a baby out with its bath water, but since she could not gauge Holme's sentiments she kept that thought to herself.

"Will she continue as his mistress?" Eyes that glittered dangerously bored into Winifred's.

She met the stare with defiance. "What does it matter? Your

daughter will be his wife."

Faced with her intransigence, he backed down. For the next hour, they devoted themselves to haggling over the dowry. Winifred came away well satisfied with the terms Holme agreed to…and determined to return at some later time, when Jeronyma's father was not at home, to inspect that young woman at first hand. If she deemed the merchandise worth the price, she would insist Nick accept the bargain.

29 ∾

August 16, 1573

"DISASTER!" Sarah wailed. "I shall be turned out. I know it. Lady Appleton will think this is all my fault."

Mark was fifteen years older than his sister and had always treated her more like a daughter than a sibling. Jennet could tell by his calm demeanor that he assumed some minor incident had provoked Sarah's outburst. He glanced at his wife and said, "Mayhap we should have gone to Saint Cuthburga's this morning instead of hearing prayers in the chapel."

Except for Sarah, who had promised to visit her mother after church, the entire household had taken advantage of the presence at Leigh Abbey of an old friend of Lady Appleton's, the clergyman and scholar Sir Gregory Speake, to worship at home. Speake, on his way to Dover to take ship for France, had been pleased to preside over morning worship in return for a night's lodging.

Jennet, who was mending one of her daughter's shifts, continued to make tiny, even stitches in the linen. "What disaster, Sarah?" she asked.

"Master Holme has been to the churchwardens to lay a charge against Lady Appleton."

At first the enormity of this news did not sink in. Jennet blinked stupidly at Sarah, then glanced at Mark. His rapidly deepening scowl told her she'd heard aright. With great care, Jennet set her mending aside and forced a question past a lump in her throat and lips that suddenly felt parched. "What charge?"

"Fornication."

Jennet's hands flew to her mouth to stifle a cry of distress.

Mark's chair teetered as he left it to come to her side. Jennet could not remember getting to her feet but was glad to find her husband standing beside her, offering one arm for support. She leaned against him, drawing on his warmth, his strength, but there was nothing he could say that could comfort her. They'd both feared this day. No matter how careful any pair of lovers tried to be, they always took the risk that someone would find them out and complain of their immorality to the church courts.

"This is not unexpected," Jennet said in a shaky voice. Indeed, at this moment it seemed to her that it had always been inevitable.

Mark raked a hand through his shaggy, mole-brown hair. Jennet recognized a reflection of her own bewilderment in his eyes. "Why now?" he asked. "Why Holme?"

"To hurt Lady Appleton," Sarah said. "To shame her before the queen."

Beset by a sudden need for swift movement to match her racing thoughts, Jennet began to pace. "The man is mad."

"What happened today?" Mark asked his sister. "And how do you come to know of Master Holme's actions?"

"There is a reason Sarah moved into Leigh Abbey," Jennet interrupted. She had never explained, but Mark had eyes in his head. He had no doubt observed that Sarah had been careful to avoid all contact with Mistress Jeronyma's father.

"Start at the beginning," Mark said, his focus on Sarah. "I see no profit in hearing this tale piecemeal."

"Mother quarreled with the vicar after church," Sarah said.

Mark and Jennet exchanged exasperated looks. There seemed no connection between Sarah's statement and Holme's actions.

"Over the church ale," Sarah elaborated. "Mother talked to Master Baldwin after the coroner's inquest, just before he left for London, and obtained his permission to hold the ale, but he told her she'd also need Master Lonsdale's approval. She thought she'd be better able to convince the vicar to agree if she approached him in public."

"She failed." Jennet was not surprised.

"Aye. He refused even to consider such a thing." A look of puzzlement creased her brow. "Anne called him a dutchman." Anne, Mark and Sarah's sister, was married to Ulich Fuller and had an opinion about everyone.

"One radical in religious matters," Mark translated. "Others call such men puritans."

"You stray from the point," Jennet interrupted. "How does Master Holme come into this?"

"Mother's quarrel with the vicar took place in the churchyard and he was there. After the vicar forbade any celebration of the feast of Saint Cuthburga, Mother said she supposed that next he'd tell the villagers they could not go nutting in the forest on Holy Rood Day. He looked confused, so she added, in a most disrespectful tone, that Holy Rood Day was fourteen September." Sarah grinned, remembering. "The vicar said she did not need a saint to sanction gathering nuts, and that the old saints' days were naught but an excuse for wanton behavior—dancing and games and men dressing up as women."

"And that gave Holme an opening," Mark guessed.

Sarah nodded. "And Mother's husband was beside himself with delight to hear Lady Appleton denounced as an immoral woman. She'll be forced to do public penance, he says."

"Edward Peacock *would* be pleased," Jennet muttered.

At Mark's blank look she started to tell him what the miller had said a few days earlier, then realized repeating Peacock's exact

words would require far too much explanation. She contented herself with a censored account. "It appears he has been brooding this last year and has decided to blame Lady Appleton for Hester's death."

"She did cut Hester open," Mark reminded her.

Jennet hit him. "You great ninny. How else could she have saved the child? And Hester was already beyond help. You do not hear Fulke condemning Lady Appleton for what she did!"

Warding off a second blow, Mark turned again to Sarah. "How far have matters gone with the churchwardens?"

"Master Holme made a disposition. He claims he went for a ride and came upon Lady Appleton, skirts up and making the beast with two backs."

"Impossible!" Jennet could not deny that her mistress and Master Baldwin were lovers, but it was beyond belief that Lady Appleton should disport herself under a hedge like the village whore.

Mark caught Jennet's forearm in a viselike grip, all that prevented her from marching straight into Eastwold to take Holme to task for his lie. Instead, she drew in a deep, calming breath.

"Certes, the churchwardens will take no action. They must know Master Holme has a grudge against his neighbors." The thought eased Jennet's mind.

"What grudge?" Mark asked.

"He thinks Master Baldwin stole Lady Appleton away from him, as if she'd ever have considered him!" Contempt made Jennet's lip curl.

"You are much mistaken about the churchwardens," Sarah said. "They have been infected with the vicar's ranting."

Jennet frowned. There were two churchwardens. One was Ulich Fuller, Grace's uncle and Anne's husband. The other was the carpenter, Goodman Sparke. Her heart sank. It had been Sparke's wife, some eight years past, who had condemned Lady Appleton out of hand when she'd been accused of murder.

"Even if the churchwardens think Master Holme has made a false charge," Mark said, "they are still obliged to act. If they do nothing, Master Holme can have them prosecuted for negligence. Once an accusation is made, they must present the matter at the next archdeacon's court."

Jennet bit her lower lip so hard she drew blood. She did not doubt Mark's assessment of the situation. In his position as steward he dealt with legal issues all the time. Bawdy court, the wits called those sessions the archdeacon held, since most cases seemed to involve the prosecution of fornication or adultery or both.

"A fine time for Master Baldwin to be gone," she muttered as she seized Sarah's arm. "Come with me to Lady Appleton."

"You want *me* to tell her she's to be summoned for fornication?"

"Why not?" Jennet took a petty but very real satisfaction from her sister-in-law's wail of distress. "Be grateful we do not live in ancient days. It was the custom once to kill any messenger who brought bad news."

30 ～

LONDON ON the Sabbath vibrated with the ringing of church bells. A sharp ear could distinguish between them, picking out the tolling of St. Mary-le-Bow in Cheapside from the clang of St. Leonard's. Oblivious to the din, Nick Baldwin made his way on foot toward Philpot Lane.

As a servant, Miles Carter had been invisible, but as a stranger asking questions at Nick's Billingsgate warehouse, his raspy voice and pockmarked face had made him stand out. Nick had

no difficulty finding workers who remembered the fellow. One recalled that Carter had said he could be reached above a certain tanner's premises if anyone had information to sell.

Nick hesitated in front of a three-story house at the corner of Philpot Lane and Little Eastcheap. The shop on the ground floor was closed up tight, this being Sunday. Nick entered through the garden gate instead, looking for an outside stair to the lodgings on the upper level. Instead he encountered an aged female weeding her onion patch.

"And who might you be?" she demanded. "My son is not at home. Come back tomorrow if you've business with him."

"It is Miles Carter's room I seek," Nick told her.

"Master Tymberley's man?"

So Tymberley was the one who lodged with the tanner. "Aye."

"Not here," she said. "I have not seen either of them for at least a fortnight."

This news surprised Nick. Tymberley had left for London ahead of him. He should have arrived by now with Carter's body.

Nick had followed his plan to declare both Carter's death and Simon's accidental. The coroner, Julius Port, had obliged by agreeing that the two men died as the result of falls. That Tymberley had whisked away his servant's body before the coroner could view it had annoyed Port, but he'd been anxious to return to Sittingbourne—he'd been engaged in personal business there when Nick's summons reached him—and had shown little interest in either victim.

Nick had thought it peculiar that Tymberley did not wait until after the inquest to leave Leigh Abbey, but he had not supposed it much mattered. If neither he nor Susanna had found evidence of murder, Port was not likely to notice anything untoward when he examined the cadaver. But if Tymberley had been in a rush to leave for London, why was he not here now?

"What parish is this, Mother?" he asked the crone.

"St. Andrew's Hubbert." Her eyes narrowed in suspicion.

"I regret to inform you that Goodman Carter died this past week."

"No concern of mine." She went back to her weeding.

"I wonder if I might leave a message for Master Tymberley... in his lodgings? I expect he will return when he's made arrangements for his man's burial."

She gave him another sharp look.

"I'd be grateful for your help," Nick said, offering a silver twopenny.

The coin persuaded her to lead the way to two small garret rooms. "Master Tymberley stays here when he's in London."

The chambers were bare save for a simple bedstead with a truckle bed beneath, a table and two stools, and a storage chest. Nick rifled through the clothing it contained. Under the old woman's robin-bright gaze, he conducted a swift but thorough search, even examining the floor for loose boards and the walls for secret hiding places. If Brian Tymberley had ever kept anything in these rooms save spare doublets and hose and changes of linen, he'd taken it away with him long since.

"I see nothing of Carter's." Nick presumed that, as Tymberley's manservant, he'd slept on the truckle bed.

"Doubt he had much." After a leisurely scratch at her nose, she hawked and spat into a convenient corner.

Another half groat had no effect. The old woman knew nothing more of her lodger or his man. For a third twopence piece, however, she agreed to send word when Tymberley returned to his rooms.

A brief stop at the church of St. Andrew's Hubbert proved fruitless. If Tymberley had brought Carter to London to be buried, the interment had not taken place in this parish. He might have been delayed en route, but as Nick had just made the same journey from Kent to London himself, he did not think it likely. If there had been an accident, robbery, or murder along Watling Street, everyone would have been talking about it. The tilt boat

from Gravesend? Not with a cadaver. Private boat hire? That seemed unlikely, too. Tymberley had borrowed a cart from Leigh Abbey to carry the body, which argued for a trip by road.

Nick puzzled over Tymberley's whereabouts all the way back to Billingsgate. That he might have lied about transporting Carter's remains to London made Nick wonder if they'd missed evidence that pointed to murder when they'd examined the body. Had Tymberley feared the coroner would notice something Nick and Susanna had not?

Panic, he supposed, could make a man do odd things. Even take a man's body and disappear with it.

The irony was that Julius Port would have paid no more attention to Carter's corpse than he had to Simon's, not when Nick had been pushing him to rule both deaths accidental. Nick had been determined upon that verdict, regardless of the truth.

He had no regrets about what he'd done. He'd had little choice. He'd not been able to prove murder and a verdict of suicide would have denied Simon burial in the churchyard. The law on self-murder was mercilessly clear. The body had to be buried between the hours of nine and twelve at night and within twenty-four hours of the finding of the coroner's inquest. Superstitious folk also believed interment must be at a crossroads and that a stake should be driven though the heart of the deceased to prevent him from returning from the dead.

Nick had heard of one case in which a sick man was not held responsible for taking his own life because he'd been distraught and lightheaded from an illness at the time and ill looked after by his servants. That precedent, however, would have been no help in Simon's case. Neither would the exception made for suicide "by the instigation of the Devil," a claim difficult to prove.

By the time Nick entered the cavernous warehouse in Thames Street that was the heart of his business, he'd resolved to find out what had become of Miles Carter's remains. Buried in another parish? There were over a hundred in London.

Nick tried to recall his few contacts with Carter while the man was alive. Only one stood out. Nick had been in earshot when the fellow's game leg caused him to trip on a loose cobblestone and bruise his toe. Curses in thieves' cant had spewed out of Carter's mouth.

Nick considered questioning the denizens of the brothels and gaols but he knew any such effort would be as futile as inquiring at every church, and for the same reason. There were too many of them.

Interviewing his workers again seemed a more logical place to begin. One of them might be able to recall some additional detail about Carter and his questions. Since it was Sunday, however, most of the servants and apprentices had the afternoon off. Resigned to a delay, Nick retired to the small, cluttered room where he kept his records, intending to review the accounts kept in his absence.

Only a few minutes passed before he discovered a new puzzle, this one inscribed in a neat italic hand. Nick stared at the words in bewilderment—a record of expenses for passage on the tilt boat from Gravesend to London. Payment had been made to Simon Brackney on the thritieth day of July.

The date jogged a memory. He'd given Simon leave to visit a sick aunt in Dover at the end of last month. He'd been gone four days, long enough to travel to London and back. But why the ruse?

Disturbed by his discovery, Nick found he could not sit still. He prowled the confines of the chamber, then halted before the room's single window to stare out at Billingsgate. The inlet, just east of London Bridge, was a port in its own right where merchant ships from France, the Low Countries, and other more distant places rode at anchor. Nick's view along the river encompassed the Custom House, the Tower of London, and a goodly stretch of the Thames beyond.

Why had Simon come to London from Kent? And who had

authorized the outlay of company funds? The answer was inescapable—someone with the authority to reimburse Simon had sent him into the city.

Nick turned his back on the view, stalked toward his writing table, and pushed aside a hanging pomander ball scented with cloves to retrieve the round money box he kept tucked in beneath a shelf suspended on the wall behind. That it was empty did not unduly surprise him. He replaced the lid with a snap and retrieved the leather-bound ledger. The notation written there had not changed since the last time he'd looked at it.

He supposed Simon might have stolen the contents of the money box as part of his plan to build a new life with Grace, but there had been no coins in his effects. Besides, Nick could think of a simpler and more likely explanation. Simon had been told to empty the container by the same person who'd authorized his reimbursement for the expense of his journey to London. To keep her own past quiet, to pay off Brian Tymberley, *Nick's mother* had dispatched her trusted servant to London with orders to bring back everything in the company money box.

31 ∾

August 17, 1573

SUSANNA COULD feel Jennet's nervousness as a palpable force in the study. Her housekeeper stood before one of the windows, looking out at the long road leading up to Leigh Abbey's gatehouse. The stiff set of her shoulders and the fact that she said nothing revealed her anxiety more plainly than any comment.

"Many such cases are dropped, Jennet. Abandoned ere they come to trial."

Susanna's attempt to reassure her old friend failed miserably.

When Jennet swung around, it was agony, not relief, Susanna saw in her features. "They will make you give him up."

A reluctant smile broke through in spite of Susanna's somber mood. "You've always been convinced my loving Nick was a mistake. You should be pleased by this turn of events."

"He made you happy."

The words *unlike Sir Robert* hung between them, unspoken. Jennet had been with Susanna for many years. She understood better than anyone what it had been like to be Sir Robert Appleton's wife.

A few swift steps brought Susanna to the casement. She caught Jennet's hands. "I have known since the beginning that this day might come." She'd had more than six years to prepare herself. Indeed, since she was determined never to remarry, she had long since acknowledged that she was wrong to keep Nick from having a family of his own. In an odd way, it was almost a relief to have had her hand forced in this way.

"What will happen now?" Jennet asked in a whisper.

Susanna nodded toward the road, where a cloud of dust heralded the approach of visitors. "The churchwardens will come to summon me to appear before the court in a disciplinary case against immorality."

"Go out the back. We'll tell them you've gone away."

"No, Jennet. This must be faced."

Susanna was torn between a desire for Nick's presence to lend support and relief that he was still in London and would not be subjected to the indignity of defending their love for each other. The men rode closer, distinguishable now.

"It may not be so bad," she said, as much to hearten Jennet as to convince herself. "It is possible the matter can be handled in an informal manner. If what the church calls a *compurgation* is ordered, I will be given the opportunity to produce purgators— witnesses to swear in court that they believe the charge against me is unfounded."

Jennet's tension eased, but only a little. "No one should be able to challenge these purgators—how can they, when Master Holme's specific charge is untrue?"

Susanna hoped that would be the case, but she did not wish to burden Jennet with her worries. "If all goes well, my good name will be restored and the case dismissed with naught but an admonition to avoid cause of suspicion in future. Indeed, should I choose to, I could then turn to the church courts myself and ask for an action of defamation to provide redress against Denzil Holme's slander."

Jennet did not look convinced. Susanna took it for a bad sign that she was worrying her lower lip with her teeth.

"If it is the part about avoiding suspicion in the future that troubles you, then be assured that Nick and I are capable of returning to mere friendship between us."

There would be times when she'd wake in the middle of the night missing him, but she was not a green girl driven by passion. She'd simply have to live like a nun from now on, devoting her life to study, content with her herbs and her books. She felt her lips kick up at one corner at the image of herself in a cloistered garden, shut away from the rest of the world, but in other ways the comparison was most apt.

Jennet's hands gripped Susanna's. "Madam, are you certain you can find these purgators you need?"

"They are customarily neighboring gentlewomen and goodwives."

"But you cannot count on Mistress Jeronyma to swear the charge has no merit, not when her father is the one who made it. And Master Baldwin's mother has no reason to help you."

"That still leaves Catherine. And you, Jennet."

She started to add the village goodwives, including Mark's mother, Joan, to the list, then hesitated. *Did* she have their support? After events in Miller Peacock's house, she was no longer quite so certain.

"Let us consider the worst that can happen," she said to Jennet instead. "If the purgators fail to convince the judge, or if there are convincing objections made to their testimony, then I will be found guilty by the church court and made to do public penance. Wear a white sheet. Carry a white rod. Confess my fault in church during Sunday service and ask God for forgiveness. This act of contrition may have to be repeated in the marketplace. On the other hand, the archdeacon can approve a milder form of punishment. Ordinary clothes. Only the vicar and churchwardens present."

Susanna forced a smile. Jennet's skin had taken on an unhealthy pallor during this recital. She worried more on her mistress's behalf than Susanna did for herself.

"It is even possible that the sentence will be commuted into payment of a fine." A hefty fine, no doubt, together with all the fees for court costs.

Relief at last flooded into Jennet's face. "You are wealthy, madam. No doubt the archdeacon will take advantage of that. I've never heard of a churchman yet who missed a chance to bring money into the diocese."

She had a point, but Susanna still hoped it would not come to that. "First I will try to convince the authorities that Master Holme's story is a lie."

"It *is* a lie."

"Aye. It is." But Susanna felt uneasy all the same. If Holme meant to bear false witness against her, why not invent a story more likely to be believed? He could as easily have claimed he'd climbed to her chamber window and seen Nick Baldwin in her bed. She'd have been unable to deny that charge.

The churchwardens at the gatehouse were Ulich Fuller and Gerald Sparke, both men Susanna had known as long as she could remember. "Go down," she instructed Jennet. "Show them into the small parlor. Then send Grace here to me. I will face them fully armored."

Nearly an hour passed before Grace added the heavy, embroidered gown that went over everything else. Then, sweltering in her court dress in the summer heat, Susanna descended to hear the charges against her. The delay had given her ample time to enumerate all the weak points in the conclusions she'd shared with Jennet.

The rustle of brocade alerted the waiting men to her arrival. Hats came off. Fuller's jaw dropped when he saw that she was dressed in formal fashion, a wide farthingale holding out an elaborate skirt, sleeves that were puffed and slashed, even a headdress the like of which was rarely seen in rural Kent. These were the clothes Susanna meant to wear to welcome the queen. They were designed to give her courage. Unfortunately, they were also remarkably uncomfortable. She could scarce breathe for the tight lacing.

"I am told you have something to say to me." She thought about sitting in the Glastonbury chair, then decided to stand behind it rather than let them tower over her. Besides, seating herself while wearing a farthingale was no simple matter.

With much bowing and scraping, and casting of anxious looks at Jennet and Grace, who had accompanied their mistress and now formed an honor guard at her back, Sparke stammered out the charge against her.

Susanna did not bother to affect surprise. Neither man was likely to believe this was the first she'd heard of the events of the previous day. Most of the parish had been in the churchyard to hear Denzil Holme's diatribe.

"Master Holme lied to you." In an involuntary movement, Susanna's hands clasped the smooth, hard wood of the chair as she spoke. The feel of that familiar, ordinary texture calmed her. She forced herself to take slow, deliberate breaths.

Each time one of her visitors stirred the rushes with an uneasy shift of weight from foot to foot, Susanna's sensitive nose caught the scent of bay leaves. That, too, had a calming effect.

After a moment, Goodman Sparke broke the silence. "Whatever we believe, madam, Master Holme has the power to charge us with neglect of our duties if we do not act upon his complaint."

"We do most humbly beg your pardon, madam," Ulich Fuller said.

"I do not fault either of you for doing your duty."

"Aye. Well." Sparke slapped his cap back into place over his bald pate. "'Tis done, then. Good day to you, madam." With a curt nod that encompassed Fuller as well as the three women, he strode out of the small parlor. They could hear the speed of his footfalls increase when he reached the passage beyond.

Fuller made no attempt to follow his companion but his nervousness increased to a marked degree. He glanced at Grace, then away.

"Is there something else you would tell me, blacksmith?" Susanna asked.

"Do you have a message for me, Uncle?" Grace's soft voice trembled.

Fuller's color heightened. Misery etched every feature of his leathery countenance as he cleared his throat and blundered into speech. "I wanted no part of this, madam. You must believe that. But my brother's girl has no one else to look out for her."

"What has Grace to do with Master Holme's accusations?"

"It is the business with Miller Peacock, madam."

Grace inhaled sharply. Jennet shushed her.

"What business is that, Goodman Fuller?" Susanna was afraid she could guess, but felt it important they be clear about the matter. Too much confusion already surrounded her dealings with the Peacocks.

"He blames you for his daughter's death."

Memories flooded in, despite Susanna heartfelt desire to keep them at bay. She'd had nightmares for weeks after Hester died. Only the fact that Jamie Rowley lived and thrived offset what she'd been forced to do to save him. She was no physician. Nor

was she a midwife or a cunning woman. She had simply read widely on a variety of subjects while researching the uses and abuses of herbs. She'd known how to cut a living child from his dead mother's womb.

Recalling Peacock's agonized expression when he'd made his accusation against her face-to-face, Susanna did not feel anger, only pity. He'd behaved like a father fresh bereaved. Ever since that impassioned encounter, she'd racked her brain to understand why, of a sudden, he should have decided she was to blame. Death in childbed was, alas, all too common.

It had been the anniversary of Hester's death, she'd decided, that had unhinged Edward Peacock's mind, causing him to cast about for someone to blame. Not God. That would have been blasphemy. Susanna, in spite of her standing in the community, was a more acceptable target. And she *had* been the one to defile his daughter's still warm body by cutting into it.

"I had hoped Miller Peacock would come to his senses," she told Fuller. "Surely his wife pointed out that the extreme measures I took were the only way to save his grandson's life."

Fuller cleared his throat. "She did, madam. And my wife agrees with her opinion. God's will must always prevail against man's puny efforts, and no amount of railing against fate or casting blame can change the past."

"You are a wise man, blacksmith."

"But Peacock clings to his anger. He bears a powerful grudge against you, Lady Appleton. When Master Holme spoke out, Peacock saw a chance for vengeance and added his voice to the demand that Sparke and I bring you before the archdeacon's court."

"Did the vicar say nothing in Lady Appleton's defense?" Jennet had been silent an uncommon long time and now burst into angry speech. "He is her kinsman! He should have spoken up for her."

Fuller glanced again at Grace. Once more color shot into his

face. "A kinsman does what he can to protect his womenfolk, but once public charges are made, 'tis passing difficult to remove the taint."

"What is it you have not said, Goodman Fuller?" Susanna's gaze sharpened. "You may speak freely here. Both Grace and Jennet are in my confidence."

Fuller's shuffling increased. He kept his gaze on the rushes as he spoke. "When I argued to postpone matters, to let cooler heads prevail, the miller took me aside and swore he'd force me to bring my own late brother's girl before the archdeacon's court if I did not act at once."

"I've done naught wrong!" Grace cried.

Jennet's arm came around the younger woman's shoulders in a protective gesture. Susanna released her grip on the chair and moved closer to the blacksmith.

"Explain yourself, Goodman Fuller. What claim does Miller Peacock make against my tiring maid?"

"He says she seduced his boy. He's sent Alan away to keep him safe."

This revelation produced more agonized wailing on Grace's part.

Safe from what? Susanna wondered. Fuller assumed Peacock meant to shield his son in the event he charged Grace with fornication, since he could scarce name one without accusing the other. But Fuller did not know the reason behind Susanna's visit to the miller's house. No one knew, save Jennet and Grace, Nick and Catherine, and Peacock and his wife, that she'd ever suspected Alan Peacock of murder. She doubted he'd done it and she'd have thought his father would have been convinced of his innocence. Was it possible that, in spite of the decision of the coroner's inquest, the miller still feared his son would be accused—and worse, convicted—of the crime?

"'Tis no sin for betrothed couples to lie together," Grace whispered.

"You are not betrothed," her uncle declared, "and never will be if Edward Peacock has his way. He does not want you wed to his son."

"Mayhap he'll claim you sinned with Simon," Jennet mused, her thoughts having paralleled Susanna's. "Since Simon is no longer able to defend either of you."

This suggestion provoked a new flood of tears. Susanna ignored Grace's unseemly display of emotion and turned to Fuller. "It would be a very proper match, the miller's son and the blacksmith's niece, and everyone in the village knows I give generous dowries to those who have been in my service."

"Aye," Fuller agreed, "but Peacock has other plans." Having said all he meant to, he sidled toward the exit.

"What plans?" Susanna called after him.

Fuller's weathered face contorted into what might have been either a wry smile or a grimace. "He means to wed his son to Mistress Jeronyma Holme."

32 ⌒

THE ROUTE Nick took on Monday led him through the city's garlic market. The pungent smell, undiluted by sweeter scents from a nearby wine wharf, helped clear his head.

He continued on past Queenhithe, hurrying by the cookshops and the stock fishmongers between Timberhithe and the fish wharf until he came to Bread Street. There, just beyond the turn into little Five Foot Lane, was the place described to him.

He studied the stair alongside the compass-maker's shop. The house had been made over into three separate tenements. The ground floor also housed a pulley-maker's shop. The premises

were divided vertically in half so that each merchant could have a parlor and a kitchen behind his place of business and two chambers on the first floor. The third tenant occupied the garret.

Did he want to go up? Nick was not at all sure he wanted his worst suspicions confirmed.

Heart heavy, steps slow, he began to climb. His breath hitched painfully when he saw a crudely painted sign showing stars and planets. The occupant of the top floor made her living as a figure-flinger, casting horoscopes for those foolish enough to believe astrological signs had the power to predict the future.

A client came out just as Nick crested the stairwell, a pretty young lass with golden curls and the cat-after-cream expression of someone who has just received excellent news. He moved aside to let her pass, then reached out to catch her arm. "Your pardon, mistress. Can you tell me if the fortune teller is any good at what she does?"

"Oh, Dame Starkey is a most wondrous fine astrologer, sir." A dimple appeared in her plump cheek as she gave Nick a flirtatious smile. "And 'tis fortunate you are to catch her between clients. Why, there are some days when she sees as many as forty people, one after another."

"She cannot spend much time with any one of them, then." And her name raised even more questions. Starkey sounded far too appropriate for an astrologer. He doubted she'd been born with that surname.

Frowning at Nick's implied criticism, the young woman pulled free. "An ordinary consultation lasts fifteen minutes," she informed him with the superior air of one who has treated herself to many such sessions.

"Indeed? I am most grateful to you for warning me, for I am fearful ignorant of such things. Can you tell me how much I should expect to pay Dame Starkey?"

She softened toward him at once. "Two shillings and sixpence for a glimpse of your future," she said, "but if you have come to

ask her help to find that which has been lost, then she charges by the item."

Hearing the door to the garret creak open, Nick made haste to fabricate a story. "My favorite mare has been stolen. What would I have to pay to discover where she is now?"

"One shilling." The answer came from behind and above.

The young woman giggled and clattered off down the stairs. Nick turned toward the speaker, a stout female of indeterminate age, garbed in a well-worn academic gown and a hood that concealed most of her facial features. Only her mouth was visible. When she opened the door wide and stepped back, she all but disappeared into the shadows of the darkened room beyond.

"Dame Starkey?"

"Come in, Nicholas Baldwin. I have been expecting you."

Had she, now? Nick followed her inside and closed the door behind him. He kept one hand on the knife at his belt as his eyes adjusted to the blackness. The only light in the gloomy interior came from glowing coals in a brazier and the faint beams of a single candle. Black cloth had been hung over the windows in the dormers to block out the sun.

"Did the stars tell you to expect me?" Nick asked in a neutral voice. When she did not answer him, he advanced toward her. "I want to know what you told Brian Tymberley."

"What I told him? Or what I sold him?"

"Spare me your riddles, madam. I know you paid visits to my mother."

There had been several encounters during a period when Nick had been out of England. According to one of his apprentices, Winifred Baldwin had been in a rage after each visit Dame Starkey made to the lodgings above the warehouse in Billingsgate. She'd slammed doors and broken glassware, the latter a circumstance unusual enough to arouse interest among the workers and cause them to remember the incidents even three years later.

The same apprentice had chanced to see Dame Starkey again

in Bread Street and had been curious enough to follow her into Five Foot Lane and discover where she lived. Afterward, the fellow had dismissed her from his thoughts...until Miles Carter appeared on the scene with his questions. Carter's willingness to pay for news of just such odd behavior had led Nick's man to unwise confidences. This morning, cap in hand, he'd confessed his disloyalty and told Nick everything he'd reported to Tymberley's servant.

Dame Starkey settled her bulk in a padded chair. Her hand came to rest on the curved top of a large storage chest. Aside from these, the only furniture in the small room was a long table covered with charts and the instruments for making them. She'd used an irregularly shaped black stone as a paperweight.

"My father before me was an astrologer," Dame Starkey said. "Many years ago he had an assistant, a young woman from the country. I was a small child when she left him."

"I see," Nick said. And he did. This woman was the daughter of the astrologer for whom his mother had once worked.

"After my father died," she continued, "I came upon some papers I thought might interest his former helper."

"You mean you thought you could use them to extort money from her." Disgust laced his words.

Dame Starkey's lip curled in contempt. "She paid me a pittance. She owed me far more. I kept the papers."

The woman's vehemence surprised Nick, since he viewed himself and his mother as the wronged parties, but before he could question her, she recovered her self-control.

"No matter." When he would have spoken, she held up a hand to silence him. "I have cast her horoscope. It will not be long before she reaps what she has sown."

"I've no patience with predictions." Nick removed a sovereign from his purse and placed it on the table. "Tell me what it was you sold to Brian Tymberley."

When Dame Starkey said nothing, he added a second sover-

eign. A slow smile spread over her shadowy features. "He is now in possession of a horoscope drawn up many years ago."

Nick frowned, uncertain how a horoscope that old could pose any threat to his mother. Anyone for whom it had been cast was most likely dead by now. She'd left the astrologer to marry his father forty-six years ago.

"I made an exact copy of what I sold to Master Tymberley." Dame Starkey's sly tone sent prickles of unease up Nick's spine. "I'll sell it to you if you have the price."

Once more, Nick delved into his purse and this time produced five gold coins. Dame Starkey opened the chest. She removed a roll of parchment tied with velvet ribbon and handed it over.

Nick held it close to the candle and uncurled the top third, enough to verify that it was a horoscope. The twelve triangles and signs of the zodiac on the square chart represented the position of the astrological houses, which he knew were supposed to determine what influence the planets had on the subject's appearance, relationships, health, and so forth. Beyond that he could interpret little.

"It seems I am in need of a translator." He reached again for his purse, but Dame Starkey caught his hand in a painful grip.

"It is dangerous to speak of such things and even more foolish to commit such findings to paper."

"At least tell me how this threatens my mother. How can it even be linked to her?"

"Her initials appear on the original," Dame Starkey said. "Winifred Marley, as she was then, served as my father's scryer. She aided him in drawing up this chart."

"Scryer?" A new indignity. Such people had a worse reputation than the figure-flingers themselves. Scryers were for the most part itinerant outcasts with no more ability to read the future or summon spirits than any other vagrant, but they preyed on the hopes and fears of their victims, making up whatever they

thought a body wanted to hear, then vanishing like smoke before they could be accused of cozening anyone. Most scryers were men, literate but lowborn. Many were criminals. All were immoral creatures, trading on the misery of others.

"She had a natural talent," Dame Starkey said. "Or so my father believed. She might have set up as a village cunning woman had she been so inclined. To waste her skills was a crime."

"And from cunning woman to witch is as short a step as from astrologer to necromancer. Is that what you threatened? To accuse her?"

"Foolish man. It is not the fact of the chart but whose chart it is that puts your mother in peril."

Nick looked again at the roll of parchment. There were no recognizable names upon it. "Whose chart is it then?"

She shook her head, as if to reprimand him. "Nay, sir. I will not speak the name aloud, but I will tell you a tale. Once there was a man high in the favor of King Henry the Eighth. He wanted to know how his sister would prosper." She jabbed a finger at the chart. "The horoscope my father drew up predicted she would take many lovers and bear the child of one of them."

"How can such a prediction be a threat to my mother?"

The sound Dame Starkey made had too much cruelty behind it to be called a chuckle. "To dare cast *some* horoscopes is treason."

Nick stared at her. That was only true if the subject of the horoscope had royal blood. Or became queen by marriage. A horrible suspicion came into his mind. "What was this courtier's name?"

Her answer confirmed his worst fears. "George," she said, and laughed again.

There was only one George who fit her description. George Boleyn, Viscount Rochford. His sister Anne had married King Henry VIII. She'd been accused of adultery, with her brother among others, and beheaded.

A horoscope predicting she'd take many lovers was dangerous

enough, but if this parchment did indeed say she'd "bear the child of one of them," then it was a keg of gunpowder waiting to explode. Anne Boleyn had borne but one child. She'd been named Elizabeth.

At present, she occupied the throne of England.

33 ~

SOON AFTER her uncle's departure from Leigh Abbey, Grace Fuller fell into a deep melancholy. She obeyed orders in a listless manner that would have had Jennet tearing her hair out, but Lady Appleton seemed capable of endless patience.

As for Lady Appleton, her mood was thoughtful. She did not speak as she climbed the stair to her chamber, and Jennet, respecting the silence even though she was wild with impatience to know what action they would take, let her mistress contemplate matters uninterrupted while they got her out of her "armor" and dressed her in a loose-bodied gown.

"Let us go into the garden," Lady Appleton said.

Jennet spared a glance at the leaden sky visible through the window but held her tongue. If it rained, they would get wet. Her herb garden brought Lady Appleton a solace no other place could match.

Repressing the dozens of questions that clamored to be asked, Jennet trailed after the other two, scowling when she felt a fine mist on her exposed face. Lady Appleton did not seem to notice the moisture. Nor did Grace. That young woman wandered off when Lady Appleton stopped to pick a flower top. After a few aimless minutes she sank down onto a convenient bench, a morose and unblinking stare her only expression.

By then Lady Appleton's hands were full. "Hyssop," she said,

handing the blossoms to Jennet. "I need to make more of the infusion we use for the catarrh."

Jennet scooped up a pot someone had left lying on its side, her intent to deposit the hyssop inside. The malevolent glare of a toad's unblinking eyes stared back at her from the interior. With a squawk she dropped the flower tops and would have dropped the clay pot as well had Lady Appleton not been close enough to lay hands on it.

"Toads keep the garden free of slugs." With great care, she replaced the container, leaving Jennet to retrieve the scattered hyssop and find a place to store it.

"Toads!" Jennet might grumble under her breath, but she was glad to see a lightening in her mistress's mood.

Lady Appleton smiled to herself as she moved off along the graveled path. By the time Jennet took the flower tops into the house, placed them carefully in a small wicker basket, and returned with a larger basket, just in case Lady Appleton was inclined to gather more herbs, the light rain had been replaced by weak sunlight. The physic garden was silent save for the crunch of shoes on loose stones. Lady Appleton continued to take her exercise. Grace had not moved from the bench. Still carrying the new basket, Jennet fell into step at her mistress's side.

After a moment, Lady Appleton spoke, her words a clear indication that she'd been pondering Master Holme's charge. "Why, I wonder, did Denzil Holme not accuse Nick in his presentment? The wording used against me implies I fornicated with some stranger I met by the side of the road."

Jennet had not noticed the churchwardens' failure to mention a man's name. "Master Baldwin is not summoned to the archdeacon's court?"

"Now that I think about it," Lady Appleton continued, "Holme's claim makes as little sense as Edward Peacock's threat against Grace. To accuse a woman of fornication, one must also identify a man."

"Peacock would not accuse his own son, and even he would not speak ill of the dead, so he'll not name Simon, either." Jennet glanced at Grace to make sure she was out of earshot. "Mayhap Peacock plans to invent another lover for her, as Holme did for you, madam."

Lady Appleton's lip curled into a humorless smile. Sarcasm laced her retort. "Mayhap we shared the same imaginary man. How, I wonder, did such an attractive, seductive fellow go about unnoticed in the parish until now?"

Another little silence fell.

"The explanation, I suppose, is the same in both cases. Denzil Holme wants his daughter to wed Nick. He'll not besmirch the prospective bridegroom's reputation. And Peacock also wants Alan to wed Jeronyma—good reason to keep his name clear of scandal."

"But surely Master Holme would never allow his daughter to marry Alan. Even Miller Peacock must realize that."

"The match is not so uneven as it might seem. Holme is a gentleman now, but only one generation removed from yeoman stock."

Jennet gave a disdainful sniff. "The same might be said of my children, but I do not expect any of them to marry into the gentry. Alan and Mistress Jeronyma? Why that is as absurd as...as my Rob and Mistress Rosamond!"

She winced at the thought. Jennet had never cared for Lady Appleton's foster daughter, but all three Jaffrey children adored her.

"Peacock's aspirations aside, he has good reason to wish me ill. Mayhap he lied to Ulich Fuller, a ploy to push him into doing what Holme wanted."

"Good reason! Madam, he does not—"

"Ah, but he does, Jennet. Let us be honest. Aside from blaming me for Hester's death, he heard me accuse his son of murder. And he doubtless faults me for Alan's illicit union with Grace. As

he should. In a well-run household, servants do not slip out to meet men at midnight."

Jennet took that criticism personally, since the maids were her responsibility, but Lady Appleton did not give her a chance to defend herself. She was too busy assuming more blame.

"Some would say I set a bad example, carrying on with Nick Baldwin."

Unable to refute that argument, Jennet held her tongue.

In an absent-minded fashion, Lady Appleton began to pinch leaves off the hairy stem of a plant that grew just at hand level. Jennet wrinkled her nose at the strong, bitter smell they gave off. Feverfew. It was one of only a dozen or so plants she could manage to keep straight, except when it blossomed. Then she tended to confuse its flowers, with their yellow centers and white petals, with wild field daisies.

"Why did Peacock send Alan away?" Lady Appleton muttered. "I dislike loose ends. We have a dozen bits and pieces, but they refuse to fall into a pattern and I cannot shake the suspicion that I have misunderstood something I've seen or heard. Moreover, there are discrepancies."

"Of what nature, madam?"

"Concerning Simon's death, for one thing. No matter what Nick would like to believe, that fall was not an accident. Someone had to have taken the hatch off the ice house. Either Simon chose a most peculiar manner in which to kill himself, or another person planned his death far enough in advance to set the scene."

"Do you think Alan pushed him through that opening?"

"Either Alan or Grace could have." Lady Appleton slanted a glance in that young woman's direction. Grace had plucked a flower, one Jennet did not recognize, and was slowly denuding it of petals. "Was I too quick to abandon my earlier suspicions?"

With no answer to give, Jennet again remained silent, but her mind was as full of questions as her mistress's. Why had Peacock sent Alan away? And to what place had he gone? She wondered if

Mark's mother knew, and if Joan would betray her husband's confidence to her daughter-in-law if she did.

"I was remiss in not questioning Grace again after Nick ruled Simon's death an accident, but it is not too late to get answers." With a determined stride, Lady Appleton closed the distance to the bench and seated herself at her tiring maid's side.

Jennet followed more slowly and chose to remain on her feet. Like the ground on either side of the gravel path, the wooden seat was quite damp.

Grace's eyes appeared lackluster until Lady Appleton asked if she had any notion where Alan might have been sent. Then they filled with tears. She cried easily, Jennet thought. Too easily.

"He has not sent word of his whereabouts to you?"

"No, madam." She sniffed and made an unsuccessful attempt to wipe away the moisture on her cheeks.

"Let me tell you, then, what replies Alan made when I questioned him about the night Miles Carter died."

Grace listened intently to this version of events, reacting only once during the narration.

"Something troubled you about the lantern Alan saw," Lady Appleton observed.

"I wonder if Alan could have been mistaken about the time?" Grace spoke as if to herself, the words so soft Jennet had to strain to hear them.

"Why is that?" Lady Appleton asked.

"Someone with a lantern was out and about before I went inside. I saw the light bobbing about in this very place."

From the ornamental garden where Grace had been, she could have seen through the passage between the kitchen door and the bake house. Whatever person had been out among the herbs had likely come through the kitchen wing, or in from the dairy or the stable.

"Why did you not tell me this before, Grace?"

"You did not ask me, madam."

"Alan was very certain. He said he saw a lantern near dawn, after staying all night to guard the house."

Jennet frowned. She and Lady Appleton, in discussing the matter after their return from Eastwold, had discounted that part of Alan's story. Neither of them had believed his claim that he'd remained at Leigh Abbey. His reference to Fulke had seemed to them merely a detail selected to give the appearance of truth to his tale. Fulke was always up early. It made sense for Alan to say he'd seen him near the stable at the crack of dawn.

"There may have been a lantern then, madam," Grace said, "but there was also one just past midnight."

"This could be very important, Grace. I believe Carter's death occurred much nearer to midnight than to dawn."

Grace seemed torn between pleasure at Lady Appleton's praise and alarm at her intense interest.

"There are things I did not ask you before, Grace," Lady Appleton continued, "but I think that I must now have all the answers you can supply." She patted Grace's hand, causing the crushed petals to tumble to the ground. "Did you know that Simon had possession of one of your garters?"

"I never gave it to him."

"It is possible the garter came into his possession because he took it from Miles Carter," Lady Appleton said.

At once all trace of bafflement left Grace's face. "You mean Simon killed him? For me?" She sounded pleased.

"He may have. Certes, more happened that night than we know. Alan did not tell me the whole truth, Grace. Nor have you."

The reprimand rendered Grace instantly contrite. She bowed her head. With one hand, she smoothed the edge of her apron.

"Did Alan ever speak to you of Miles Carter?" Lady Appleton asked. "Did he ever meet the fellow before Carter discovered you two in the oak tree?"

"Alan overheard Carter quarreling one evening." Grace slant-

ed her mistress a sly glance that Lady Appleton missed seeing. Jennet did not. "He'd come to Leigh Abbey to meet me and was well hidden. Carter did not know he was there."

"A quarrel? With whom?"

"Fulke Rowley. And now I think on it, it could have been Fulke I saw in this garden with the lantern."

Lady Appleton lifted a skeptical brow. "He'd have been some distance away from you. Difficult to recognize."

"But Fulke had a good reason to want Miles Carter dead. More reason than Alan or Simon did."

Although Jennet saw alarm flash in Lady Appleton's eyes, her voice and demeanor revealed nothing but an admirable patience. "What reason, Grace?"

"Why, to protect Lady Glenelg. Fulke threatened Goodman Carter, madam. Alan heard him."

"When did this quarrel take place, and where?" If Lady Appleton's tone grew sharp, her tiring maid did not seem to notice. She was too eager to exonerate her lover.

"It was during Master Tymberley's second visit to Leigh Abbey, before the construction of the banqueting house began."

"And what, exactly, did Alan hear Fulke say?"

With blithe disregard for the consequences this information might have for Fulke, Grace answered. "He accused Miles Carter of following Lady Glenelg. And he said that if he ever caught him at it again, he'd kill him!"

34 ～

A WHIFF OF violets lingered in Fulke Rowley's cottage. Catherine's scent. Susanna had chosen her time well, however. It was early evening, just after supper. She knew both Catherine and

Jennet were busy with their children. She should be able to question her horsemaster without interference from either of them.

Fulke, however, was not in the front room with his son. Instead, Joyce, the laundress, dandled the boy on her knee. She looked as startled to see Susanna as Susanna was to see her.

"Madam!" She tried to scramble to her feet, but Susanna waved her back.

"Stay, I beg you."

Joyce tightened her grip on Jamie's waist. Thinking this part of the game, the child gave a squeal of delight. He was clearly at ease with the woman and it occurred to Susanna that as a widower with a young son, Fulke likely received visits from all the female staff at Leigh Abbey. She fought a smile.

It faded when, searching for Fulke, her gaze fell on the door to the inner room that served as his bedchamber. She'd been in this cottage many times since the night Hester died, but of a sudden poignant memories stirred. She was catapulted back to that night the previous August, the night of Hester's lying-in.

Joyce had been present. Catherine had, too, but her flowery essence had been overwhelmed by more powerful aromas. To fulfill its role as birthing chamber, the room had been closed up tight. Dark, over-warm, and airless, it had been redolent of sweat and the strong, rank odor of rue. The midwife had urged Hester to drink an infusion of that herb to encourage contractions.

Joan Peacock had also been in attendance on Jamie's birth. She'd placed an eagle stone on Hester's lower abdomen in the belief this would attract the unborn child in the same way a magnet attracts iron. Susanna did not believe in such superstitious nonsense herself, but she made it a practice never to discourage anything that might give a sufferer comfort.

She'd felt out of place in the company gathered around the straining mother-to-be. Even Catherine was more familiar with the needs and rituals of women in childbed than Susanna. Her presence had been unnecessary, save only that she was expected,

as lady of the manor, to put in an appearance. When labor began, the husband customarily sent for the midwife and every other female in the vicinity. Kinswomen and members of the same household were especially welcome, since being surrounded by friendly faces was said to ease the pain.

Susanna supposed company provided a distraction. She had no firsthand experience with childbirth herself and had witnessed only a handful of birthings in her entire lifetime. She'd seen Rob Jaffrey born, but she'd not been present when his two older sisters came into the world. Catherine's children had been born in London. There had not been enough time to send for Susanna in either case. Typical of Catherine, Susanna thought now—she was always in a hurry.

Hester had not been so fortunate. Her labor had been protracted and ultimately fatal.

Those gathered in the birthing chamber had been prepared for death. Most had borne witness to the loss of at least one mother or newborn child, or both at once. Although they'd grieved, Hester's friends and relations had accepted it as God's will when she went into convulsions and then, with horrible abruptness, stopped breathing. They'd assumed that her child, as yet unborn, would die with her.

Susanna had not.

She blinked and the present returned. That child, Jamie, hands trustingly linked with Joyce's, was taking tentative steps toward her across the wooden floor.

Susanna fought an urge to retreat. Small children made her uneasy. Forcing a smile, she held her ground and praised his progress when he came to a halt a foot away from her. He stared at her in sudden consternation, remembering, she supposed, the last time she'd visited him. On that occasion, she'd poked and prodded at his sore ears and made him cry.

"I hoped for a word with Fulke," she said to Joyce.

"He's in the stable, madam. Some problem with Vanguard."

This appeared to be a day for evoking painful memories, Susanna thought as she retraced her steps. Vanguard had belonged to her late husband, a big black courser he'd doted upon. After Robert's death, Susanna had given the horse to Catherine, since the animal had been an unwelcome reminder that Robert had preferred his company to that of his wife. When Catherine returned to Leigh Abbey to live, however, she'd brought the stallion with her, for she was as fond of the animal as Robert had been.

In the stable, the pleasant scent of fresh hay almost obscured the odor of used litter. It was quiet save for the soft murmur of Fulke's voice as he talked to the horse. The grooms, Susanna supposed, had already retired to their room above.

Vanguard sensed her presence before Fulke did and stretched his long neck toward her. The large black eyes had always struck Susanna as looking a bit reproachful, but she shook off the fancy and reached out to pat the white blaze on his forehead, the only part of him that was not the color of midnight.

"The trouble was not serious," Fulke assured her. "He favored one leg, but he's not gone lame. It was only a stone caught in the shoe."

"Vanguard is not the one I came to see."

Fulke released the hoof he'd just examined. If he was nervous about anything, it was not readily apparent. Then again, Fulke had always been a stolid fellow.

"I am hopeful you can add to our knowledge of the events that took place the night Miles Carter was murdered." She had been remiss, she realized, in failing to question him the morning after. She had not talked to the grooms, either, only the house servants. She'd intended to, but her suspicions of Grace had distracted her, and then Simon's death had intervened. Until this latest information came to light, it had not seemed important to pursue her inquiries into the stable.

Fulke did not appear unduly surprised to hear his mistress contradict the official ruling on Carter's death. He picked up a

brush made of hedgehog skin, too rough and sharp to use on Vanguard's already well-groomed coat, and applied it instead, with steady, rhythmic sweeps, to the horse's mane. "You'll have heard I quarreled with the fellow."

"Aye. And that you threatened to kill him."

"I may have. I do not remember the exact words I used. I was passing angry at the time." His hand clenched on the brush, then relaxed.

"You accused him of following Catherine."

"And so he was. She thought someone was watching her. That made me uneasy. Carter trailed after her from the house to my cottage, careful to keep out of her sight."

"You feared for her safety?"

"I did not want her troubled."

"Some would say the way to prevent that is not to be alone with her."

"There is no harm in her visits, but no reason to call attention to them, either." After a moment, he added, "And she always insists she's come to see Jamie."

Fulke had proven his loyalty to Susanna over and over. He was an honorable man, and he had ever been protective of Catherine. But he was, Susanna realized, only a year or two older than that young woman. Hester had been five years Catherine's junior.

"You are concerned for Catherine's reputation," she said. "So am I."

"I worry about her. She is stubbornly loyal. I could not live with myself if she put young Gavin's future in jeopardy simply to spend time with me and mine."

"And you thought Carter might spread rumors about her behavior."

"Aye. I warned him off." Fulke turned to face her, his gaze direct. "I did not kill him, Lady Appleton, but I felt no remorse when the fellow turned up dead. He was vermin and his master is not much better."

"Did you know Catherine paid Master Tymberley fifty gold angels to keep him sweet?"

Fulke leaned his forehead against Vanguard's flank, having shifted his attentions with the brush to the animal's tail. "Aye. She told me after. I fear she has accomplished naught by it but encouraging him to demand more."

"Tymberley will be stopped. But not by murder." Susanna closed the distance between them. One hand came to rest on the rough dagswain blanket thrown over the side of Vanguard's stall. It put her in mind of the one Grace and Alan must have taken with them to the banqueting house and made her wonder what had happened to it. Had Alan had the presence of mind to remove it? Or had Simon taken it away with him? Or had there been someone else in the tree that night?

"I must ask you about the night Carter died. Were you anywhere near the oak?"

"No, madam. Nor do I know why he went there."

"It seems Carter made a practice of demanding favors from serving women. He had an unfortunate encounter with one of them shortly before he fell to his death. She was on her way back to the house, around midnight, when she saw a light moving in my physic garden. She says you were the one carrying it."

"I was out that night, but not near the oak and not in your garden, madam. Still, I know who it was she might have seen. Master Tymberley passed through the kitchen yard shortly after the rain stopped that night. A trip to the common privy, I presumed. But he had a lantern, and there would have been nothing to stop him from walking wherever he chose after he relieved himself."

"But you did not see him in the garden?"

"No."

"Why did you not mention this before?"

"I did not know it signified." Fulke sent an aggrieved look her way. "Madam, Carter's death was adjudged an accident and what little I heard about it, being busy with my own concerns at home

and in the stable, I believed he died in a fall not long before you found his body. Nearer dawn than the middle of the night."

"As everyone was intended to think," Susanna admitted. "But how is it you were up at midnight?"

"One of the horses suffered from bots." Fulke indicated a dun-colored double-backed gelding—a horse with the broad back essential for a sidesaddle such as Susanna used. "The first day we treated him with a quart of new milk with half a pint of honey in it, to keep the worms quiet. The second day I gave a drench—a quarter pound of fern seed, a half pound of savin, a half pound of stonecrop, two spoonfuls of brimstone, and two of chimney soot, steeped in a quart of strong ale for two hours and then strained. The treatment on the third day, the one before Carter's body was found, required the closest supervision—six purging pills, given three in the morning and three at night."

"Of what composition?" The herbalist in Susanna was curious, though she no longer doubted that Fulke had been too busy in the stable to murder Miles Carter.

"A pound of lard; three ounces each of liquorice, aniseed, and fenugreek; two ounces of aloes, and one ounce of agaric."

"How do you convince the horse to swallow one of these pills?" They'd be huge, she imagined.

Fulke grinned. "I catch hold of his tongue and hold it fast while I hurl one in and thrust it down his throat with a rolling pin. Three days of feeding on naught but mashes and warm water complete the cure."

"This treatment kills the bots?"

"Oh, no, madam. Nothing kills worms, bots, or truncheons. But it makes the horse's belly such an unpleasant place to live that they do flee it."

Thinking she now knew more than she cared to about nursing horses, and glad she only ministered to people, Susanna was about to resume questioning Fulke when he volunteered part of the information she was after.

"I was in and out of the stable all night. I did not bother with a lantern, since the moon was at the full. Once the rain ended and the clouds vanished, I had all the light I needed to find my way."

"Can anyone verify your whereabouts?"

"One or the other of the grooms was with me most of the time," Fulke said. "Do you want to question them?" He gestured toward the saddle room, which adjoined the stable and led to the stair that gave access to lodgings above.

Susanna saw no need to trouble the grooms, but before she could say so, the clatter of hooves on the cobblestones heralded a late arrival in the stable yard.

Unconcerned, Fulke crossed to the oat-bin, unlocking it and reaching inside for a handful to feed Vanguard as a treat. Susanna stayed where she was, and was glad she had when Brian Tymberley entered the stable.

"Well met, Goodman Rowley." Tymberley did not notice Susanna in the shadows by Vanguard's stall.

"Have you come to return the cart, Master Tymberley?" Fulke removed the key from the bin's lock and pocketed it. His free hand clenched into a fist around Vanguard's oats.

"Aye, and your bottel horse, too."

The contempt in Tymberley's tone was for the nag loaned to him to pull the cart. Susanna had been told he'd tied his bay behind and dispensed with a driver, the better to depart swiftly with Carter's body.

"See to my mount," Tymberley ordered. A sneer distorted his features. "And when you next see Lady Glenelg, tell her I expect another payment by tomorrow night."

He laughed and left the stable.

Only Susanna's tight grasp on her horsemaster's arm prevented Fulke from going after the queen's man. She shared his desire to thrash the villain to within an inch of his life, but this was not the time for rash actions.

35 ∽

August 18, 1573

A MAIDSERVANT showed Brian Tymberley into the parlor at Whitethorn Manor and left him there with her mistress.

"Well?" Winifred Baldwin demanded. "Have you brought what you promised me?"

Tymberley scowled. "You will receive it after you have paid for it. And the price, I fear, has gone up. I have incurred…unexpected costs."

She lifted an eyebrow at that. "It is scarce my fault that your errand boy fell out of a tree. I had the coins ready." She waited a beat, then added, "I will not buy a pig in a poke."

"You have seen the goods already."

Under Winifred's steady stare, he wilted like a beanstalk in a drought. He fiddled with his ruff, twisted one of his rings, avoided looking at her direct. Her eyes narrowed. Was it possible he no longer had the document?

For the first time, she wondered if Miles Carter's death might have brought an unexpected benefit. If Tymberley's man had been up to something at the time of his death, if he'd had possession of the evidence then…what? She frowned. If only she'd been there, at that oak tree. The roll of parchment could not have been on his person, else it would have been found, but he might have hidden it somewhere, or it might have been removed by some unknown party after his death.

The sound of Tymberley clearing his throat reclaimed her attention.

"Your man killed mine, madam. I deserve recompense."

"Your man apparently threatened the woman mine intended to marry. If Simon ended his worthless life, that has naught to do with me."

"Do you wish your sordid history made public, then? And the real reason your man was at the banqueting house that night?"

"If you do not have the proof, you can scarce reveal anything." She almost smiled at Tymberley's growing frustration. With any luck at all, that damning horoscope had been tossed away as worthless. To the unenlightened, it would have seemed naught but gibberish. A frugal finder might have scraped the ink off the parchment to reuse it. Either way, the danger it represented to Winifred would no longer exist.

"You take a very great risk, madam."

The malice in his expression would have frightened most people, but Winifred did not fear anything. Not anymore. "What is your price?" she asked, more out of curiosity than because she intended to pay it.

"Five hundred pounds."

"On your word to deliver a document you cannot prove is in your possession? You may expect payment, Master Tymberley, when the virgin St. Frideswide marries."

And with that, she ordered him thrown out of her house.

36 ～

WHEN CATHERINE first saw Susanna approaching, she felt naught but pleasure. It was a perfect afternoon now that she had all her favorite people with her. She and Fulke, together with the three children, Avise, and an assortment of cats and dogs, had gathered behind Fulke's cottage to dine. They sat on quilts spread on the ground, an assortment of foodstuffs around them. She'd organized the meal on the spur of the moment, prompted by her knowledge that Brian Tymberley had returned to Leigh Abbey. She had no desire to spoil her appetite by sharing dinner with him.

She'd successfully avoided Tymberley all morning. She'd

watched him ride off with a sense of relief, but she was unwilling to trust him not to come back and spoil her day. Both Fulke and Avise had been forbidden to speak his name.

As Susanna came closer, Catherine's spirits sank. She could tell by the expression on the other woman's face that something was amiss. More trouble with Denzil Holme? It still infuriated Catherine that the churchwardens had taken his word against Susanna's. She'd already pledged to act as a purgator.

"Avise, engage the children in a game of catch," Catherine ordered.

Gavin balked at first, until Avise produced a sweetmeat to lure him.

Once they were out of earshot, Susanna admitted she had a serious matter to discuss. Catherine listened in ever-increasing indignation, outraged when she heard of the demand for money Tymberley had made the previous evening.

"I asked Fulke not to relay that message," Susanna said. "I wanted time to plan what to do."

"You are not to pay him one penny more," Fulke said in the most forceful tone Catherine had ever heard him use with her.

"I must."

"No. What you must do is bring charges against him. You have done nothing wrong, Catherine." Susanna had a determined glint in her eyes.

"And you did not lie with some stranger in a ditch but that has not stopped Denzil Holme from ruining your good name."

"He has ruined nothing, as you will see when we go before the archdeacon."

"I cannot take the risk Tymberley will make good on his threat. Not when my children's future is at stake."

"Better to use the money to make the queen sweet. As for Tymberley, given what I learned from Fulke last night, it may be possible to counter his threats with one of our own." She turned to Fulke. "You told me Tymberley was out that night, after Carter

was last seen alive. What more satisfying conclusion than that he killed his own man?"

Eager to embrace this theory, Catherine leaned forward. "And if Simon witnessed the crime, why then, there's reason for Tymberley to have killed him, too."

But Susanna shook her head. "If Simon was a witness, he'd have told Nick. And we have discovered no reason why either Simon or Carter should have gone to the banqueting house that night. We have enough for a threat, but as yet we lack the small but important details necessary to prove guilt in a court of law."

A bright blue ball landed on the quilt. "A missing piece," Catherine murmured, "like Gavin's ball."

The little boy plopped himself down in front of her and grabbed for the toy. "Throw, Mama?" He offered it to her with a winsome smile.

Catherine laughed and gathered her son close.

"A missing ball?" Susanna sounded confused. "This ball?"

"No. The one we cannot find is smaller than this one, half the size of a tennis ball, and stuffed with wool and covered in leather that has been dyed bright red. It disappeared a few days ago. It was his favorite." She would have to buy him another red ball the next time she was in Canterbury.

"Small enough to slip into a pocket."

The odd note in Susanna's voice arrested Catherine's attention even as she nodded. She set Gavin upright, handed him the blue ball, and sent him back to his sister with a gentle pat on the bottom.

"Do you recall when you first missed this red ball?" Susanna asked.

"It was the same day Tymberley left for London. Remember? I supped with you and Nick Baldwin and left early to help Gavin hunt for it."

"If memory serves, that was also the day Jeronyma Holme paid you a visit. Well, there's one small mystery solved." Her lips

twitched into a small, ironic smile. "I must take what joy I can from it."

Catherine's mouth dropped. "Never say you think Jeronyma stole my son's toy. What on earth would she want with it?"

Susanna made herself more comfortable on the quilt. "That is a long and complex story. Let me share your dinner and I will tell it."

"Gladly," said Catherine, and reached for the platter of cold meats.

37 ～

DETERMINED to discover what the horoscope he'd bought from Dame Starkey contained, Nick Baldwin arrived at Mortlake, eight miles west of London, just at dusk. He'd wasted most of the day in another futile search for Brian Tymberley. The fellow had not returned to his rooms in Philpot Lane. Nick had begun to wonder if he'd ever come to London at all.

The house Nick sought was situated opposite a small church and next to an asparagus field, one of a cluster of dwellings along the Thames towpath. He'd been there before but it seemed to have grown since his last visit into a ramshackle collection of buildings linked together by a series of passages.

John Dee, the astrologer, a tall, thin man who wore his long beard trimmed to a point, was at home. When Nick told him he'd come to ask for help with a delicate matter, Dee led him along a winding corridor impregnated with chemical smells to his private study, a well-appointed room boasting a fireplace and a solid pair of double doors to keep out both noxious odors and extraneous sound. The last rays of the setting sun poured through a large, west-facing window.

"These days I earn my keep offering services as varied as

tuition, astrological readings, dream interpretation, medical consultations, and forensic advice," Dee said with a cynical smile. "All at set fees."

From the hidden pocket in the lining of his doublet, Nick produced the horoscope. "I need this translated."

When they'd agreed on a price, Dee took the rolled parchment to his desk and studied it for some time, pausing to consult several books before giving an opinion. "This horoscope is a mixture of nonsense and real astrology. I practice mathematical-based astrology, not this foolish sort of divination."

"But you can interpret it?"

"The two luminaries are in opposition, a common configuration. Jupiter basks with the Sun in the serene and warm sign of Cancer." He pointed to a passage in Greek in one of his reference books. "Jupiter's distance from the sign rising on the eastern horizon indicates this person will be skilled in science. 'If he would be lord alone,' Claudius Ptolemy writes, 'Jupiter would also promote honor, happiness, content, and peace.' Unfortunately, Jupiter is not lord alone. Here he is threatened by Mars, compromising his benign influence. There are other disturbing signs, as well. The star Antares is present. It has an influence similar to that of Mars." Dee shook his head, visibly disturbed. "I see mischief and destruction."

"Do you see treason?"

Dee's response was reassuring in its promptness. "No. Why did you think I would?"

"I was told...it was implied this was the horoscope of a queen."

Dee appeared to find this amusing. "It is illegal to publish fond, fantastical, or false prophesy, or foretell bloodshed or war on the basis of coats of arms or weather. To draw up the horoscope of a monarch is also illegal, unless that monarch is the one who commissioned it. It is considered a form of spying through magical surveillance."

"Is a queen consort considered a monarch?" Nick had surmised, from what Dame Starkey had told him, that at some point between 1523 and 1527, when his mother had worked as an astrologer's assistant, George Boleyn had commissioned a horoscope for his sister. That Anne Boleyn had later married King Henry had been enough to turn George's act into treason.

It had puzzled Nick all along that Dame Starkey should have put herself at risk by keeping such a dangerous document, especially if it contained, as she claimed, a prediction that its subject would take many lovers and have a child by one of them. Even the suggestion that King Henry might not have been Elizabeth Tudor's father was unquestionably treason.

"This is not the horoscope of a queen of either sort," John Dee said.

Nick did not doubt his word. He'd not have asked Dee to interpret the horoscope if he had not trusted him. It contained, or so he'd believed, information damning enough to allow Brian Tymberley to demand blackmail from Winifred Baldwin.

"This is the nativity," Dee continued, "of a woman born in London in the year 1525. An astrologer's daughter, by what I see here." He tapped the parchment.

Nick eased himself into a chair and stared at the document spread open on Dee's desk. "Why would Dame Starkey give me her own horoscope?" And what had she sold to Tymberley? She'd claimed this was a copy, but what if there were two different horoscopes? Did Tymberley have Anne Boleyn's? Or was the very existence of such a thing a fabrication?

"I have been cozened," he muttered, unsure how or why, but certain Dame Starkey had set out to deceive him.

Nick doubted Tymberley understood the arcane symbols any better than he did. So what did he believe he had? And what did he *really* have? Winifred Baldwin had sent Simon to London for gold. That seemed to prove she meant to meet Tymberley's de-

mands. But why? With what had he threatened her? Nick shot a sharp look at Dee, who was watching him intently.

"Tell me all you can discern about the woman for whom this horoscope was cast." There must be more in the document. "Does it give her real name?"

"It does not record any names, but her birth date and those of both her father and her mother are here." Dee rattled them off.

Nick recognized one of them. Stunned, he considered the implications. Throat dry, heart racing, he remembered how careful Dame Starkey had been not to let him get a good look at her face. Still, he'd seen the general shape and height of her. He'd listened to her voice, watched her lips.

With appalling clarity, he saw the truth. Dame Starkey was his half sister, the illegitimate child of his mother and the third-rate figure flinger who'd kept her as his mistress until she met and married Nick's father.

Nick swallowed hard as another possibility occurred to him. "Can you tell if this woman's parents were legally married?"

Dee jabbed one long finger into the parchment. "See these symbols?"

Nick nodded.

Dee's explanation was long and complex, but the first few words were sufficient to confirm Nick's worst fear. The subject of the horoscope had been born in wedlock. Since there was no provision for divorce in the New Religion, and Nick knew the astrologer had still been alive two years later when Winifred wed Nick's father, that meant the second marriage had been bigamous.

It was Nick who was illegitimate.

38 ～

August 19, 1573

WINIFRED had promised herself she would return to Holme Hall in order to inspect her son's prospective bride. She'd studied the young woman in church but had never exchanged more than a few words with her at one time. On the day after she sent Tymberley packing, she decided to remedy that. After all, Nick would soon be returning to Whitethorn Manor. She wanted this matter of his marriage settled by the time she saw him again.

"My father has gone to Sandwich on business," Jeronyma told her when Winifred insisted upon being shown into that young woman's chamber.

"So your servants told mine. That is why I came today." Since Holme was not expected to return until the morrow, he could not interfere in her interrogation of his daughter.

Winifred gave the room a cursory survey, but the buk of her attention remained on Jeronyma. She was a pretty thing and yet, close up, she had a certain vacuous look. A wife should be biddable, Winifred told herself, but she found little reassurance in the thought.

"Are you a virgin?"

Jeronyma blushed prettily at the blunt question and assured Winifred that she was.

"Excellent."

Before they could proceed to other matters, a maidservant poked her head around the edge of the door. "New-come visitors, Mistress Jeronyma. I have put Lady Glenelg and Lady Appleton in the master's draw-to chamber."

Jeronyma clapped her hands in delight. "More company! Oh, wonderful. Let us all have wine and cakes."

"By St. Frideswide's girdle," Winifred swore. "What can they want?" Absently, she rubbed her side. The pain was getting worse. Spreading. Soon she would have to increase the doses of laudanum.

"I must ask them in to discover their purpose, madam," Jeronyma said.

"But Master Holme forbade you to consort with Lady Appleton," her maid whispered, plainly horrified that her mistress meant to disobey a father's edict.

Winifred cast a considering gaze upon her hand-picked future daughter-in-law. Was she as witless as she seemed? Or just devious?

"Father is not here," Jeronyma observed with a bright smile.

"No doubt that is the only reason Lady Appleton dares pay this visit." Winifred was not surprised by the fact that Leigh Abbey servants were as efficient at gathering information as her own. "As it happens, however, I do not wish to consort with Lady Appleton any more than your father does."

"I cannot send Lady Glenelg away. Father said he wished me to pursue my acquaintance with her." Jeronyma lowered her voice to a conspiratorial whisper. "She is a noblewoman."

"Very well, then. Tell me where I may wait, out of sight, until these unexpected callers have gone away again."

Jeronyma's vapid features creased into a frown. "I can go down to them and leave you here, but—"

"Do so, then. At once."

But Jeronyma had dithered too long. Footsteps from beyond the door warned Winifred that the two women were already above stairs. With a speed that belied her age and infirmity, Winifred retreated through a convenient curtain, hoping to conceal herself in the adjoining room.

What a confounded nuisance, she thought. But she took advantage of the opportunity to examine Jeronyma's bedchamber. It was a pleasant room containing a bedstead, a wardrobe chest, a small chair with a wide seat, and a table. A pierced wooden screen concealed the close stool.

Moving quietly, Winifred plucked up the chair, placed it closer to the doorway, and settled in to listen to the conversation in the next room.

Catherine Glenelg's pleasant voice reached her first, but there was an edge to her tone. "How did this come to be in your father's house, Jeronyma?"

Winifred leaned forward until she had one eye aligned with the narrow gap between curtain and doorframe. "This" was the red ball she'd noticed on her last visit to Holme Hall.

"You stole this from Leigh Abbey, Mistress Jeronyma," Catherine continued, answering her own question.

"It is proof you take things that do not belong to you," said Susanna Appleton. "You have stolen a great many items over the years, not the least of them the queen's ring, which Jennet Jaffrey returned to Her Majesty at great risk to her own good name."

Jeronyma offered neither denial nor protest.

Winifred felt a new pain rip through her as she drew back from the peephole. So that was what Nick had meant about honesty. He'd had the right of it. The woman she'd hand-picked for him would not do at all.

"You paid Brian Tymberley for his silence." Lady Appleton's voice gentled as she went on. "Has he made new demands?"

"He knows I have no money left." Jeronyma replied in such low tones that Winifred almost missed what she said.

"You paid him more than once, then? First at court and again since you've been here in Kent?"

Jeronyma must have nodded because Lady Appleton went on with the interrogation. As more details emerged, Winifred's opinion was confirmed. Jeronyma would not do, not for Nick. A pity, but there it was.

"Did you take anything else from Leigh Abbey the day you stole my son's ball?"

An ominous silence followed Catherine Glenelg's question. It stretched out until Winifred felt compelled to lean forward once more and tweak the curtain aside. Jeronyma sat slumped on a stool, her face buried in her hands. Her muffled words scarce carried into the inner room.

"I took a paper."

"What kind of paper?" Lady Appleton asked.

"Whose was it?"

Jeronyma answered Lady Glenelg first. "It belonged to Master Tymberley. I took it from his chamber."

"Why on earth did you go into his room?" Lady Glenelg stood, hands on her hips, shaking her head in disbelief as she stared down at the distressed gentlewoman's bent head. "You claimed you wanted nothing more than to stay out of his sight," she said.

"It was a mistake." Jeronyma sounded close to tears. "I meant to hide in the linen room. I did later."

Lady Glenelg and Lady Appleton exchanged a skeptical look. "And how long did it take you to realize you were in Master Tymberley's chamber instead of the one next to it?"

After a quick peep out from between her fingers, Jeronyma answered. "There was a wooden box by the bed. When I opened it, I saw it contained a ring I'd seen Master Tymberley wear. And other things, including a roll of parchment."

Winifred's interest quickened.

Lady Appleton knelt beside Jeronyma's stool and lifted the young woman's chin with her fingers. Her voice was all sympathy now. "Why take the paper and not the jewelry?"

"I do not know."

"What did this parchment contain?" Lady Glenelg asked. "Mayhap it relates to Tymberley's demands for blackmail."

"I could not read it," Jeronyma told them. "It was written in strange symbols."

With as much stealth as she could manage, Winifred rose from her chair and began a rapid search of Jeronyma's bedchamber. She heard the murmur of voices continue in the other room but caught only part of the conversation.

Lady Glenelg made an exasperated sound.

Lady Appleton said, "Remember what Sarah told Jennet. This

is ever the way of it—she loses interest in an object as soon as she takes it."

Lady Glenelg's voice sounded much closer to the door to the inner room. "We must search for it. It might prove to be something we can use to stop Tymberley."

Just as a hand appeared, grasping the edge of the curtain, Winifred caught sight of the horoscope. Jeronyma had carelessly dropped it on the small table next to a collection of perfume bottles, paint pots, and boxes of face powder. Taking it with her, Winifred ducked behind the screen.

It was indeed the document Tymberley had shown her when he made his first demand for money. Overconfident fool! Had he imagined his possessions so safe at Leigh Abbey? If she'd guessed he'd be so careless, she'd have searched his chamber for the document and stolen it herself.

The three women now entered Jeronyma's bedchamber. Before they could discover her on their own, Winifred tucked the horoscope into her garter and emerged from concealment, ostentatiously adjusting her skirts. She fixed Jeronyma with a look of contempt. "Your maidservant, mistress, makes a poor job of scrubbing the chamber pot."

Jeronyma's response was a nervous giggle. Lady Glenelg and Lady Appleton looked taken aback, but neither said a word.

"See me to my horse, Jeronyma," Winifred demanded. "Then you may return to your other guests." She swept out, assuming the young woman would follow.

In the stableyard, while they waited for a groom to bring out Winifred's little black mare, she delayed only long enough to assure herself there were no intrusive eyes or ears about before she gripped Jeronyma by the shoulders. "Listen well, girl. You will repeat nothing of what passed between us today. Do you understand me?"

"Yes, madam. I understand very well." Defiance glinted in Jeronyma's eyes but her tone was mild as milk.

"Excellent. Now let us settle this business of your marriage to my son."

Color drained from Jeronyma's already pale face. "I have no wish to marry—"

Winifred cut her off in mid-sentence. "He does not want to marry you, either." With what she considered admirable restraint, Winifred refrained from elaborating. "There will be no betrothal."

Jeronyma looked relieved.

Winifred glanced back at Holme Hall as she rode away. She had come close to making a ghastly mistake. She'd been so eager to find a young virgin to bear Nick sons that she'd almost matched him with a thief.

Still, this was not the outcome she had hoped for. Where was she to find a replacement bride before time ran out?

The answer came to her as she pondered the double-edged definition of an honest woman. There was one possibility left. The more she thought about it, the better she liked the idea.

Resolved to broach the subject with Nick as soon as he returned from London, Winifred urged her horse to a faster pace. A widow of childbearing age would do just as well as a virgin. And Nick could not possibly object to her choice this time.

Perfect. She chortled to herself. Catherine Glenelg was the perfect wife for him.

39 ~

NICK BALDWIN bypassed Rochester, where he was accustomed to stop for the night on the two-day journey from London to Whitethorn Manor, and pushed on to Sittingbourne, eight miles closer to Canterbury along Watling Street. He knew he was close to the place when he saw the sign pointing the way to the

Isle of Sheppey. The marshes of the Swale also lay to the east. Ahead, after a profusion of cedars, yews, and giant elms, were cherry orchards extensive enough to make the area famous.

At the inn, as he'd hoped, he found Julius Port. The last time they'd talked, in Eastwold, the coroner had told Nick all about the cousin's estate he had to settle as executor. He'd expected to spend at least another week in this little town.

Port made Nick welcome, even offering to share his private parlor. As the two men supped, the coroner broached the subject of Brian Tymberley. "Did you find the fellow, then? A bad business, him running off with the corpse before my inquest."

"No luck, I fear. More peculiar still, I was unable to discover what became of Carter's body."

"Must be buried somewhere," Port said with a laugh. His expression sobered as Nick recounted his efforts to learn more about both Carter and his master.

"A raspy voice, you say? That can happen when a man is hanged." At Nick's startled look, he chuckled. "Well you might wonder how that can be. But some survive it. I met one such. The rope broke, see you, and down he tumbled, still breathing. Left a scar about the throat, and permanent damage to his voice, but for all that he was alive and well. It was years afterward that he crossed my path."

"They did not, I suppose, see fit to hang him twice for the same crime." It seemed a tricky point of law, but when a man could be sentenced to death for stealing a shilling's worth of meat, juries tended to be lenient.

"I do not recall that I ever heard what charge led to his conviction, only that he was a very young man at the time."

"How did you come to meet this fellow?" Nick's question was prompted more by polite conversation than avid curiosity.

"We shared an inn chamber. In London, it was. I must admit I thought him a braggart, but I did believe his story. Took him at his word that he'd seen the error of his ways, too—until the next day

when I woke to find my purse gone and the ring stolen right off my finger."

The glimmer of an idea in his mind, Nick asked if this villain had a name.

"Said he was called Jack Hardwick, but no doubt that was a false identity. I looked for him after. Never found a trace of him."

"Would you have recognized him again, even years later?"

Port thought about it. "I'd remember that voice."

"And his face?"

"Why, I suppose I would. As I recall it was much pock-marked." At Nick's sudden tension, Port paused in the act of lifting the cup to his lips and his eyes narrowed. "Never say you think it possible this was the same man?"

"Miles Carter died of a broken neck, so I'd not have noticed any old scarring, and it could explain why Tymberley absconded with the body. He dared not take the chance you'd recognize the dead man. He'd not want to risk having his name linked with that of a known thief."

In Nick's mind the connection was as clear as if he'd drawn a diagram on the table linen in front of him. Tymberley could have met "Jack Hardwick" the same way Port had, but if Tymberley had caught the fellow robbing him he'd have offered him employment.

Nick gave Julius Port an edited version of Tymberley's recent activities. "Work for me or go straight to gaol: That's how he'd have argued. Tymberley acquired the use of the fellow's illicit talents. Hardwick, as Carter, gained protection of a sort from the law and a roof over his head."

But Port was frowning. "All that may be true, but why should this Tymberley think I'd recognize his man as Jack Hardwick?"

"Because Carter must have seen you or heard your name and warned him that you could. Think, man. In your travels in the last few months were you near any of the other houses Tymberley inspected in advance of the queen's progress? If Carter caught

sight of you, he'd take care to stay out of your way, and he might well have taken the added precaution of informing his master of the danger."

Port gnawed thoughtfully on the chicken leg. "I did hear rumors of queen's men in the area. When was it? Early summer? With so many little trips for these inquests, the journeys all run together after a time." He licked each finger clean, shook his head at the futility of proving anything without a body, and turned the conversation to other matters.

Nick let the subject drop, but he was convinced he'd stumbled onto the truth. It had been just after he'd mentioned Port's name to Tymberley that Tymberley decided to take his man's body to London for burial. He'd set out in a borrowed cart. Somewhere along the London road, he'd vanished. Or turned off.

Nick spent a restless night resisting the urge to get out of bed and make lists, as Susanna was wont to do. He tallied up the facts in his head instead. By morning, he thought he knew what had happened.

After bidding Port farewell, Nick left Sittingbourne and set out along the road to Canterbury, but when he came to a particular crossroads he stopped, once again considering his choices. His arrival at Whitethorn Manor would be delayed by at least a day if he went first to Hothfield, where the queen and her retinue were scheduled to stop for the night. On the other hand, he did not mind putting off the inevitable confrontation with his mother.

His decision made, he left Watling Street and took the first of a series of narrow lanes. Before he returned home, he would have the answer to at least one of his questions.

40 ↶

August 20, 1573

"NATHANIEL—good day to you, Cousin." Susanna regarded her kinsman, the vicar, with wary eyes as he was shown into the inner chamber beyond the dining parlor. She had been expecting a visit from him ever since Denzil Holme had sworn out his presentment against her. This was, she reminded herself, the clergyman who had succeeded in expelling the organ from the parish church and wanted to banish the singing of psalms. He considered a game of cards on the Sabbath to be a great sin.

"It is a propitious day," Nathaniel Lonsdale declared. Her brows lifted at the excessive volume of his voice. His face was flushed. His hands, moving in an agitated fashion as he spoke, caused his black gown to flap. "Denzil Holme has withdrawn his complaint against you."

Surprise nearly made Susanna drop the goblet she'd just filled with Canary wine.

"He has confessed to me that he lied. His daughter took him to task for his sins and informed him she would herself act as one of your purgators if you came before the archdeacon's court."

Susanna filled a second goblet for herself and gulped a fortifying swallow. When she and Catherine had left Jeronyma the previous day, they'd had little hope for that young woman. Frivolous and fretful by turn, she'd given the strong impression that she forgot her own troubles, let alone anyone else's, the moment some new thought distracted her.

"This news is most welcome." She offered him the wine.

He waved the goblet aside. "I've several other matters to discuss with you, all most pressing."

"Speak, then. You have my full attention."

He drew himself up, taking on the air of dignity he usually reserved for the pulpit. "Widowhood," he intoned, "is an unnatural state. It is contrary to God and man to continue in such wicked-

ness, for it is the duty of women to marry and let their husbands make decisions for them."

"Decisions such as what man shall have the living of Saint Cuthburga's?" Susanna set aside both goblets. This was familiar territory. "Does it not occur to you, Nathaniel, that if I'd had a husband deciding such matters for me, you might never have been appointed to your present post?"

His mouth opened and closed but no sound came out. Bulging eyes increased the resemblance to a freshly landed fish.

"Do you like Eastwold, Nathaniel? You have a congregation, a fine house to live in, for all that Goodwife Peacock feels it should be enlarged, and a generous annuity. You lack a wife, but have an income adequate to get you one if you so desire."

With an abruptness that startled her, he recovered himself. "Do you threaten to replace me, Cousin?" Nathaniel had the audacity to smirk at her. "Is that wise? You will soon lose whatever reputation for fairness you possess if you send me away."

Wondering if the mention of a wife had sparked this defiance, Susanna studied him through slitted eyes. "I pray you, continue to speak your mind, Nathaniel. I value honesty. It is a vengeful nature I cannot abide."

As she'd intended, that statement gave him pause. He took a moment to gather his thoughts, then launched into a diatribe against immoral behavior.

"—better to marry than to burn," he concluded some twenty minutes later.

"And a celibate life?" she inquired. "Is that permitted?"

He frowned, uncertain how to answer her. "'Tis better than a life of sin," he conceded, "but—"

"Excellent."

"Is there some reason you and Master Baldwin cannot wed?"

"Ah, we come to the point at last. There is a most excellent reason. I am barren. Better he should find a young, fertile wife than wed me. Mistress Jeronyma Holme's name has been men-

tioned," she added, although she was certain, after yesterday's events, that the match would never be made. Jeronyma, doubtless out of contrariness, had been open in her dislike of Winifred Baldwin after Nick's mother left.

Nathaniel sucked in a breath, turned away, then spun around to thunder at her. "He'll not have her!"

Susanna stared. Jeronyma and...Nathaniel? "My dear, if you think to wed her yourself, there is something you should know."

"She has already told me everything." His color high once more, a defiant gleam in his eyes, he looked ready to do battle. "That is another of the matters I wished to discuss with you."

"Let us discuss it, then."

She waited.

He paced. After a moment, he brushed cat hair off the cushions scattered across the window seat, adjusted his Geneva gown, and sat. "She came to me yesterday morning."

He painted an affecting portrait of a repentant Jeronyma, desperate for forgiveness.

"But Nathaniel," Susanna interrupted when he showed signs of waxing poetic, "surely Jeronyma has sinned by taking that which did not belong to her."

"Everything has been returned. Her loyal servants have seen to that. And your good self. No accusations will be made against her. There will be no trial and no public penance. And after she confessed to me, she promised never to let herself be tempted to steal again. I accompanied her back to Holme Hall," he continued. "Her father had just returned from Sandwich, where the citizens are in a frenzy of preparation for the queen's brief visit to their town. Jeronyma confronted him with his lie about you. It did much trouble her that he should disparage my kinswoman."

"Did she admit to her father that she was a thief?"

"I absolved her of the need." A most unholy smugness radiated from the vicar. "Still, she was very brave to face her father. He was angry, but honor triumphed in the end."

"How did she persuade him?"

"Between us, Jeronyma and I convinced Denzil Holme that no one in Eastwold believed his fabrication. I reminded him that you'd be within your rights to charge him with slander once you were acquitted, as you were sure to be with Mistress Jeronyma's testimony. He saw the error of his ways. Even now he is on his way to the archdeacon to swear he was mistaken in his identification. The presentment against you will be withdrawn."

"You'd do well to visit the archdeacon yourself, to assure him you have your parish well in hand."

"An excellent suggestion...Cousin." But he made no move to leave.

"Have you more concerns?"

"Aye. There is the matter of your tiring woman."

"Ah. Grace. You must talk to Edward Peacock about her. He is the one who refuses to allow Grace to marry his son."

"I would speak first to the young woman herself."

Susanna sent for her maid. "Anything else?"

Nathaniel's features hardened. "Brian Tymberley."

"Ah. I perceive that Jeronyma also told you about his threats."

"She did, and I've convinced her that she need not reveal what secrets he threatened to expose in order to give evidence against him. He extorted money from her. I intend to see that the fellow is punished for that. I will thrash the truth out of him with my own hands if need be."

"My dear Nathaniel, there is hope for you yet. I fear, however, that your bird has flown. Tymberley had another victim—no, I will not say who—and when that person refused to pay for his continued silence, he took himself off."

And good riddance, or so Susanna had thought at the time. Catherine was rightly nervous about what Tymberley might do next.

"Will he return?"

"That depends, I suppose, upon whether he's gone to the queen, or fled the country."

A third possibility occurred to her, but she kept her thoughts to herself.

A moment later, Jennet came into the room. She spared Nathaniel a curious glance, but her words, breathy with suppressed excitement, were directed at Susanna. "You sent for Grace, madam?"

"Yes, Jennet. She is not ill, I trust?"

"Oh, no, madam. Quite well, I fancy. But she is missing, and she's taken all she owns with her."

41 ∽

August 21, 1573

AT MIDMORNING the next day, Joan Peacock sent word to Leigh Abbey that Grace Fuller, now Grace Peacock, was safe and well. She and Alan intended to start a new life far away from Alan's father and Eastwold.

"Much luck to them," Fulke remarked a short time later as he saddled Susanna's mare.

She acknowledged his skepticism with a rueful smile. She'd provide Grace with a dowry, as she'd promised, but unless the young couple lived frugally, that money would not last long. She hoped Alan would surprise her and make something of himself, but she was not optimistic.

Neither did she expect much to come of asking questions of Nick's mother, and yet that was what she intended to do today, before Nick returned from London. It seemed to Susanna that Winifred Baldwin was the one person left who might have answers.

She knew Tymberley had other victims. She and Catherine had come close to finding proof of it when they'd searched for the document Jeronyma took from his chamber. They'd not found it.

Although Sarah claimed her mistress was passing careless with things she took, losing interest once she had them, and it would be easy enough to lose track of a roll of parchment, Susanna could not help but wonder if it had been found. Reclaimed, mayhap, by the one it most concerned?

If Winifred *had* taken the parchment Jeronyma stole from Tymberley, then she must have done so because it threatened her in some way. From the garbled description Jeronyma had given, the paper sounded like a horoscope, and since Susanna knew Winifred had once been the mistress of an astrologer, it followed that Tymberley could have used this fact to extort money from her.

As she had on the morning she'd found Carter's body, Susanna took the path through the woods and rode to Whitethorn Manor. Had Winifred sent Simon to meet Carter at the banqueting house? That was the first question she would ask. Given Winifred's age and dignity, she was not likely to have kept such an appointment in person but Simon had been in her employ for years. She'd have trusted him to deliver the blackmail.

The flaw in this reasoning was that no purse full of coins had been found at the scene of Carter's murder. Simon might have taken it away again. Or Tymberley, out and about that night, could have retrieved it himself. Before or after Carter's fall? Susanna wondered. Had Tymberley, mayhap, killed his own man? If he'd thought he'd been seen by Simon, that might have led him to kill again.

Whitethorn Manor seemed abnormally quiet when Susanna arrived.

"Is all well?" she asked Toby when he came out to help her dismount.

"Mistress Baldwin has not yet risen from her bed," he said.

"Is she ill?" Susanna inquired.

Toby looked uncomfortable. "There are many days now when she does not appear below stairs until noontide. And with Master

Baldwin away, there is no one else to make the maids bestir themselves."

Toby, Susanna realized, had not the authority, and there was no housekeeper. Winifred kept the keys herself. The cook had other concerns. Susanna supposed Simon had been the closest thing to a house steward at Whitethorn Manor. "I'd hoped to talk to her about Simon's death."

Toby's face worked. For a moment, Susanna thought he might cry. Then he shook himself. "No one is allowed to attend on her until she's risen and dressed on her own."

Susanna glanced at the upper floor of the house and tried to quell her impatience. She could make good use of the wait. Toby had been Simon's closest friend, the one person who'd been sure all along that he'd never have killed himself. What more did he know?

"Will you show me Simon's lodgings, Toby?" Nick had searched, but he might have overlooked something.

Once her horse had been seen to, the young man led her to the room he and Simon had shared. He was young, Susanna thought. Scarce one-and-twenty, with the sort of fairness that burned bright red when he was embarrassed. The pale fuzz that had decorated his cheeks and chin a year or so ago had finally grown into a proper beard, but he still had the face of an innocent.

The first thing she noticed in the room Simon and Toby had shared was a second blanket, a dagswain blanket, neatly folded at the foot of a field bed. "Simon's?" she asked.

Color shot into his face. "I do not know where it came from."

"It appeared just before Simon's death?"

He nodded.

"The same time as the garter?"

Again a nod. Toby refused to meet her eyes.

One question answered, thought Susanna.

She remembered something Toby had said when they'd first

questioned him. Simon had talked of having a way to earn money to buy land. A nest egg? Nick had found nothing when he searched. Now Susanna wondered if Simon had meant he expected to be paid a large sum, in the near future, mayhap for keeping silent about something he knew.

What if Winifred had sent Simon to the meeting with Carter with orders to kill? No, she thought. No reason to kill Carter. Tymberley? Had Winifred expected the mastermind himself to be waiting in the banqueting house? "Tell me again about Simon's last day," she urged Toby. "I arrived with word of Carter's death. I imagine that news spread like wildfire."

"Aye, madam."

"Did Simon seem surprised to hear of it?"

"It...troubled him. No one likes it when there's murder done," he added.

Winifred had, Susanna thought, recalling the older woman's avid interest. But she'd been taken aback when she'd heard it was Carter who lay dead. "Did Simon talk to Mistress Baldwin that day?"

Once again, Toby seemed ill at ease. "Aye."

"You have no reason to fear her wrath if you tell me what you know, Toby. Nick Baldwin is master here, not his mother."

"Easy for you to say, madam. You do not have to live at Whitethorn Manor."

"Did Simon fear her, too?"

"He served her out of loyalty," Toby admitted. "And she was more kind to him than to me. Encouraged him to keep her company sometimes. Tell her things."

In other words, she'd used him as a spy. "Did she trust him in return?"

A reluctant nod answered her.

"And he did talk to her privily the day he died?"

"Aye, madam. Twice."

"Do you know what passed between them?"

"Only a little of it, madam. The first time, Mistress Baldwin sent for him. 'Twas just after you and the master left to inspect Goodman Carter's body. I did not see him again until after Master Baldwin returned and called each of us in to ask questions. Simon's turn came after mine."

"Was it after that when Simon spoke of having the money to make a life with Grace?"

Toby nodded.

"I see." And later that day, Grace had taken the poppy syrup. "Did Simon speak with her or send any message to her?"

"I do not think so, madam."

"And you say he met with Mistress Baldwin a second time?"

"Aye, madam. In the late afternoon. I recognized her voice and Simon's when I passed by an open window."

"What did they say to one another?"

Toby glanced nervously toward the door to make sure no one else was nearby. "I did not overhear much, madam. But Simon did say he was concerned for Grace's good name."

"And your mistress's reply?"

"She told him not to be more of a fool than he was already."

Susanna frowned. "Had Simon heard the false rumor that Grace killed herself?" She still wondered why he'd not gone to Leigh Abbey to find out the truth.

"I cannot say what Simon heard, but I knew naught of any suicide, Grace's *or* Simon's, until the master told me. Your Joyce passed on the story about the poppy syrup right enough—told Cook when she came avisiting. But that was not till evening," he added as an afterthought, "and there was naught said about Grace being like to die from it."

Susanna blinked at him in surprise. It had been Winifred Baldwin, not Toby, who'd told Nick that Simon had been distraught over Grace's death. She'd given them a reason for Simon to take his own life and they'd seized upon it, glad of an answer. But what if she had lied?

A horrible suspicion crept into Susanna's mind. Winifred might not have sent Simon to kill Tymberley, but if he'd slain Carter and confessed his crime to her, what would she have done? Advised him to say nothing to her son? Told him the death was sure to be ruled accidental? Promised him a reward for his silence?

But Simon, after he'd been questioned by Nick, must have had second thoughts. Fear of discovery. A guilty conscience. He'd gone to Winifred, told her he could not live with what he'd done. No. Toby had overheard mention of Grace. Simon had not wanted her to be blamed. Perhaps he'd intended to admit his own guilt to spare her. He'd no doubt sworn he'd leave Winifred out of his explanation, too, but she'd have realized what might happen. If Nick pressed him for the reason he'd been at the banqueting house, he might have broken, confessed that he'd gone there to pay Winifred's blackmail money to Carter.

By some means, Winifred Baldwin had convinced Simon to put off talking to her son. Then she'd persuaded him to meet her that night. She'd opened the hatch above the ice-well and waited.

A few minutes after leaving Toby, Susanna stood before Winifred Baldwin's bedchamber door. It was closed but not locked. Winifred assumed her standing orders to her servants would be obeyed without question.

Bent on accusing a violent and temperamental woman of murdering her own servant, Susanna was unprepared for the sight that met her eyes. Winifred sat naked in her bed, her back against a bolster. Her eyes were closed, her breathing ragged, and her lax hands were still greasy with the residue of the salve she had just finished rubbing onto her right breast.

Moved to pity, Susanna stared at the ghastly expanse of exposed flesh. The oily mixture, freshly applied, glistened in the light from the window but it did not conceal the abscess beneath. The entire breast was grotesquely misshapen. Smaller lesions had formed, mayhap from the treatment rather than as a result of the tumors and ulcers within, and the nipple had fallen away.

Only when she shifted her gaze to Winifred's face did Susanna realize Nick's mother had opened her eyes. The old woman glared but seemed too weak to do more.

"You have been keeping a heavy burden to yourself," Susanna said in a gentle voice.

They had never liked each other, but she could not help but feel sympathy for the other woman's suffering. There was no cure for such growths of the breast, just pain and certain death.

All brisk efficiency, she crossed the room to the low table by the bed that held Winifred's medicines. Among them she recognized poppy syrup and laudanum. She picked up the container that held the latter. "How much?"

"Two or three grams a night for the last four months."

No hurt and some comfort, Susanna thought, but the narcotic would be less effective against pain as time went on, unless Winifred took a dose sufficient to render her unconscious. "Have you been seen by a reputable physician?"

Winifred snorted and made a passable job of imitating one of the doctors she'd consulted. "Madam, you have a cancer, which is a hard swelling that resists the touch and causes most vehement pain. This is caused by a black choler gathered in that part, or by reason of a hard tumor ill-cured, which has turned into a cancer and acquired a malignant disposition."

Susanna said nothing. There was little comfort she could offer. Lord Robin Dudley's wife had been suffering from such a tumor on the breast when she died in a tumble down a flight of stairs. Some said that had been a blessing in disguise...for her, at any rate. A few had even suggested that the fall had been deliberate self-murder. Then there had been the marchioness of Northampton, Lady Cobham's sister-in-law. She had likewise been afflicted by a pernicious cancer. She had traveled to the Continent in search of a cure. She'd found none. The most learned physicians in the world could do nothing but watch women die.

Rendered querulous by Susanna's unspoken empathy, Wini-

fred revived enough to grope for one of the smaller bottles on the table by the bed. Examining it first to make certain it was the one she wanted, she pulled out the stopper and drained the contents, smacking her lips when the bottle was empty. "A reviving cordial," she said. Two bright spots of color appeared on her cheeks.

Susanna did not inquire what was in it, though she wanted to. Instead she asked, "Why have you kept your illness secret from Nick?"

"I am not ready for him to know. And why should I tell anyone when I've found a way to manage the pain?" When Susanna did not respond, Winifred added, voice testy, "Do you think you are the only one who can read books and find remedies? Paracelsus, the fellow calls himself. Came up with a formula for this laudanum. Much to be commended. I did not need your help to find it. I do not need anyone's help, nor their pity, neither."

With an effort, she threw back the coverlet and got out of bed. Scorning Susanna's offer of assistance, she dressed herself in one of the loose gowns she favored, adding an extra pad of fabric between her chemise and the bodice to absorb the pus oozing out of her suppurating breast. With a grimace of pain, she reached up to adjust her hair and headdress. Then she rang a hand bell, the signal for her maid to bring bread, cheese, and ale.

Before long, she was settled on the window seat with a modest repast beside her on the cushions. The servant had brought an extra goblet, but Winifred did not offer drink to Susanna. "Why are you here?" she demanded.

"To ask you certain questions about Simon Brackney's death."

"Never able to leave well enough alone, are you?"

"Not when I believe there may be a murderer left free to kill again."

"Bah! Overweening pride. Rampant curiosity. Those things are what move you!"

Susanna winced at the accusations. True? If they were, she

would have to live with that uncomfortable self-knowledge, and with the guilt of badgering a dying woman, but she did not intend to back down.

"Did Simon go to the banqueting house that night at your behest?"

Winifred considered the question, then asked one of her own. "Why would I send Simon there? If you are so clever, you tell me."

"To pay Brian Tymberley for his silence. You overheard our conversation at Holme Hall. You know Tymberley made a practice of extorting money to keep secrets. Was that horoscope of your making?"

"A very evil man, is Master Brian Tymberley. Mayhap he killed Simon."

"Why should he?"

Winifred's eyes sparkled. She was enjoying this.

"I believe that Simon had the misfortune to arrive at that banqueting house in time to see Grace Fuller run away," Susanna said. "He climbed into the oak tree and found Miles Carter there. He was in possession of a woman's garter. Grace's garter."

A cruel smile on her face, Winifred laughed. "The fool asked if it belonged to her. Left himself open to Carter's taunts. You can imagine the sort of things Tymberley's man said. In the end, Simon got so angry he lunged at Carter, trying to get the garter away from him. They fought, the rail broke, and Carter fell."

"An accident."

Winifred shrugged, then winced.

"Why not let Simon tell Nick the truth, then?"

"Why should he? It would be ruled an accident if he kept silent. It *was*."

"There were muddy footprints," Susanna told her.

"I did wonder. Ah, well. And Simon was weak. I say he killed himself out of guilt."

"But he was desperate to clear Grace of any suspicion that

might attach itself to her. And he told you his intention. Do you know what I think happened then, Winifred?"

"I wait with bated breath for you to tell me."

"You lured Simon to the ice house and pushed him through the open hatch to keep him from giving away your involvement, for if Simon confessed to being there at the banqueting house, then Nick would soon know you had been ready to pay blackmail."

What secret could be so terrible that Winifred would kill to keep it? Susanna was not certain she wanted to know. She hoped Winifred would deny the accusation. She wanted to be wrong, for Nick's sake, but she did not believe she was.

Winifred's gleeful malevolence seemed to fill the chamber, sending a chill along Susanna's spine. "And what do you mean to do about it, Susanna Appleton? Will you put my son through the disgrace of my trial and execution? How wasteful when I am dying already!"

"Trial and execution would serve no purpose," Susanna agreed, "and both deaths have already been declared accidents."

Nor was she sure she could bring herself to tell Nick that his mother was a murderer. Winifred, she supposed, counted on her reluctance to cause Nick pain. She frowned. Keeping such a dark secret would undermine the trust they shared. That would please Nick's mother, too.

The sound of an approaching rider reached them through the open window. Winifred peered down into the courtyard. "My son is home."

Buoyed up by the effects of whatever potion she'd imbibed, she moved without apparent pain and busied herself topping off her goblet and filling another, which she offered to Susanna. "Shall we give the illusion of friendship? For Nick's sake?"

Susanna took the goblet just as Nick burst in on them. Still covered with dust and sweat from his long morning's ride, he looked first for his mother, then shifted his gaze to Susanna. She

could tell he was surprised to see her, but at the same time relief made his shoulders sag. "I am glad to find you here," he said. "I feared Brian Tymberley might have returned before me. He's a desperate man and may be dangerous to anyone who attempts to thwart him."

"He's been and gone, Nick, and none of us the worse for it." She set the goblet aside to reach for his hands.

He grasped hers briefly, then glanced at his mother. "I both hoped and feared I might find him here."

"What happened in London?" Susanna asked. "Did you confront him?"

"He never meant to go there. When he left Leigh Abbey he traveled direct to Sissinghurst Castle, where the queen had stopped on her progress. In her retinue is a young man Tymberley hoped would pay him for his silence. He was wrong. There is now a warrant sworn out for his arrest. He's wanted for questioning by the Privy Council."

"But he left here with Carter's body," Susanna said. "What did he do with it?"

"I suspect he buried it in some lonely section of wood along the way. Chances are it will never be found."

They might be able to trace the cart, Susanna thought. Tymberley must have left it with someone and retrieved it on the return journey.

Nick reached for the goblet Susanna had abandoned. Winifred pressed her own, freshly filled, into his hand instead. Susanna let the other woman have her small triumph. Nick did not, she noticed, meet his mother's eyes as he nodded his thanks for the drink.

His thirst slaked, Nick continued his tale, explaining how the coroner's encounter with a man who had been hanged might have prompted Tymberley's sudden departure from the parish with Carter's body. "After I left Julius Port, I rode to Hothfield and discovered what Tymberley had been up to at court. The queen's

principal secretary believes Tymberley has fled to France, but it seemed to me more likely he'd come here before fleeing the country. He'd want to take as much money as possible with him into exile."

"He tried all his old tricks," Susanna admitted. "Jeronyma refused to pay again. So did Catherine."

An indignant sound issued from Winifred's direction. "Never tell me Lady Glenelg has done something to be ashamed of! Bad enough the Holme girl proved a thief. Are there no honest women left?"

"Honest women?" Nick echoed.

The odd note in his voice warned Susanna that he was about to lose his temper, but his mother seemed to notice nothing amiss.

"I know about Jeronyma Holme now," Winifred said. "Marriage to her is out of the question. Indeed, I did think a widow might suit you better."

Nick's gaze shot to Susanna.

"Not her! I meant to propose that you marry Catherine Glenelg."

A bubble of hysterical laughter threatened Susanna's composure. She could not imagine a match more absurd. But Winifred saw nothing amusing in her suggestion. She caught Nick by the front of his doublet and demanded he tell her what it was Catherine had paid Tymberley to hide.

"That, Mother, is none of your business. Let us discuss instead why you paid him."

Winifred's scowl rivaled her son's. "I've no notion what you mean."

"I mean this." He detached her grip and withdrew a roll of parchment from inside his doublet. "This horoscope." He waved it under her nose. "I know who it belongs to, mother. I know what it says."

Winifred snatched it from him, anger radiating from her, but her hand trembled as she unrolled the parchment. Then color

leeched from her face so rapidly that Susanna feared she might faint. She started toward the older woman.

Winifred's fierce expression warded her off. "Send your mistress away, Nick. There is no need to air our dirty laundry in front of outsiders."

"She has a right to know I am a bastard, Mother."

The word hung in the air like a living presence. Tears pooled at the corners of Winifred's eyes.

"As you have no doubt guessed, I met your *legitimate* child in London." Nick's voice had dulled as his anger faded. Disillusionment made his shoulders slump. Bitterness laced the harsh words he addressed to his mother. "You had one child by your true husband, the astrologer. A pity he was still alive when you decided to move up in the world and marry Bevis Baldwin. I do not suppose my father ever knew you'd committed bigamy. Or that you abandoned your daughter because being the wife of a merchant was so much more comfortable than staying with a third-rate figure-flinger."

Susanna's heart ached for Nick as he told his mother how he'd set out to discover Tymberley's secrets and stumbled upon hers. Susanna had rarely felt more helpless. She understood now why Winifred had killed. She'd been desperate to keep Nick from learning the truth about his own birth.

Shouts and thumps elsewhere in the house took a long time to penetrate through what followed: Nick's shouting and Winifred's invective. She might not have any defense of her actions all those years ago, but she did not intend to let Nick forget that she'd raised him and loved him and even run the business for him when he'd been abroad. She stopped short of telling him she'd done murder for his sake and Susanna did not remedy the omission.

With an abruptness that made Susanna jump, Nick turned to her and gestured toward the passage. "Find out what all the commotion is about."

She was not given to following orders when they were barked

at her, but under the circumstances, she decided to do as he bade her. By the time she opened the door, the worst of the battle was over. Nick's servants, led by Toby, had succeeded in overpowering an intruder.

"We caught him, madam!" Toby croaked. From the bruises at his throat, he'd grappled hand-to-hand with the man who was now his prisoner.

Brian Tymberley had similar marks where his ruff had been torn away. He gasped and wheezed like a man who had also been struck in the middle of the chest...or the privates.

"Bring him here," Susanna ordered. If naught else, this distraction would stop the painful recriminations between mother and son.

"He had his hand in the cash box," Toby announced.

"Villain!" Winifred shouted.

"Thief," Nick corrected in another of those dangerously mild tones. "Leave him there on the floor, Toby. I will deal with him." He thanked the serving men profusely but hustled them away before turning his attention to the disheveled and desperate courtier sprawled on the rush matting.

Still choking and sputtering, Tymberley managed to heave himself to a sitting position.

"Here. Give him this." Winifred picked up the goblet Susanna had abandoned and passed it to Nick to give to Tymberley.

He gulped it down, greedily draining the contents, then showed his thanks by threatening Nick. "Try and hold me here and I will tell everyone of your mother's sins."

"So be it," Nick told him.

Winifred said nothing, but she watched the prisoner with avid eyes, almost gloating over his distress.

Whoever had pummeled him had probably broken a rib, Susanna thought. She felt no immediate compulsion to offer aid. Not yet. Let him answer a few questions first. She'd start with something simple. "Where did you go when you left Leigh Abbey two days ago?"

"What does it matter?"

"I am curious," Susanna told him. "And what can it hurt to tell us? We already know the trouble you're in. Mayhap, if you co-operate, we can be persuaded to help you when you come before the Privy Council."

At the mention of that august body, Tymberley's face took on an unhealthy pallor. Uncertainty made his voice quiver. "I hid in the same deserted farmhouse where I spent the night on my way to Sissinghurst."

"Is that where you left the cart and horse?" She hoped he'd had the common humanity to turn the beast loose to graze.

"Aye." Perplexity overspread his features.

And then, as Susanna watched, Tymberley gasped in pain and clutched at his chest. His eyes wide, he slowly toppled over. By the time his head struck the plank floor, he was no longer breathing.

Susanna stared, belatedly divining the cause of his collapse. Her gaze jerked to Winifred. "Poison," she whispered.

She felt every bit of color leech from her face. Winifred had originally intended the contents of that goblet for her. Only Nick's timely entrance had prevented her from drinking.

"Is he dead?" Winifred asked.

Susanna knelt by the body. "Yes."

"Poison?" Nick echoed.

"There may have been a bit of my medicine in that goblet," Winifred said in dismissive tones. "How was I to know it would kill him?"

Shock warred with disbelief in Nick's eyes as he turned his tormented gaze to Susanna. He knew, as she did, that his mother's act had been deliberate.

Did he also realize Winifred had killed Simon?

"He should have been brought to trial," Nick said.

"Bah!" said Winifred. "Better this way."

"Better that I arrest my own mother for murder?"

"You will not accuse me. You are not so cruel. Besides, I have

only a short time left to live." In a few curt words, she described her condition.

Nick looked to Susanna for confirmation.

"She tells you true, Nick."

"That must be what she meant, then."

"Who?" Winifred demanded.

"The woman who calls herself Dame Starkey. She has a Christian name, I presume?"

"Griselda. Griselda Ferrers."

"Yes. My...sister. It seems she cast your horoscope, Mother. She predicts you will soon reap what you have sown." Nick hesitated. "She also told me of another horoscope, one you helped her father prepare."

"I imagine she did." A hint of amusement showed briefly in Winifred's expression.

Nick did not seem to notice. He spoke to his mother with deep regret in his voice. "If the other horoscope still exists, Mother, it is not just murder you'll be charged with."

"Something worse?" Winifred asked, but Susanna could see she did not take Nick's warning seriously.

"Much worse, if it was commissioned by George Boleyn for his sister. Was such a horoscope sold to Tymberley as she claims?"

"Griselda lied. The horoscope Tymberley had was her own nativity."

"Does she still have the other, then?"

"What does it matter if she does?"

"George Boleyn's sister married King Henry," Nick reminded her. "To cast the horoscope of a queen is treason. And this particular horoscope predicted its subject would have a child by her lover."

Susanna grasped the implications at once and felt a clench of panic, but Nick's mother simply sat down on the edge of her bed and began to lecture him in the tone of one addressing a small, not-very-intelligent child.

"George Boleyn had *two* sisters. The horoscope that so troubles you was not drawn up for Anne. It was cast for *Mary* Boleyn, who counted among her lovers the kings of France and England. The child that horoscope foretold is her son by old King Henry, a bastard with no claim to the throne. To predict Mary Boleyn's future was never treason."

"Griselda lied to me?" Nick stumbled over the name.

Winifred laughed. "Yes. To cause trouble between us, as did her other lies. She is not as clever as she thinks she is. She misread her own nativity. When she tried to use it to extort money from me, I soon set her straight. I told her, as I now tell you, that I never married her father."

Nick did not look convinced. "Then why pay Tymberley? Why kill him?"

As one, all three of them looked at the dead man.

"He deserved to die," Winifred declared, "and that is all I mean to say about murder, suicide, horoscopes, or extortion. Make what you will of it."

Nick took her at her word. He called Toby in. "Send for Julius Port," he ordered. "Then take Tymberley's body to a storehouse. Then fetch my mother's maid to pack her belongings. I am taking her back to London with me."

"I cannot leave now," Winifred objected. "Not when the queen herself is on her way here to knight you!"

"There was never a chance of such a thing except in your mind. We leave on the morrow."

"Nick," Susanna protested. "She is dying."

"I do not need your sympathy," Winifred snapped. The maid's arrival did not improve her temper, but she seemed to see the futility in further protest and addressed herself, though with ill grace, to preparations for the journey.

"I will be gone for some time, Susanna," Nick said when he'd led her from the room. "I must deal with matters in London on my own."

She brushed her lips across his cheek. "Nothing she has done makes you less than you are, Nick, nor can it change how I feel about you."

"There will be no trial. No scandal. I will keep her close, a prisoner in her own chamber, until she dies."

"It will not be long."

"She lied to me, Susanna." Nick sounded close to tears. "John Dee translated Griselda's nativity. She is the legitimate child. I am the one base born. A bastard."

"That makes no difference to me, Nick. Promise me you'll return to Whitethorn Manor."

He hesitated so long that she thought he intended to refuse. He would agree if she promised to marry him, Susanna thought. She was sore tempted to make the offer, but something held her back until, at last, he nodded.

"I will return."

42 ∾

One week later
August 28, 1573

CARRYING a jug of cider and two glass goblets, Jennet climbed the little knoll to where Lady Appleton sat on her stone bench, which had been restored to its former location beneath the ancient oak tree. The last vestiges of the banqueting house had been hauled away, a small blessing in a week fraught with disappointment and distressing developments.

"Fresh made, madam." Jennet filled both goblets.

Lady Appleton left off fanning herself in the heat of a summer afternoon and accepted the libation.

"Mistress Jeronyma has gone back to Lady Cobham." Jennet

hoped this news would cheer her mistress, who had been in low spirits ever since Master Baldwin had taken his mother off to London. She was dying, Lady Appleton said.

"To Cobham Hall?" Lady Appleton asked.

"Aye." She'd taken Sarah, who had returned to Holme Hall a few days after Nathaniel Lonsdale's visit to Leigh Abbey. "They're to rejoin the court at the end of the queen's progress."

"What of Jeronyma's marriage?"

"Mark's mother says the vicar and Master Holme are still thick as thieves. No doubt the betrothal will be announced soon." Jeronyma Holme as the vicar's wife? Jennet could not quite imagine it.

She sipped her cider, savoring the tart flavor of the apples. Their very surroundings, which seemed to soothe Lady Appleton, only increased her vexation. The memory of that accursed banqueting house still cast its shadow here.

"It is not fair that the queen should punish us for an unfortunate series of accidents."

She'd voiced the same complaint a dozen times since the message arrived from the queen's house at Westenhanger. Two days after Brian Tymberley's death, Elizabeth of England had decided to forego her visit to Leigh Abbey in favor of extending her stay in Sandwich. Lady Appleton had been neither disturbed nor disappointed to have the royal visit canceled, but Jennet did much resent the sudden change in plans.

"You can scarce blame Her Majesty for thinking twice about lodging in a spot where three sudden deaths occurred in less than a fortnight," Lady Appleton said.

"It is not as if any of them were murders," Jennet protested, "and the queen would have been in no danger here."

Lady Appleton resumed fanning herself and contemplated the peaceful vista before her.

"Do you think the queen might come to Leigh Abbey another year?" Jennet asked when the silence became too much for her.

Lady Appleton did not reply at once. She sipped more of the cider. Then, slowly, her lips curved into a crooked smile. "I have no idea, Jennet," she said, "and I consider that a blessing. Mere mortals were never meant to see into the future."

FINIS

⌒ A Note from the Author

ONE CHALLENGE in writing a series involves continuity. When I wrote *Face Down in the Marrow-Bone Pie*, I arbitrarily placed Leigh Abbey halfway between Dover and Canterbury, near the main road to London. I described bits and pieces of Lady Appleton's home in that book and others, but most of the action in the stories took place elsewhere. In *Face Down Beneath the Eleanor Cross*, I set a scene in the parish church. But when I came to write *Face Down Below the Banqueting House*, I knew I had to be much more specific. Suddenly it was necessary that I know a great deal more about the location of Leigh Abbey in relation to nearby towns and other country houses. In addition, I needed to visualize the arrangement of rooms at Leigh Abbey and familiarize myself with the pecking order of servants within that household.

Leigh Abbey and its environs are not based on any one real place. The geographical location of my fictional Leigh Abbey is the village of Barfreston (formerly spelled Barfrestone and Barfreystone) in Kent, which is distinguished by an elaborate little Norman church. Like my fictional Eastwold, it is off the beaten path. I've taken the liberty of making Barfreystone Jennet's birthplace, but Eastwold, Leigh Abbey, and Whitethorn Manor exist only in the pages of Lady Appleton's adventures. Her home is a com-

posite of a number of extant medieval and Elizabethan houses I visited in search of a model for Leigh Abbey. I'd like to take this opportunity to thank all the friendly, helpful people who answered my questions in Barfreston and at Haddon Hall, Rufford Old Hall, Speke Hall, Cothele, Barrington Court, Athelhampton, Montacute, Ightham Mote, and Penshurst.

If you are looking for books on Elizabethan houses, or if you are interested in my sources on such topics as fortune tellers, the progresses of Queen Elizabeth, the activities of the "bawdy courts," and the laws regulating wardship, you'll find an extensive bibliography at my website, www.KathyLynnEmerson.com.

I love doing research, and have attempted to make my presentation of life in the sixteenth century as accurate as possible, but my primary goal in writing this book has been to tell a good story. Enjoy!

∿ About the Author

KATHY LYNN EMERSON has been interested in the Elizabethan period since she was a schoolgirl. In adddition to books and stories in the *Face Down* series, she has used that setting in several romance novels. She also wrote the highly praised *Writer's Guide to Everyday Life in Renaissance England* for Writer's Digest Books.

Emerson lives in Maine with her husband and three cats. She welcomes visitors and e-mail at www.KathyLynnEmerson.com.

MORE MYSTERIES
FROM PERSEVERANCE PRESS
For the New Golden Age

Available now—

Evil Intentions, **A Feng Shui Mystery**
by Denise Osborne
ISBN 1-880284-77-4
A shocking and questionable suicide linked to white slavery and to members of
an elite Washington, D.C. family embroils Feng Shui practitioner Salome Water-
house in an investigation that threatens everyone involved.

Tropic of Murder, **A Nick Hoffman Mystery**
by Lev Raphael
ISBN 1-880284-68-5
Professor Nick Hoffman flees mounting chaos at the State University of Michi-
gan for a Caribbean getaway, but his winter paradise turns into a nightmare of
deceit, danger, and revenge.

Death Duties, **A Port Silva Mystery**
by Janet LaPierre
ISBN 1-880284-74-X
The mother-and-daughter private investigative team introduced in Shamus-
nominated *Keepers,* Patience and Verity Mackellar, take on a challenging new
case. A visitor to Port Silva hires them to clear her grandfather of anonymous
charges that caused his suicide there thirty years earlier.

A Fugue in Hell's Kitchen, **A Katy Green Mystery**
by Hal Glatzer
ISBN 1-880284-70-7
In New York City in 1939, musician Katy Green's hunt for a stolen music manu-
script turns into a fugue of mayhem, madness, and death. Prequel to *Too Dead To
Swing.*

The Affair of the Incognito Tenant, **A Mystery With Sherlock Holmes**
by Lora Roberts
ISBN 1-880284-67-7
In 1903 in a Sussex village, a young, widowed housekeeper welcomes the
mysterious Mr. Sigerson to the manor house in her charge—and unknowingly
opens the door to theft, bloody terror, and murder.

Silence Is Golden, **A Connor Westphal Mystery**
by Penny Warner
ISBN 1-880284-66-9
When the folks of Flat Skunk rediscover gold in them thar hills, the modern-day stampede brings money-hungry miners to the Gold Country town, and head-lines for deaf reporter Connor Westphal's newspaper—not to mention murder.

The Beastly Bloodline, **A Delilah Doolittle Pet Detective Mystery**
by Patricia Guiver
ISBN 1-880284-69-3
Wild horses ordinarily couldn't drag British expatriate Delilah to a dude ranch. But when a wealthy client asks her to solve the mysterious death of a valuable show horse, she runs into some rude dudes trying to cut her out of the herd—and finds herself on a trail ride to murder.

Death, Bones, and Stately Homes,
A Tori Miracle Pennsylvania Dutch Mystery
by Valerie S. Malmont
ISBN 1-880284-65-0
Finding a tuxedo-clad skeleton, Tori Miracle fears it could halt Lickin Creek's annual house tour. While dealing with disappearing and reappearing bodies, a stalker, and an escaped convict, Tori unravels the secrets of the Bride's House and Morgan Manor, which the townsfolk wish to hide.

Slippery Slopes and Other Deadly Things,
A Carrie Carlin Biofeedback Mystery
by Nancy Tesler
ISBN 1-880284-64-2
Biofeedback practitioner/single mom/amateur sleuth Carrie Carlin is up to her neck in snow, sex, and strangulation when her stress management convention is interrupted by murder on the slopes of a Vermont ski resort.

REFERENCE/MYSTERY WRITING
How To Write Killer Fiction:
The Funhouse of Mystery & the Roller Coaster of Suspense
by Carolyn Wheat
ISBN 1-880284-62-6
The highly regarded author of the Cass Jameson legal mysteries explains the dif-ference between mysteries (the art of the whodunit) and novels of suspense (the hero's journey) and offers tips and inspiration for writing in either genre. Wheat shows how to make your book work, from the first word to the final revision.

Another Fine Mess, **A Bridget Montrose Mystery**
by Lora Roberts
ISBN 1-880284-54-5
Bridget Montrose wrote a surprise bestseller, but now her publisher wants
another one. A writers' retreat seems the perfect opportunity to work in the
rarefied company of other authors...except that one of them has a different
ending in mind.

Flash Point, **A Susan Kim Delancey Mystery**
by Nancy Baker Jacobs
ISBN 1-880284-56-1
A serial arsonist is killing young mothers in the Bay Area. Now Susan Kim
Delancey, California's newly appointed chief arson investigator, is in a race
against time to catch the murderer and find the dead women's missing babies—
before more lives end in flames.

Open Season on Lawyers, **A Novel of Suspense**
by Taffy Cannon
ISBN 1-880284-51-0
Somebody is killing the sleazy attorneys of Los Angeles. LAPD Detective Joanna
Davis matches wits with a killer who tailors each murder to a specific abuse of
legal practice. They call him The Atterminator—and he likes it.

Too Dead To Swing, **A Katy Green Mystery**
by Hal Glatzer
ISBN 1-880284-53-7
It's 1940, and musician Katy Green joins an all-female swing band touring
California by train—but she soon discovers that somebody's out for blood.
First book publication of the award-winning audio-play. Cast of characters,
illustrations, and map included.

The Tumbleweed Murders, **A Claire Sharples Botanical Mystery**
by Rebecca Rothenberg, completed by Taffy Cannon
ISBN 1-880284-43-X

Keepers, **A Port Silva Mystery**
by Janet LaPierre
Shamus Award nominee, *Best Paperback Original 2001*
ISBN 1-880284-44-8

Blind Side, A Connor Westphal Mystery
by Penny Warner
ISBN 1-880284-42-1

The Kidnapping of Rosie Dawn, A Joe Barley Mystery
by Eric Wright
Barry Award, *Best Paperback Original 2000*. Edgar, Ellis, and Anthony Award
nominee
ISBN 1-880284-40-5

Guns and Roses, An Irish Eyes Travel Mystery
by Taffy Cannon
Agatha and Macavity Award nominee, *Best Novel 2000*
ISBN 1-880284-34-0

Royal Flush, A Jake Samson & Rosie Vicente Mystery
by Shelley Singer
ISBN 1-880284-33-2

Baby Mine, A Port Silva Mystery
by Janet LaPierre
ISBN 1-880284-32-4

Forthcoming—

Crimson Snow, A Hilda Johansson Mystery
by Jeanne M. Dams
The murder of a popular schoolteacher shocks South Bend, Indiana. Young Erik
Johansson was in Miss Jacobs's class, but his sister Hilda, housemaid to the
prominent Studebaker family and preoccupied with her pending marriage, re-
fuses to investigate this time—until Erik forces her hand. Based on an unsolved
case from 1904.

Paradise Lost, A Novel of Suspense
by Taffy Cannon
Appearances deceive in the kidnapping of two young women from a posh Santa
Barbara health spa, as relatives and the public at large try to meet environmental
ransom demands, and the clock ticks toward the deadline.